MODERN ART
A CRASH
COURSE

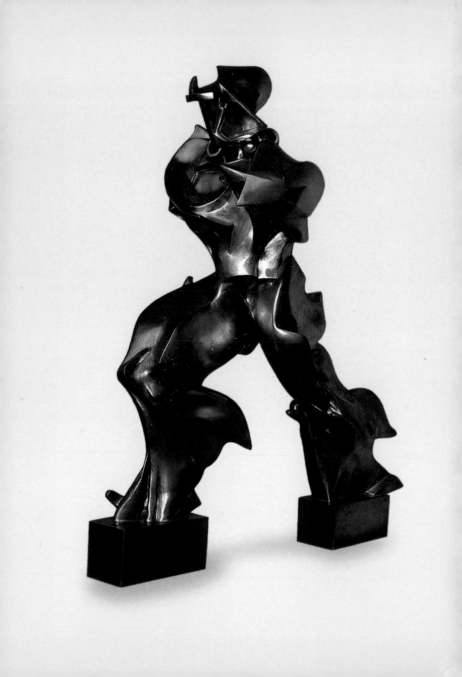

MODERN ART
A CRASH
COURSE
CORY BELL

WATSON-GUPTILL
PUBLICATIONS

New York

Library of Congress
Catalog Card Number: 00-109871

ISBN 0-8230-0985-8

This book was conceived, designed, and produced by
THE IVY PRESS LIMITED
The Old Candlemakers, West Street,
Lewes, East Sussex, BN7 2NZ, England

Art director: PETER BRIDGEWATER
Publisher: SOPHIE COLLINS
Editorial director: STEVE LUCK
Designer: JANE LANAWAY
Editor: GRAPVINE PUBLISHING SERVICES
DTP designer: CHRIS LANAWAY
Picture research: VANESSA FLETCHER
Illustrations: IVAN HISSEY

Printed and bound in China by
Hong Kong Graphic and Printing Ltd.

1 2 3 4 5 6 7 8 9 10/06 05 04 03 02 01 00 99 98

Contents

Introduction

Remember the 20th century? That weird and lurid dream, from which we all woke up a short while ago (most of us with lousy hangovers)? Pinch yourself and blink: what was that all about?

Well, here are some clues: a bunch of objects left lying around the room. The strangest bunch of objects—paintings that are baffling, mesmerizing, sometimes indescribably beautiful; assemblages of steel

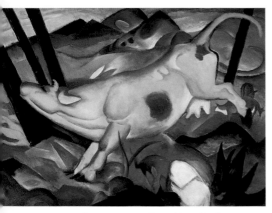

New visions of nature: Franz Marc's *Yellow Cow* (1911) demonstrates the exultant wildness of early 20th-century art. (I'll have whatever he's having.)

and glass and plastic and felt; video loops and rumors of revolutionary events; manic manifestos and turgid catalogs; helium balloons, libraries of lead, giant earthworks, and casts of frozen blood. Bizarre and giddying leftovers of the dream, we bundle them together under the label "modern art."

How this course works

Each double-page spread is devoted to an artist, an artistic movement, or a group of works with something in common, and the story proceeds more or less chronologically. On each spread there are some regular features. It won't take you long to figure them out but check the boxes on pages 8–11 for more information.

*But how do we make sense of them?
What did all those artists imagine they
were doing, back then before the
big date change?*

*This short book exists to meet that
question. Its main purpose is to give
some shape and to make some sense of
the crazy junkyard we are left with.
Its purpose is not, primarily, to judge what was good
and bad among the artistic reputations of the century;
it's to understand what led to them in the first place.
But judgments will come anyway. In fact, sometimes
we are going to have to be really rude.*

Timeline
More of a contextual chronology than a timeline, because artists and movements are constantly overlapping. A selected list of major events happening at the time the artists were painting, to illuminate the world they inhabited. For example, the Jehovah's Witnesses denomination was founded in the year that Dali painted *Persistence of Memory*, and the world's first kidney transplant was performed the year before Rauschenberg began his series of *Black Paintings*.

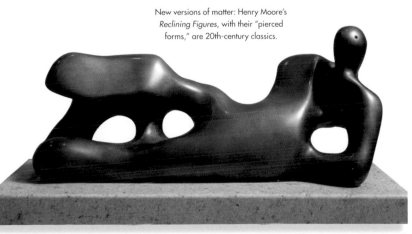

New versions of matter: Henry Moore's *Reclining Figures*, with their "pierced forms," are 20th-century classics.

One thing's certain: there's no way we can get near modern art by talking as if it's all in deathly earnest, only to be spoken of in hushed tones and polysyllables. Modern art is absurd, very often; it's manic, over-the-top, pretentious, sometimes even the con that conservative types suspect it to be. It's just that, for those who have got involved in creating it, being thought of as all those things is a risk worth taking. For the sake of what? Hopefully this book will answer that question too.

One note: of course, "modern art" began before 1900. You can date its birth to Manet, painting in the

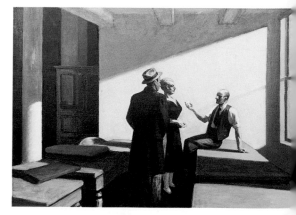

The poetic stoicism of Edward Hopper's *Conference at Night* (1949). Wichita Art Museum.

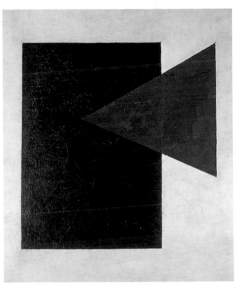

1860s; or Courbet round about 1850; or Goya or David, in the wake of the French Revolution. . . But that way you are picking out a "true" line of modern art from all that wasn't "modern"

in the 19th century. We're not doing that here: we're trying to look in as many directions as possible (admittedly from a viewpoint in the West) at the visual art of a century that was thoroughly obsessed with its own modernity.

And now we've woken up, and we're in another era; and "modern art" is dead.

Long live modern art!

Cory Bell

1900 Emile Gallé's exotic glassware is a hit at the Paris Exhibition.

1901 Queen Victoria dies in London at the age of 81. She is succeeded by her son, Edward.

1902 Enrico Caruso makes his first phonograph recordings and gets paid a fee of $4,000 for performing ten songs and arias.

1900~1903

Have We Got the Right Century?
Sargent, Art Nouveau

March 1900: Sir George Sitwell and family are daily reporting to the London studio of John Singer SARGENT *(1856–1925). While the children fidget in their finery, the baronet and the master of the "swagger portrait" playfully squabble. "My daughter's nose is longer than that!" he rebukes. Sargent responds by lengthening the father's own proboscis.*

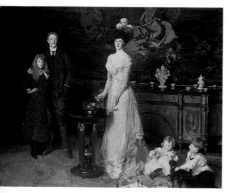

John Singer Sargent, *The Sitwell Family* (1900). Private collection. Edith (in red) and Sacheverell and Osbert (sitting well with the dog) will grow up to become literary celebrities.

The Englishman requires a match for an 18th-century ancestral portrait; the American expatriate paints while looking over his shoulder to the shorthand brushwork of Manet, forty years earlier, and over Manet's shoulder toward the ultimate master of laconic cool, Velázquez; but as usual he botches the job by laying the paint on slightly too thick.

This is everything 20th-century art is *not* going to be! Cozy patronage, deference to tradition, above all this whole business

INNER CIRCLE

Who's the world's leading artist in 1900? Any smart contemporary will point you to Auguste Rodin (1840–1917). Burly and priapic, world-and-woman-conquering, a stubborn artisan yet fired with dynamic poetic visions, the sculptor of *The Thinker* (1880) is himself a statue to turn-of-the-century conceptions of art. Watch the clay ripple and surge into fleshliness under his strong hands, only to break off disruptively in startling fragmentary forms. Watch his studio, home to a new sculptural generation, convert it to bronze and marble: what embodiments of vitality, energy, lust!

of simulating appearances: chuck all that! Modern art is going to attack all existing setups; revolutionize artistic forms and meanings; present the mind with new visions. Isn't it? Those are the hopes that growing numbers of artists have been fired with through the late 19th century: as the

1902 Scottish architect Charles Rennie Mackintosh begins work on Hill House, Edinburgh.

1903 Winsor McCay creates a comic strip called "Dreams of a Rarebit Fiend" in which the character's taste for rich cheese rarebits causes nightmares about cannibalism and deformity.

1903 Buffalo Bill's Wild West Show visits Manchester, England, to great acclaim.

date changes, a host of young Europeans are looking for ways to realize them. Ah, but doesn't every revolution turn into its own institution? Look at what's happening to Art Nouveau. The snaky swirls and writhing high-tech bindweed that seemed so uncompromisingly radical when Siegfried Bing started his eponymous Paris shop in 1895 are fast turning into a pan-European cliché. From Brussels, where *Henry VAN DE VELDE* (1867–1957) and *Victor HORTA* (1861–1947) act as the style's R&D team with their group Les Vingt, they've spread to Glasgow, thence to Vienna—whose *Jugendstil* is, the Scottish reckon, a market-grabbing rip-off of their own *Charles Rennie MACKINTOSH* (1868–1928) —and to the *modernistas* of Barcelona, culminating in the architecture of *Antoni GAUDÍ* (1852–1926).

Their tentacles entwine with the gaily colored, fairytale decorations of the "World of Art" group in St. Petersburg—*Leon BAKST* (1866–1924) and the like— while back in Paris, they poke up through the boulevards at the Métro

One of the *Dance Movement* bronzes by August Rodin (c.1910). Paris, Musée Rodin. "Just hold that leg up a bit longer, can you?"

station entrances of Hector Guimard. Van de Velde advocates a fusion of artistic imagination, technological innovation, and "organic" design principles, abolishing barriers between high art and decoration. He won't be the last to do so.

Problem is, this vegetable vogue rather lacks a head, or a heart. *Alphonse MUCHA* (1860–1939), the Czech genius of the poster, painters like the Dutch *Jan TOOROP* (1858–1928) and sculptors like the English *Alfred GILBERT* (1854–1934) all weave their sinuosities around banal fantasies of ideal femininity. The new century must hold something more in store than their wafty bloodless maidens, traipsing and simpering in the ether—and something more vital than the retro chic of Sargent's high society.

1900 Oscar Wilde, having spent three years in exile in France, dies in Paris.

1902 Sir Ronald Ross demonstrates that malaria is transmitted in the bite of the female *Anopheles* mosquito.

1904 George Matthew Schilling is reported to be the first man to have walked around the world (he began walking in 1897).

1900~1907
Enter The Boss
Picasso

Pablo PICASSO (1881–1973) is the backbone of 20th-century art. Whatever character it has, it has through him. Too massive a figure for any succeeding artist to ignore wholly; too vast an oeuvre, equally, for anyone to embrace wholly. Movements to which others devoted their whole careers seem to spin off from his unconsidered scribbles.

Irritatingly, this is just how he'd want us to think of him. His achievements were only matched by his arrogance. Full of self-serving stories (the boy genius who put his

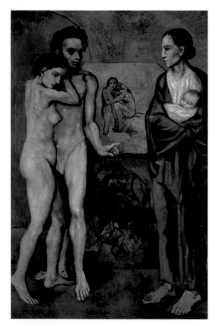

That's life: *La Vie* by Picasso (1903), under the influence of Gauguin, Rodin, and absinthe. Cleveland, Cleveland Museum of Art.

useless painter father out of business by 13), he was paranoiacally cagey about his artistic debts—not to mention his complex love life, the subtext to so much of his imagery. Anyone wanting the lowdown on these matters should turn to John Richardson's biography: enough to say, here, that he had worked his way through the whole swatch of style options ("Down with style! Does God have a style?") in Europe by the time he turned Blue around 1901, in what remains for poster shops the most popular of his "Periods." Still keeping one foot in Barcelona, he's looking (as he most times would) at bodies, while shouldering heavy thoughts about Life, Love, Death etc. The poetry is very upfront, even corny, in the Blue stuff; later it's buried deeper in the workmanship, yet always lurking.

Next, moving wholesale to Paris come 1904, Picasso is picturing harlequins and whores as symbols for his self-important

1905 In New York, Tiffany's sells a pearl necklace for $1 million (equivalent to approximately $7.6 million today).

1906 A cartoonist called Thomas Aloysius "Tad" Dorgan draws a dachshund inside a frankfurter bun and the "hot dog" gets its name.

1907 In New York, the Salvation Army begins a suicide counseling service.

alienation. He's thinking hard about how to prove himself No. 1 artist in town. Throughout this Rose Period, he's honing his passionate, figure-probing draftsmanship, a process of getting to the heart of the object he's looking at that always stays open-ended, as if no final image were possible. That sense of nonfinality cuts through to a whole new level, however, in 1907 when he launches into a big canvas of *Demoiselles* from an imaginary brothel. He's well into one archaic rendition—

Henri Rousseau, *The Snake Charmer*. Paris, Musée d'Orsay. The "modern" style of 1907.

INNER CIRCLE

Caught up in Picasso's phenomenal fame are his lovers: chiefly, (1) Fernande Olivier, with him 1905–12 (2) "Eva" Humbert, 1912–15 (3) Olga, Mme. Picasso 1917–35, Russian ballerina (4) Marie-Thérèse Walter, 1927–40, illicit teenage muse (5) Dora Maar, 1936–43, Serb photographer (6) Françoise Gilot, 1943–53, author of the ego-knocking *My Life with Picasso*, and (7) Jacqueline Roque, from 1954, his eventual widow. Plus his patron Gertrude Stein, self-important American memoirist; and the *bande à Picasso*, of assorted cronies.

OUTER FRINGE

Everyone's favorite artist, across the prewar avant-garde—Kandinsky to Picasso— was the self-taught old customs official, Henri Rousseau (1844–1910). "Le Douanier" was the one guy who *really* painted like he meant it: he saw it in his mind's eye—jungles, tigers, ladies, flowers—he set it down naive, like nature itself. Picasso and friends prepared a banquet for him in 1907: he gamely played up to his celebrity. "We are the two masters today," he famously told Picasso, "I in the modern style, you in the Egyptian."

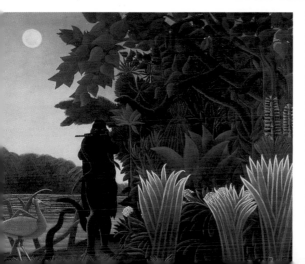

based on an ancient Iberian sculpture that a friend lifted for him from the Louvre—when the primitivist buzz gets him looking at African carving: he can't reconcile the clash of impulses; decides the indecision is his real decision. The results— the tensest, most bristly screw-up of all time— dismay his friends. And set art on its giddy forward course for fifty years.

15

1900 Johann Hurlinger walks 868 miles on his hands, in 55 daily 10-hour stints, from Vienna to Paris.

1903 Jack London writes *Call of the Wild.*

1904 Remarriage between a divorced person and their "accomplice in adultery" is finally authorized under French law.

1900~1918
Vienna: The Whirl
Klimt, Kokoschka, Schiele

Delirious opulence: imperial gold, the wild allure of archaic ornament, gorgeous profusions of nubile nudity; yet breathy, light-filled, fresh-eyed…. A sumptuous and lofty synesthesia to the strains of Richard Strauss, to texts by Friedrich Nietzsche and with hefty liftings from the figure rhetoric of Auguste Rodin.

This, roughly, is how *Gustav KLIMT* (1862–1918) conceived his "Vienna Secession" version of Art Nouveau style circa 1900, in his grandiose murals for the city's university. "Secession" was a label to indicate his dropping out of the stuffy old

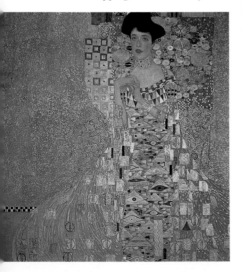

Gustav Klimt, *Adele Block-Bauer* (1907). Vienna, Österreichische Gallerie. A girl with the Midas touch.

INNER CIRCLE
Your average European painter of the early 1900s is probably doing late Impressionism. What was bold and modernistic in 1874 has become tame and rather conservative, although it's the style that the 1890s' young avant-gardist, Pierre Bonnard, is now heading for (for where he ends up, *see page 58*). Meanwhile the movement's aging founder, Claude Monet (1840–1926), immerses himself in his Giverny garden. Millionaire, monument, increasing anachronism: his waterlily extravaganzas will mean little to the new century until New York latches on to them in the 1950s (*see page 90*).

Artists' Association, but it didn't mean you couldn't combine vision and money in a reformulation of the Austrian ideal, the *Gesamtkunstwerk*, the total work of art.

It didn't quite work out. The nudes proved too rude; the official backers got cold feet; Klimt bought himself out of the job in 1905. A swaggering womanizer, he remained Vienna's recognized artistic supremo, but the eeriness of his work

1910 Halley's Comet is visible in the skies and a number of natural disasters are attributed to it.

1914 It is reported that his wife, the Duchess of Hohenberg, tries to save Archduke Francis Ferdinand by throwing herself in front of him when he is shot in Sarajevo, but both die.

1917 Georgia O'Keeffe paints a pile of bones in the New Mexico desert and Alfred Stieglitz photographs them.

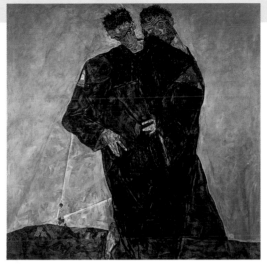

Egon Schiele, *Self-portrait with Klimt* (1912). Vienna, Leopold collection. Artistic father-figure and scowling son.

angles and gashes of his equally ill-nourished models, he reaches out a clammy feverish hand to the viewer, communicating a terminal tension of diseased desire as the flavor of modern humanity. "Hey, Egon!" you feel like saying, "Lighten up! It's not the end ..." But no: life seems to have come at Schiele—orphaned, forever broke, tried for obscenity, carried off by flu on the verge of fame—as chill and mean as he set it down.

Modernity is set to be harsh. The era of opulence is over: among Schiele's friends count *Adolf Loos* (1870–1933), the architect who leads the 20th-century war against ornament in favor of the functional line. This will be an age on the edge.

came to the fore in portraits of characters succumbing to the whirling swoon of the abstract. Across town, someone called Freud was talking to anyone who'd listen about "the unconscious"…

Neurosis, psychosis: the rising generation knew their way around such stuff; had checked out the driven careers of Van Gogh and Munch. *Oskar KOKOSCHKA* (1886–1980), the archetypal skinhead-badboy charismatic darling of high society, wielded his pen like a flick-knife in drawings of visionary violence; unlike many another such, he would prove to have longevity, modulating his act to take in tenderness and take on landscape, across a shifting career of many decades.

Egon SCHIELE (1890–1918), in contrast, painted like he was caught inside his own act. Trapped in the mirror, fingering his selfhood, fondling his manhood, ogling the

OUTER FRINGE

Modern art, mad loner division: Hungarian pharmacist Tivadar Csontváry (1853–1919) is told by an angel he will be the greatest since Raphael. A little training later, he tours the Mediterranean, mailing canvases home Returning, it's soon clear he's crazy, and after his death his canvases are being flogged for wagon-covers before some keen-eyed art-czar steps in. Crazily, the angel was on to something. The paintings are majestically extreme, delivering stupendous intensities of color in a language at least as innovative as Gauguin's. Get a cheap flight to Budapest!

1905 In *The Jungle*, Upton Sinclair exposes dire practices in the meat industry, like sausages containing rats that have eaten poisoned bread and lard containing the remains of employees who fell into boiling vats.

1905 Heinz baked beans are introduced in the north of England, where housewives are advised that they make a nutritious meal for men returning from work.

1906 50,000 people are killed when a typhoon hits Hong Kong.

1905~1907

Easy Comes Hard
Matisse and the Fauves

The listless and unpromising son of a storekeeper in France's industrial north, Henri MATISSE (1869–1954) was convalescing from a hernia in 1890 when a fellow patient tried to cheer him up by demonstrating his painting-by-numbers kit. Henri's father, several art-school entrance boards, and crowds of Parisian gallery-goers in 1905 regarded this action as an ill-considered kindness, tempting a clumsy fool to reach for an art beyond his grasp. Since then, opinions have swung in another direction.

INNER CIRCLE

André Derain, hefty, bold, and articulate, was the most media-friendly personality of the Fauves; through his lifetime, he remained one of the biggest figures of French art, rivaling Matisse and Picasso. Why has his reputation hit the mud since then? Reason: after his Fauve days, people find it hard to take his incessant style-chasing: moving from Matisse's circle to Picasso's, thence to neo-classicism—often all in the space of the same uncomfortably iffy canvas. As with Vlaminck and Kees van Dongen, his youthful pizzazz also looks retrospectively besmirched by his elderly canoodling with the Nazi occupiers of France.

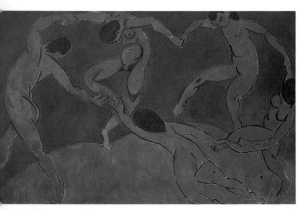

Henri Matisse, *The Dance* (1910). St. Petersburg, Hermitage. One of Matisse's "grand decorations" provides one of early modern art's most exultant moments.

Matisse has become a byword for visual delight: a joyous celebrant of liberated color and pleasurable living, the artist "born to simplify painting" who can make even his blacks glow. What's hard, now, is to see how fiercely he fought for this serenity. The life painter's twin anxieties both to *get it right* and to *make it live* turned for Matisse into a wrestle between his concern for the shapes of things and his feel for the color lurking in the tube, the latter blurting out over the

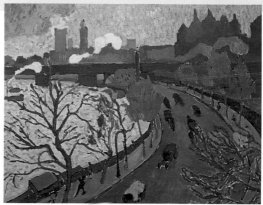

André Derain, *Charing Cross Bridge* (c.1906). Paris, Musée d'Orsay.

canvas in the *Woman with a Hat* (1905), the one that made the crowds howl. "Comme des fauves" ("like wild beasts") wrote a critic of Matisse and his younger coexhibitors *André DERAIN* (1880–1954), *Maurice de VLAMINCK* (1876–1958), and *Albert MARQUET* (1875–1947). Spurred on by the "look, no modeling!" 1890 manner of Van Gogh and Gauguin, and by the pointillism of Signac, the gang had found a new way of representing nature. Kick those colors off their customary barstools and force them to get up and dance! Once you really get them moving with each other, reckoned the Fauves, what you're painting will hold up as a unity without leaning on armrests of habitual association. Flesh can be bright green, grass bright blue! It's a giddy, short-lived moment in Parisian art: the group heads different ways after 1907.

For Matisse, there remained those polarized anxieties, tilting him forward this way and that through the next decade—into sculpture, into responses to Cubism—but leaving him to find his center of gravity in the example of Cézanne and the French tradition of the female nude. He came at the radical, radiant simplicity of his later years (*see page 58*) doggedly, yes even clumsily—figures with banana-bunch

hands— but always impelled by a lofty mission to reform the art. Only someone ludicrously at odds with art-scene cred could make his 1908 pronouncement in favor of an art that offers "the tired businessman" relaxation "like a good armchair." Making the bourgeois comfortable? You must be joking! But this was the one painter Picasso would look in the eye as an equal.

OUTER FRINGE

Painting with an eye to Matisse, and with an eye to Matisse's mentor Cézanne, became an international habit in the decade from 1905. For instance, in Russia, Robert Falk (1886–1958); in Armenia, Martiros Saryan (1900–72) making an attractive halfway house between Matisse and the Persian art he sometimes resembles; in Hungary, Lajos Tihanyi (1885–1938); in Scotland, S.J. Peploe (1871–1935) and the "Scottish Colorists"; in England, Vanessa Bell (1879–1961) and Duncan Grant (1885–1978), the "Bloomsbury artists" (*see also page 34*).

1905 Mutiny on the Battleship *Potemkin* after a sailor complains about bad food and the first lieutenant shoots him.

1906 Hairdresser Charles Nesslet introduces the permanent wave; it takes ten to twelve hours and costs $1,000.

1907 Britain signs the Triple Entente with France and Russia, lining up against the Triple Alliance of Germany, Austro-Hungary, and Italy.

1905~1914

The Savages of Saxony
Die Brücke

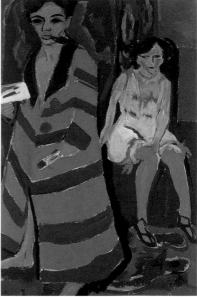

Ernst Ludwig Kirchner, *Self-portrait with Model* (1910/26). Hamburg, Kunsthalle.

The Dresden Ethnographic Museum houses all sorts of interesting loot from Germany's late-started overseas empire in Africa and Polynesia, not to mention curios from India. Sometimes "natives" are shipped in to stage dances and mudhut-building in the grounds, no doubt to inspire stay-at-home Germans to greater colonial enterprise.

Where better to spend an educational afternoon? Members of Die Brücke, a young artists' exhibiting group with a Nietzschean-sounding moniker ("the bridge" to the new age), come with their sketchbooks and the memory of Gauguin, carried off by syphilis in Tahiti four years before their 1905 foundation. Add to that, the trail blazed through 1890s Germany by the brutally desperate, angst-driven Norwegian *Edvard Munch* (1863–1944).

Odd-man-out

Georges Rouault (1871–1958), an odd-man-out among the French of Matisse's generation (*see page 18*), closer at heart to the spiritual urgency of German art, retains a rare interest in Jesus. His sorrowing, staccato oils and gouaches of judges, clowns, and whores, with their debt to stained-glass luminosity, look the most powerful, deep-rooted Christian art of their time.

Looking at the exotic carvings, new possibilities, new syntheses emerge!

"Primitivism," with its premise that non-Westerners, children, and the insane all share a special access of artistic urgency, is an idea whose time has hopefully passed. But for all the colonialist contradictions, this was its moment of power. An intuition about woodgrain and axe-marks and chop-chop-chop, just-do-it urgency runs through the little group. *Ernst Ludwig Kirchner* (1880–1938) and his younger

1909 In Britain, David Lloyd George's "People's Budget" introduces old age pensions for those over seventy.

1910 Duncan Black and Alonzo Decker found a tool company in Baltimore.

1914 The first airplane meal is served on a flight from Russia to Ukraine.

INNER CIRCLE

"Isms" have been up and running in art criticism ever since "Realism" in 1850. Coining new ones is an everyday matter by 1911. So OK, reckons a German journalist, back in the 1870s we had *Impressionism* People recording that tingling feeling when light hits the eyeball. Let's call what these Die Brücke guys are doing *Ex*... Got it? People coughing up what's inside them and splattering its colors on the world outside... Neat, eh? People seemed to think so and the label stuck.

OUTER FRINGE

Do you remember, back in the old days there was something called Christianity, and art was about it? Emil Nolde (1867–1956), briefly with Die Brücke) draws on the stark power of Romanesque church carvings in his gospel paintings: an artist not so much devout as passionate for every sort of intensity, whether through flowers, dancing girls, North German landscapes, or the heat of sheer saturated color.

friends *Erich Heckel* (1883–1970), *Peter Bleyl* (1880–1966) and *Karl Schmidt-Rottluff* (1884–1976). It connects the South Sea totems with their notions of Germanness—the call of the forest, the long-abandoned medium of the woodcut. It's a shortcut to sharp stark lines and sheer hot color fresh from the tube. It dares them to stake out their visions of "real living"—often meaning, in their early years, people throwing off their clothes and running into the woods and the lakes (naturism was a hot new vogue).

Sure, real life also means walking down the street among all the city's weirdos and getting girls into your room, and feeling screwed up and alienated because it's a dog's life being an artist—all aspects of reality the group looked uncompromisingly in the eye after its 1910 move to Berlin. Here, after a spat with the previous decade's breakaways, they seceded from the Berlin Secession to form—what else?—

their *Neue* Secession. And then they themselves broke up. But their hacking, sparky manner, with its startling accent on process rather than product, started to catch: a self-taught artist called *Ludwig Meidner* (1884–1966) used it in 1913 to paint wild images of cities all in flames, bombs raining down from the sky. Very forward-looking. . .

Georges Rouault, *In the Salon* (1906). Private collection. So elegant, these Parisiennes...

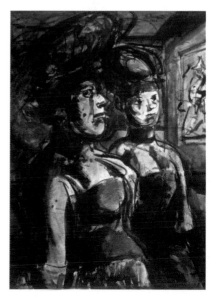

1905 Stieglitz opens New York's 291 Gallery at 291 Fifth Avenue. Until 1908, it only shows photography.

1906 The British Empire covers an area of 11,908,378 square miles, more than a fifth of the land surface of the globe.

1908 Oxfordshire County Council are investigating reports of a child of three years old who is said to smoke ten cigarettes a day.

1905~1917

Bedpans, Ashcans, and Pine Trees
Camden Town, Ashcan, Group of 7

Who started the "modern art hang," that style in big white galleries with thinly scattered artworks? Who started English speakers thinking about formalism, that idea that art-is-art-and-issues-is-issues-and-never-the-twain-shall-meet?

Painting gets its hands dirty.

James Abbot McNeill WHISTLER (1834–1903): an American, like Sargent, at home both in England and France. But that irascible fin-de-siècle poseur, that dreamy river-painter and dreary portraitist died in 1903, leaving the stage free for *Walter SICKERT* (1860–1942), his sometime acolyte and wittiest critic, to put on a contrasting act as the London art world's premier loudmouth. After Whistler's idealism—realism, spelled *dirty*.

Dip your brush in sludge, drag it across sacking. Paint ageing whores in run-down lodging-houses. Art as art, bah! Paint literary, make up stories (with interchangeable titles). There was much teasing in this—Sickert's paintings turned out as exquisite as Whistler's, if by a different route. But it was impetus enough to gather up *Spencer GORE* (1878–1914), *Harold GILMAN* (1876–1919), *Malcolm DRUMMOND* (1880–1945) et al. into their London school of lyrical grunge, the Camden Town Group (from 1911).

In Whistler's homeland, urban realism meant a different kind of excitement. Painting the great rip in the granite where a New York station is under construction, grappling with boxers in an Irish immigrants' dive. *George*

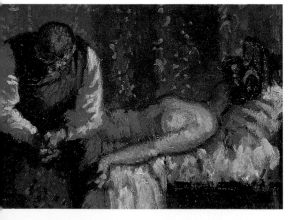

Walter Sickert, *The Camden Town Murder, or What Shall We Do for the Rent?* (1908–9). New Haven, Connecticut, Yale Center for the Arts.

1910 The Dalai Lama flees Tibet for India as Chinese troops invade Lhasa.

1912 The *New York Journal* publishes the world's first crossword puzzle.

1915 German troops use poison gas to achieve a victory over the French at Ypres.

BELLOWS (1882–1925) communicates an era of brutal dynamism. Like the works of what will later be labeled "the Ashcan school" (c.1905–14)— the equally punchy *George LUKS* (1867–1933), the gentler-eyed *John SLOAN* (1871–1951), *William GLACKENS* (1870–1938), *Everett SHINN* (1876–1953), and their mentor *Robert HENRI* (1865–1929)—Bellows's art feeds on a demand for the facts of American modernity. Many of these New Yorkers had trained doing reportage sketches.

Northward, however, *modern* and *national* means getting away from metropolitan humanity. Canada's "Group of Seven" take to the northern wilds from 1913, adapting the saturated color and stripped-down drawing of recent Scandinavian art to create one of the world's last full-hearted invocations of sublime landscape.

As much as its bracing repertory of pines and glaciers, the movement's focal image is the upturned canoe of its dazzling founder *Tom THOMSON* (b. 1877), found bobbing

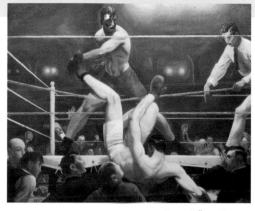

George Bellows, *Dempsey and Firpo* (1924). New York, Whitney Museum. Irish boxers getting rough.

> ### OUTER FRINGE
> The Button-up Brigade. Gwen John (1878–1961) —sister of Augustus (see Inner Circle) and sometime lover of Rodin —emerges from their shadow, retrospectively, as a superior spokeswoman for spiritual self-reliance through her small but scrupulous body of portraiture and interiors. The Finnish Helene Schjerfbeck (1862–1946), Scandinavia's most dignified modern-art alternative to Munch, subjects herself to an even sterner interrogation in her daunting self-portraits, seeking out the skull beneath her skin.

> ### INNER CIRCLE
> The Pants-down School. The equation "artist" = "guy who sleeps around and gets away with it"—one of the reasons people are drawn to the idea of becoming a professional artist—makes a strong running in the early 20th century. Notably, Rodin; Klimt; Kees van Dongen (1877–1968), the Dutch Fauve; in England, the elegant draftsman but flimsy painter Augustus John (1878–1961), who patted the head of every child he met "in case it should turn out to be one of my own"; plus those macho maestros Lovis Corinth (1858–1925), the blowsy German, and Jacek Malczewski (1854–1929), the broody Pole.

in Tea Lake in 1917—a martyrdom to art inspiring *Lawren HARRIS* (1885–1970), *Fred VARLEY* (1881–1969), and *A.Y. JACKSON* (1882–1974) through the following decade.

1907 The Playboy of the Western World opens at the Abbey Theatre in Dublin, causing a riot.

1908 In France the champagne harvest is ruined, causing widespread distress among socialites.

1909 In The Psychology of Coquetry, Georg Simmel defines it as a feminine attitude of refusing everything while maintaining an attitude of acceptance.

1907~1912

Things Aren't What They Used To Be
Cubism

At this point, things get complicated. Literally. Things get a bit seen-this-way, a bit seen-that-way; they're sort of identifiable, sort of ungraspable; you've got endless clues about how things stand, but maybe all you've got is clues, maybe all there is is clues.

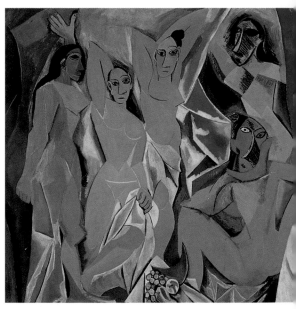

Pablo Picasso, *Les Demoiselles d'Avignon* (1907). New York, MOMA. Possibly unfinished; probably unfinishable. Nicknamed after a supposed Barcelona brothel on Calle d'Avignon.

I s this broken-glass vision a revelation of the way things really are, a revelation of what painting really is, or are the two revelations one and the same? Don't attempt to answer that question. Picasso and Braque never really dealt with it—they gave unconvincing post-mortem explanations, pretending it was clear as day—but while it lasted, between 1907 and 1914, their mutual experiment thrived and advanced along the lines of progressively developing paradoxes.

OK, we're talking about what some reviewer in 1909 dubbed Cubism, a label coined by *Jean* METZINGER (1883–1956) and *Albert* GLEIZES (1881–1953) in their 1913 book of that name. These painters and their friends wanted to promote a cutting-edge style with a new philosophy behind it (*see* Outer Fringe box); but the duo they were lifting it from were too wrapped up in their internal dialog to think in terms of ideological gang warfare.

1910 French artist Robert Delaunay gives his painting of the Eiffel Tower to his wife Sonia as a wedding present.

1911 The word "jinx" first comes into use to describe people or things that seem to have unlucky effects.

1912 Scientists laugh when Alfred Wegener suggests that the continents used to be joined together and gradually broke up and drifted apart over the millennia.

We left Picasso standing before the disliked *Demoiselles d'Avignon*, which his new friend GEORGES BRAQUE (1882–1963), a former Fauve, describes as "spitting gasoline." But the impetus of that drastically fractured image joins with the example of the recently dead Cézanne to jolt Braque into a whole new take on the figure in his next canvases; one which Pablo in turn responds to. Cézanne had defiantly grappled with appearances, trying to wring solid fact out of their flickering and get it down on canvas; conventional perspective got in the way of his arduous quest for the truth about objects. The heroics of the curmudgeonly old Provençal galvanized two young men brought up against the inadequacy of every available tool for representing things, and propelled them on a quasi-scientific research project. They did fieldwork in the hills and villages of southern France, they experimented on their women and friends, above all they set up their lab around still-lifes; the simpler the terms of reference, the tougher the interrogation could be. ("Analytic Cubism" is how historians term the stuff from 1908 to 1910.) Never mind color (that was the Fauves' bag): if I draw a line, must that mean there's an object to one side, space on the other? Can't I make it mean both on either? What have lines really got to do with objects anyway? What are objects, what is space?

As the game develops between them, it looks like the objects are being questioned virtually out of existence, buried under a brushwood of ambiguous edges. "Hermetic Cubism," *c.*1911 and then "Synthetic...", 1912–14: using these or *any* sort of markers (letters, housepaint, wallpaper, sand, you name it) as a kind of visual algebra, you can devise a whole new sort of aesthetic equation: *this* no longer represents *that*, nothing's tied, it's all in play; you're around a new corner...

INNER CIRCLE

Juan Gris (1887–1927) stands alone as the one associate, apart from Braque, that Picasso really brought into his Cubist game. Arriving in Paris from Madrid in 1910, he quickly proved adept at the new idiom, bringing to it a systematic ingenuity—his still-lifes are plotted out with mathematical precision—and a concise, witty touch all his own.

OUTER FRINGE

Picasso's too cool to show in the prewar Paris Salons (like John Lennon, "you've got to be good looking, 'cos he's so hard to see"); Braque exhibits, though. The vogue switches from Fauve color to—hey, how d'you do that thing he's doing, it's got a kind of *chunky* look, hasn't it? Boxed-up reality—it's scientific, it's *four-dimensional*! (Einstein's theories have been in the press.) Exponents of this drearily literal but influential mode of "Salon Cubist" thinking, which leads to Art Deco (*see page 57*), include Gleizes, Metzinger, André Lhote, and young Fernand Léger (*see page 42*).

1907 A Russo-Japanese pact protects seals and sea lions from being culled.

1910 Constantin Brancusi produces *The Kiss* and places it in Paris's Montparnasse cemetery as a monument to Tatyana Rachevksaya, who committed suicide after an unhappy love affair.

1913 Nijinsky performs in the opening of Igor Stravinsky's avant-garde ballet *The Rite of Spring*.

1907~1920

Cutting Out the Beefsteak
Brancusi, Maillol, Modigliani

"Biftek." Small, wiry, and cocksure, Constantin BRANCUSI (1876–1957) dismissively flicks through the plates in the Histoire de la Sculpture. Even Michelangelo meets the same comment: "Encore de biftek."

INNER CIRCLE

In means out, void means mass: taking their cue in Paris from Picasso's *Guitar* of 1912, the Cubist sculptors explore 3-D potentialities for paradox. Notably, Henri Laurens (1885–1954), moving into the new field of still-life sculpture; the Lithuanian Jacques Lipchitz (1891–1973); and the Ukrainian Alexander Archipenko (1887–1964) with his "sculpto-paintings"—each of them developing and expanding the new language through their long careers.

*F*lab is roughly what he's talking about, rather than red-blooded servings of protein. From the Renaissance down, western statuary is weighed down with juddering excrescences (see our *Crash Course* on the Renaissance to find out why). Habitually, sculptors add lump on lump of soft gooey clay, then translate the results into marble—and what's second-hand is so often inert. Stop adding, stop modeling. Face that block for carving directly. Find the image you're seeking by addressing the actual stone, or wood, or metal, that it consists of.

CHICKEN VS. EGG

It's simple, in fact it's simplicity itself. Brancusi's cutting away to find the absolutely necessary images—whether of heads (from 1907), of birds (from 1911), or lovers kissing (1912). He buys what Plato says about essences that lie behind appearances. The result—new for sculpture—is a totally self-enclosed object, instead of a jointed bunch of tensions. An egg, not a chicken. One problem: you need the right context to see something "just being itself." Otherwise your polished, subtly shaped metal might well be taken simply for a machine part, which is how the US Customs read Brancusi's imported goods in 1926. He sues them for damages and wins:

Constantin Brancusi, *Bird in Space.* He repeated this subject many times (1923–40).

1916 The British army use armored cars for the first time just north of the Somme.

1917 Apollinaire, Cocteau, and Max Jacob are witnesses at the wedding of Picasso and the Russian dancer Olga Khokhlova. They would part in 1935.

1920 H.H. Berry invents the imitation coal fire.

he takes great pains to get the context right for his exhibits, and this includes promoting his own mystique. The Romanian peasant woodcarver who "walks all the way to Paris" to study, who refuses however to work under Rodin, who at length revisits his native land triumphantly to deliver the radically minimal *Endless Column* (1938) for the Memorial park of Tirgu Jiu: the artist's image is as finely honed as his sculpture's beautiful surfaces.

His own context includes early work with *Aristide MAILLOL* (1861–1944) in the 1900s, and later contact with *Amedeo MODIGLIANI* (1884–1920). Maillol, like Brancusi, shifts the emphasis of sculpture from Rodin's yearning dramas toward a concentration on stable forms; or, to drop the artspeak, he just loves making big nude women. (Nothing wrong with loving your wife. "When I need to check something, I just go into the kitchen and lift up her chemise.") Maillol becomes a fixture of French public culture— always keen on tits, as the buildings of Paris demonstrate—from the early 1900s. Modigliani, with his svelter line in sexiness, is a fixture of Montparnasse's bars and gutters from 1906 onward.

Amedeo Modigliani, *Reclining Nude* (1917–18). Stuttgart, Staatsgalerie.

OUTER FRINGE

Jacob Epstein (1880–1959) is the chief sculptor to bring modern idioms to England, and to take the flak for doing so. American in upbringing, he trained in Paris and kept in touch with Brancusi and Picasso when he settled in London in 1905. Here, storm after storm broke as each new carving was unveiled, through the 1940s. (Often because he wouldn't emasculate his tight-clenched, primitivized nudes.) His anguished bronze robot, the *Rock Drill* (1913–15), remains the definitive monument to the whole concept of the "Machine Age."

Was his life and death as the ultimate bohemian wreck (loaded on absinthe and opium, dancing naked and declaiming Dante) the necessary dross behind his suave clean elegance of line?

The looming marble heads done alongside Brancusi between 1909 and 1915 are his most daunting work; the later girlie paintings have a look of "primitive" turning into chic.

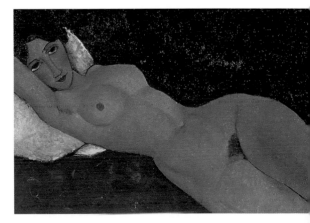

1909 Louis Blériot flies across the English Channel in a monoplane, taking just 33 minutes to complete the 26-mile journey.

1910 Barney Oldfield sets a world land speed record of 130mph at Daytona Beach, Florida, driving a Blitzen Benz.

1911 In Rome, the Victor Emmanuel II monument designed by Giuseppe Succani is completed after 28 years" work.

1909~1914

Faster! Faster!

Futurism

Umberto Boccioni, *Unique Forms of Continuity in Space* (1913). New York, MOMA.

Cypresses, moonlight gleaming on the marbles and the balustrades, an aria from the balcony ZANG TUMB TUMB SCRABRRRRAANG gondoliers under the Rialto WE'LL FILL IN YOUR STINKING LITTLE CANALS the majesty of Titian, Michelangelo AND TRAINS AND TRAMS WILL HURTLE DOWN NEW HIGHWAYS TRANSPORTING HIGHSPEED MERCHANDISE. . . .

Uphill work, being Italian and modern in 1909! Poet Filippo Marinetti feels the dead hand of national heritage weighing on his shoulder, and shakes it off in fury. Storming from venue to venue with a performing troupe of "Noise Tuners" ("Buzzers, Exploders, Gurglers") and a strong man to protect him, he hurls abuse at the hallowed beauties of Florence, Padua, Venice, causing riots. He comes with his manifesto: *FUTURISM*. He's had it published in *Le Figaro*, the top Paris paper: he's important, controversial! People come flocking when he takes the word across the Channel to London (*see page 34*).

So what's his "ism" about, if not just for the sake of self-promotion? Well—we've got to be modern, and modern means *totally dynamic*. Electricity and racing cars are where it's at in "the Machine Age." Everything is energy! Look at the new media—cinema and the high-speed camera. Things keep moving, we keep moving, there are no fixed objects. "Who can still believe in the opacity of our bodies," in the age of the X ray? Matter and mind, everything interpenetrates!

INNER CIRCLE

Futurism in the Land of the Future: Joseph Stella picks up the zany, let's-all-get-smashed giddiness of Severini's *Pan-pan at Monico's* and runs it across the Atlantic to Coney Island (*Battle of Lights: Mardi Gras*, 1914): makes a big deal of crossing the Hudson in his thunderous images of Brooklyn Bridge. John Marin does a subtler, more responsive take in his 1910s watercolors of New York. Offering American avant-gardists a platform: the indispensible animateur Alfred Stieglitz (1864–1946), manager of the 291 Gallery, writer, major photographer.

1912 As the *Titanic* sinks, the last tune the band play is the hit song "Autumn."

1913 The Armory show opens in New York featuring works by Kandinsky, Rodin, and Duchamp; the public are shocked.

1914 A 23-year-old wins the Nobel Prize for Chemistry and the following year, a 25-year-old wins the Physics prize.

Can you picture it? (Never mind that paintings and sculptures are in themselves pretty static media.) Like the early science-fiction illustrators, the Futurist artists wrap their graphic skills around a mind-stretching agenda of ideas. Trying to convey everything being everywhere at once means painting lots of rays and translucent planes, which looks strangely like Cubism. Or not so strangely, considering these Milanese have checked out their French avant-garde rivals before daring to exhibit in Paris in 1911. The results veer between crass imitations of multiple-exposure photography and dazzlingly inventive emblems for their age —no matter whether the artists involved are self-taught, like *Umberto* BOCCIONI (1882–1916), or people with a rich body of work outside Futurism, like *Giacomo*

OUTER FRINGE

Italy's other great modern pioneer: the sculptures of Medardo Rosso (1858–1928) still look challenging in their haunted fluidity— faces and figures emerging from the blur of street impressions, an atmosphere given translucent substance in wax. In their day (the end of the 19th century) they proposed a revolution in sculptural form, though it would take time for the Futurists to catch onto it.

BALLA (1871–1958) and *Carlo* CARRÀ (1881–1966). *Gino* SEVERINI (1883–1966) is the artist who seems to have seen the fun in Futurism, with his riotous eye-bewildering dancehall imagery. Boccioni— the man who gave you the pinhead in the uncomfortable waders, *Unique Forms of Continuity in Space* (1913)—looks like the movement's definitive artist, but that's because he died on service in 1916 before he could direct his energies elsewhere.

World War I drew a line under Futurist activity. Or maybe, "war, sole hygiene of the world" as Marinetti put it, was itself the ultimate Futurist activity. As a survivor, he threw his lot in with the logical next step: Fascism.

Gino Severini, *Pan-pan at Monico's* (1911). What were they serving at the bar that night?

1909 Belgian Leo Baekeland invents Bakelite, a plastic that sets hard; it is initially used for electrical insulation.

1910 Moishe Segal (who would become known as Marc Chagall) leaves his lover Bella Rosenfeld to go to Paris, returning to her in 1915. She would later appear in his paintings of lovers flying over rooftops.

1911 Henry Ginaca invents a machine that can shell, core, and chop the ends of between 75 and 96 pineapples per minute.

1909~1914

Sideways is More Spiritual
Kandinsky and the Blaue Reiter

Returning one evening "from my sketching" (or was it from the bar?), Vasily KANDINSKY (1866–1944) opens the studio door and "a picture of indescribable and incandescent loveliness" meets his eyes, "depicting no identifiable object, entirely composed of bright color patches." Then the penny drops: it's one of his own landscapes, turned on its side. So—eureka!—who needs a subject? At that moment, as Kandinsky tells it, abstraction is born.

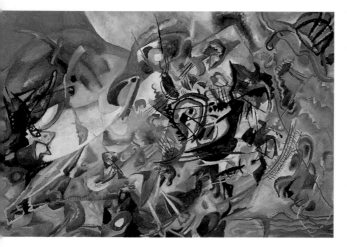

Vasily Kandinsky, *Composition no. 7*, (1913). Moscow, Tretyakov Gallery.

There's a bit more to it than that, though. Kandinsky, a lawyer-turned-painter whose flair for lateral thinking is matched by his stylish self-promotion, is working at the time of this incident (c.1909) in Munich, where he's moved from Moscow. Back in Russia, the Symbolist thinking of fin-de-siècle Europe is still going strong: all the arts should work together to take the spirit to a higher plane. The composer Alexandr Scriabin looks for colors to accompany his chords, while *Mikalojus Čiurlionis* (1875–1911) from Lithuania works up pictorial "Fugues" around landscapelike motifs. (Hauntingly lugubrious images. He died insane.)

Chiming in with this are the mystic strains of Madame Blavatsky's "Theosophy." Kandinsky eagerly buys up its pseudo-scientific pictures of "thought-images." So now, in Munich, he's pushing

1912 Turkey surrenders to the Balkan states of Bulgaria and Serbia, ending Ottoman rule, and the map of the region is redrawn as a new country, Albania, declares independence.

1913 In England, many people report seeing strange lights hovering in the night sky and fear that it is a German airship.

1914 *Pygmalion*, by George Bernard Shaw, opens in London; it features the cockney Eliza Doolittle who is turned into a lady by Professor Higgins.

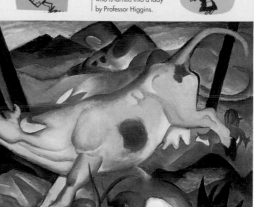

Franz Marc, *The Yellow Cow* (1911). New York, Guggenheim Museum. He preferred painting animals to people.

his former folksy Old-Russia imagery to disclose a heart of sheer color, which equals music, which equals spiritual vibration. Following his revelation, he drops the Cossacks and onion-domes altogether and embarks on the moody, skittish splodgefests of his *Compositions* (1911–14), providing program-notes in his text *On the Spiritual in Art* (1912).

Kandinsky is prime mover to the avant-gardists of Munich—his partner *Gabriele MÜNTER* (1877–1962), his fellow Russian *Alexei JAWLENSKY* (1864–1941), the Germans *August MACKE* (1887–1914) and *Franz MARC* (1880–1916; he of the vibrant cows and pantheistic horses)—all (in the crashing judgment of the *Crash Course*) better painters than he. They share with the Die Brücke (*see page 20*) gang a taste for exotic "primitive" reference points and for insistently glaring primary colors. But this *Blaue Reiter* grouping, named after the magazine they ran from 1911 till war disbanded them, have loftier aspirations. Among their numbers, note the young Paul Klee (*see page 53*).

INNER CIRCLE

In pre-WW1 Moscow, two shrewd-eyed businessmen, Sergei Shchukin and Ivan Morozov, ship home stacks of hot, brand new Matisses and Picassos, giving young Russian artists the cue to leapfrog over old Western conventions in their search for a new style of Russian art. But what on earth is that going to be? Nationalistically primitive, like the provincial signboards Natalia Goncharova and her partner Mikhail Larionov imitate in 1909? Or taking on the Parisians at their own game, like the post-Picasso constructions of Vladimir Tatlin in 1914? Or post-Italian-Futurist (as a way of being anti-French), which is where Goncharova and Larionov head after Marinetti's Russian tour of 1913, with their "Rayonism"? Or perhaps trying to be all of these—*vsechestvo*, roughly translated as "everythingness"—which is how Kazimir Malevich finds himself labeled in 1914? Shouting on all sides; very confusing; the story continues (*see page 40*).

1910 British explorers discover pygmies living in the mountains of Dutch New Guinea.

1911 The ancient Inca town of Macchu Picchu, carved out of a mountainside, is discovered in Peru.

1912 Karl Jung publishes *The Psychology of the Unconscious;* he believes word association games make patients reveal their complexes.

1910~1914
Up, Up, and Away
Collage, Orphism

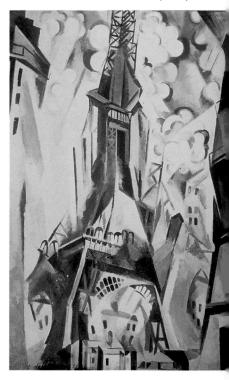

Robert Delaunay, *The Eiffel Tower* (1910). Basle, Kunstmuseum. Views of Paris and the Eiffel Tower in particular were favorite subjects of his in the prewar years.

Slyly witty in Victorian parlors, ladies would snip away at discarded lithographs and paste the figures in nonsense juxtapositions to decorate a screen. Slyly witty in bohemian Paris, Picasso and Braque took paste and pen to wallpapers and newspapers from 1911—and produced the most absurdly over-analyzed keyworks of modernism.

"That the isolated bottle seems to rest on a table formed by the newspaper itself suggests that the economic structure making café life possible rests on the uncertain and despotic whimsy of uncontrollable world events." Oh, lighten up, Patricia Leighten, and hey, just relax, this is only a café, don't you know? (We at *Crash Course* have to read this stuff exactly so as to save you the bother.)

Collage and the pseudo-trompe-l'oeil experiments with chair-caning and the para-still-life "constructions" starting with Picasso's *Guitar* of 1912, are the works of

> ### INNER CIRCLE
> The *real* avant-garde in pre-WW1 Paris is whatever Guillaume Apollinaire (1880–1918) says it is. Poet, pornographer, pretentious propagandist for whatever looks "advanced," he remains the liveliest and most loved celebrity in prewar artistic Paris. Foibles like setting the fey paintings of Marie Laurencin (1885–1956), his mistress, on the same plane as Picasso's are forgotten when he dies in 1918 two days before war's end.

1912 Hungarian Harry Houdini is shackled upside-down in a water-filled tank, with his ankles held in stocks and his body confined in a steel grille; he escapes within minutes.

1913 Madeleine Vionnet creates the bias-cut dress, cutting fabric against the grain.

1914 In London, suffragette Mary Richardson slashes Velázquez's *Rokeby Venus*, causing $25,000 worth of damage.

OUTER FRINGE

"It's just decoration." From the moment of its birth, abstract painting has had to confront that dismissal. It's exactly what Delaunay's Orphism gets accused of by Morgan Russell (1886–1953) and Stanton Macdonald-Wright (1890–1973), two Americans in Paris. Their "Synchromism," they say, is *totally different*. It's "pure expression of *form* through color." Actually, most of us couldn't tell a Synchrotist canvas from an Orphist, but that's because we haven't done Russell's heavy-duty reading on color optics.

two supremely intelligent artists in a supremely lighthearted mood. They can juggle physical-object and sign-for-object, solid and painted, and each time everything stays in the air, stays playful, paradoxical, graceful. All around them, however, it's ferment, "isms" fizzing in every bistro of Montparnasse. Apollinaire, Picasso's erstwhile propagandist, is shifting his gaze from Cubist muddiness toward the happy-colored paintings of *Robert Delaunay* (1885–1941).

Arriving in 1910 with a stylish marriage of airplanes and multiple planes, techno-imagery with novel perspective, Delaunay makes his impact through sheer *prettiness*: a quality that carries him through when he launches into the radiant, look-no-objects ether of *Circular Forms* (1913). By now he's been talking new-age, new-physics, new-realities hyperbole about "simultaneism" with his Russian wife *Sonia* (1885–1979) and fellow painters *Francis Picabia* (1879–1953) and *Fernand Léger* (1881–1955); he's also been looking at the massive *Amorpha: Fugue in Two Colors*

exhibited in 1912 by *Frantisek Kupka* (1871–1957). Kupka, a Czech who might fairly claim to be the first oil painter to burst the figuration barrier (from 1909), comes from a conceptual base much like Kandinsky's (*see page 30*), but stands aloof both from the guru of Munich and the Parisian gang, who are christened—by Apollinaire, in 1913, namechecking the god of music—the Orphists. To Apollinaire also we owe the label that's stuck: abstraction. Suddenly, it seems that painters all over the avant-garde world are shedding the burden that's clung to them since the year zero, the accurate representation of physical objects. Look, we're free!

Frantisek Kupka, maqette for *Fugue in Two Colors* (1912). Paris, private collection.

1910 Dr. Crippen is arrested for murdering his wife, after the captain of the liner Montrose radios Scotland Yard.

1911 The Siege of Sidney Street begins when police surround a house in London looking for a gang who murdered three police officers. It ends after the house is set on fire.

1912 English golfer Harry Vardon invents the overlapping Vardon grip.

1910~1916
Over the Top
Bloomsbury, Vorticism

"I have a feeling this news will be bad for art": Augustus John, leaning across a table at London's Café Royal, to Wyndham Lewis, August 4, 1914. Never a truer word, Mr. John: from Paris to Munich to Vienna, Europe's frenetic little art cliques swiftly collapse under the pressure of mobilization, like so many punctured balloons.

Does *LEWIS* (1882–1957) nod his agreement? Doesn't the outbreak of real gunfire detract attention from the typographical blitzkrieg of *BLAST*, his freshly published magazine? Or does it make it yet more relevant? *DAMN ENGLAND*... damn near everything,

goes his hilariously aggressive screed. Hang on, haven't we heard that kind of thing somewhere before?

Yes, in London, as in Moscow, Futurism (*see page* 28) has sparked off local imitations, splintering an already confused art scene. Back in 1910, the confidently insular tastes of the Edwardian art world had been ruffled by the first English showing of Cézanne; two years later, in their second "Post-Impressionist" show, the critics *Roger FRY* (1866–1934) and *Clive BELL* (1881–1964) assaulted notions of "proper draftsmanship" with Matisse and Picasso. The painting of *Vanessa BELL* (1879–1961) and *Duncan GRANT* (1885–1978), their friends in the Bloomsbury Group, looks like part of this

> **INNER CIRCLE**
> Vorticism's romantic legend: Henri Gaudier-Brzeska, born 1891 in provincial France, finds the doors of artistic Paris closed in 1911. Decamps to London with Polish companion Sophie to whose surname he joins his own: meets Lewis and poet Ezra Pound, who latch onto his work. 1914: signs up. Spring 1915: "I am enjoying this war—to me it's a fine sport." June 1915: shot dead. No time, in 23 years, to put a foot wrong artistically, fast though he moves through styles: every carving, every sketch dazzlingly strong, witty and graceful.

> **OUTER FRINGE**
> Bloomsbury's romantic legend: Dora Carrington (1893–1932) has recently been the subject of a badly scripted movie that included lots about her gay partner Lytton Strachey and her sometime lover Mark Gertler (painter of the compelling anti-war satire *The Merry-Go-Round*, 1916), but said nothing about her own work. In fact her small, intense oeuvre, with its passion for landscape, relates less to Bloomsbury art than to the work of her former art-school friends, the brothers Paul and John Nash (*see page* 50).

1913 Professor Percival Lowell detects the presence of oxygen on Mars, arousing speculation that life as it is known on Earth could be possible there.

1915 War poet Rupert Brooke dies of blood poisoning and is buried on the island of Skyros: "...some corner of a foreign field/That is forever England.'

1916 The Battle of the Somme lasts 142 days and results in a record 1.22 million dead and wounded.

Christopher Nevinson, *Column on the March* (1916). Birmingham Museums and Art Gallery.

clear: imagine a stiff toilet-bowl brush, whirring the pipes of culture clean.

So now the moment of the machine has arrived. Vorticism's strongest painter, *David BOMBERG* (1890–1957), develops body-dissolving systems to tackle massed action. (He'll change: *see page 83*.) In contrast Nevinson uses the style accessories of "Cubo-Futurism" to convey the soldier's own experience. His flange-faceted reports on trench life bring crowds flocking in 1916. Modernism that's popular? Surely that can't be right?

French invasion. Fry next conceives of a utopian enterprise to get London's artists working anonymously as interior decorators. His "Omega Workshops" will bring 20th-century light to stuffy English houses with the bright, brushy, chunky look of contemporary Paris. Anyone can come along and work! Lewis is among the many who take him up on it in 1913. Result: almost instant argument between Fry and Lewis. Lewis then attacks everything "Bloomsbury," starting a hostility that will run for decades.

Bloomsbury's for softies and sensualists, but Lewis is hard, macho, rigorous! Like *Christopher NEVINSON* (1889–1946) he poses as the man for the Machine Age. He and *Henri GAUDIER-BRZESKA* (1891–1915) are going to *BLAST* 1914 England with their "Vortex." Their *what?* The magazine doesn't make that too

David Bomberg, *In the Hold* (c.1914). London, Tate Gallery

1912 In Paris the first neon sign appears, advertising Cinzano.

1915 The prehistoric site of Stonehenge, Wiltshire, is sold for $9,900.

1916 Coca-Cola is first sold in the classic contour bottle, designed by the Root Glass Company of Terre Haute, Indiana.

1912~1923
Just Say *No*
Duchamp

The art of technology.

Paris, late 1912: Cubism, Orphism, Futurism, thisism, thatism, too much. Too many painters, too many cluttered canvases... Why not make a clean break and simply NOT PAINT? Neat, eh? Radical gesture! Only the ideas of Marcel DUCHAMP (1887–1968) proved anything but simple in their implications, because, while he could take or leave the actual making of art, he could never leave toying with the art world.

His elder brothers were doing OK as avant-garde artists—*Raymond DUCHAMP-VILLON* (1876–1918) bidded to be France's foremost Futurist with *The Horse* (1914); *Jacques VILLON* (1875–1963) painted enigmatic abstractions of real distinction. Marcel Duchamp himself had turned in a couple of sardonically ingenious semi-Futurist canvases. But the exhibiting jury had taken his title *Nude Descending a Staircase* for a joke at their expense, so... *Je m'en fous!* I don't give a damn! Hand them a shovel, straight from the shop, let them show that! "That's not art." Oh yeah? Prove it!

This wasn't the first such anything-goes joke to be seen in Paris. New York, however, was fresh to such gestures. Duchamp's reputation took off there after his *Nude Descending...* proved the focal point of the 1913 Armory Show, that launched the Parisian avant-garde across

the Atlantic. Accompanied by fellow *jemenfoutiste* Francis Picabia, millionaire dilettante and former Orphist (*see page 44*), Duchamp became Manhattan's pet European curiosity. Their act played up to the fashionable line of "This is the Machine Age," specializing in nudge-nudge click-click mechanized sexual innuendo and equally mechanized art products—no more willful brushwork, but art dictated

OUTER FRINGE

Is modern art "difficult" for the sake of being private? This question, raised by Duchamp's *Bride*, also emerges in the work of the American Marsden Hartley (1877–1943). One of those for whom *gay* always seems to mean *sad*, Hartley uses avant-garde European techniques in the 1910s, American landscape in the 1930s, to create covert, oblique memorials to his own hapless romances. His work is affecting precisely because he *doesn't* wear his heart on his sleeve.

1917 J.M. Flagg designs the famous 'I Want YOU for US Army" poster, with a pointing Uncle Sam.

1921 Erich Mendelsohn's Einstein Observatory is unveiled in Potsdam, a striking example of Expressionist architecture.

1923 American photographer Edward Weston photographs Tina Modotti naked on the terrace of his house.

by technology and chance. Among Duchamp's various forays in this direction, *Fountain*, the signed urinal submitted for exhibition in 1917, marked the New York moment of arrival for Dada (*see page 44*).

STALEMATE

Duchamp moved on from such "readymades" and punning one-liners like his mustachioed Mona Lisa (subtitled *L.H.O.O.Q.*, spelling "She's got a hot ass" in French, 1921), to a project to devise the definitively incomplete monument to his contact-suspending anti-art. With every component determined by an internal logic resting on arbitrary factors, *The Bride Stripped Bare by her Bachelors, Even* (1920–23) stands as his bizarre melancholy masterpiece; sadder for the splintering of its glass, an accident in transit Duchamp accepted as part of its chance-based character. Following this, he shifted his activities to tournament chess. Yet he remained hovering in the doorway of the New York art scene through decades, as teaser, middleman, elder statesman, marketing boxed-set reproductions of his greatest hits, claiming to have long thrown in the towel. If only! His death in 1969 revealed that years had been spent on a secret installation in his apartment, a masturbatory fantasy bathetic enough to

Marcel Duchamp, *The Bride Stripped Bare by her Bachelors, Even* (1920–23). Philadelphia, Museum of Art. A Machine Age sculpture in (accidentally broken) glass and metal.

embarrass all but his most reverential exegetes. No matter. It went to join the rest of his slender oeuvre in the Philadelphia Museum of Art, because by now Duchamp had been enshrined, in the niche facing Picasso, as modern art's official alternative patron saint. For details of which peculiar process, *see page 87*.

1912 In the US, a new Food and Drug law bans manufacturers from making farfetched claims about therapeutic effects.

1914 Americans begin making their own spaghetti and macaroni in the US after the war prevents imports from Italy.

1922 T.S. Eliot publishes *The Waste Land*, commenting on the sterility of modern society.

1912~1930

The Ineffability of Artichokes
De Chirico, *pittura metafisica*

Giorgio de Chirico, *Melancholy of Turin* (1915). Private collection.

"Form": that's what modern art is all about, if you read the leading critics of the early 20th century. French art—Cézanne, Matisse, and the Cubists—thinks about how 3-D relates to 2-D, how seeing things relates to knowing about them, how lines and colors harmonize; and French art is tops.

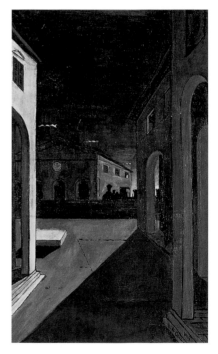

But this forgets that back in the late 19th century, art, not just among the habitually "spiritual" Germans but also in Gauguin's Paris, had been a matter of "visions" and "symbols." Conjuring images for life's mysterious essence— however intellectually uncool it sounds, is a conception of art that refuses to be ignored. It's where the "blue" Picasso started from; and so, when in 1912 he comes across a lone Italian in Paris, painting railroad stations, artichokes, and colonnades in eerie perspective and lighting, it's not so strange that he and his gang hail him as their big new discovery.

Trained in Munich by Max Klinger (a quite extraordinary artist himself), *Giorgio de CHIRICO* (1888–1978) stands apart in Cubism's heyday. Depending on your point of view, he is either the last of the Symbolists, or the first of the Surrealists.

De Chirico's paintings add a new prop to the modernist's stockroom: the tailor's dummy, the human with the missing identity; everyone will make use of it. That said, his avant-garde credibility is brief. The poetry and plaintive gawkiness of his Paris paintings make way, after his 1917 meeting with former Futurist *Carlo CARRÀ* (1881–1966), to a reactionary

1923 Mussolini bans gambling in Italy.

1927 3,000 custard pies are thrown in the Laurel and Hardy movie *The Battle of the Century*.

1930 Ettore Bugatti launches the Bugatti Royale, the largest car ever produced.

bombast of classical references. (Later, desperately, he'll turn to painting rip-offs of his own earlier style and selling them with backdated signatures. Lawsuits result.) Carrà, however, gains as an artist from their joint program of "Meta-physical Painting." The label's meanings are loose—think lots about Italy's past (Futurism's so *passé*), look hard at a small repertory of essential objects until you find the mystery inherent in them—but in his hands, its vagueness firms up fascinatingly. You're looking at Renaissance perspectives, but seen through post-Cubist eyes, where spaces and objects have become equivalent.

> ### INNER CIRCLE
> "Classic form" turns from common sense into a conundrum for sculptors in the wake of Brancusi and Cubism. Like Rodin's pupil Antoine Bourdelle (1861–1929), Arturo Martini (1889–1947) comes at his female nudes through an intense engagement with the archaic past—but restlessly thinks through new ways for the Etruscan to connect with the contemporary.

> ### OUTER FRINGE
> Giorgio Morandi (1890–1964) is Bologna's artistic legend, and one of the heroes of modernist good taste. A still-lifer who stayed put in his apartment through 40 years, fighting the same old battles with the bottles; an exemplary case of utterly issue-free aesthetic dedication to form. "Nothing is more abstract than the visual world."

Numerous Italians in the 1920s—*Felice CASORATI* (1883–1963), *Virgilio GUIDI* (1891–1984), *Antonio DONGHI* (b. 1897)—explore this rich pictorial scam, sometimes called "magic realism'; it's also taken up by the Munich painter *Georg SCHRIMPF* (1889–1938), and connects with the sculpture of Martini *(see* Inner Circle box). It's a figurative art that fits into modernity uneasily, because (a) it seems to sit a bit too comfortably with Fascism (b) its animating principle is nostalgia. Yet this is where Morandi starts off from (see Outer Fringe box); and de Chirico is what Cologne's leading Dadaist, Max Ernst, is looking at in 1920 when he picks up a brush and heads for Surrealism *(see page 62).*

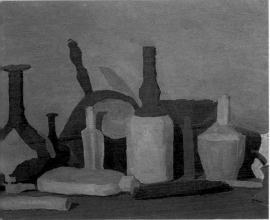

Giorgio Morandi, *Still-life with Objects in Violet*. Florence, Longhi Collection.

1913 New York's vast Grand Central Station opens to the public, the largest railroad station in the world.

1915 Ivan Puni has problems at "0.10 The Last Futurist Painting Exhibition" when Malevich and Tatlin refuse to exhibit in the same room.

1916 Faith healer Grigory Rasputin is murdered when nobles fear he has too much influence at the Russian court.

1913~1918

Zero as Hero
Malevich and Tatlin

"After this, what more can be done?" It's the critical feedback the avant-garde always seems to be begging for; this one's really the ultimate *gesture. The line gets an early airing in Petrograd, the let's-not-sound-German St. Petersburg of 1915. As the Tsar's armies crumble before the Kaiser's, Russia's advanced artists (see also page 30) invite the public to consider other matters: assemblages of junk, a bullet-smashed pane of glass, a live mouse in a trap. They're happy to deliver "a slap in the face of public taste" (as an earlier manifesto had been called) and anyway they have their own wars to think about. Before the opening of* The Last Futurist Show, *their two rival leaders, Kasimir* MALEVICH *(1878–1935) and Vladimir* TATLIN *(1885–1953), are seen slugging it out fist to fist.*

Tatlin has trekked to Paris, strumming a balalaika to pay his way, to sit at the feet of Picasso. He's picked up on the way Picasso's "constructions" are plunked into the space around them as actual interventions in it: he takes this foot-in-the-door approach into his seminal, now-vanished "counter-reliefs" and will extend it into his mighty, never-to-be-built "Tatlin Tower," the open-structured, giddily dynamic

Vladimir Tatlin, *Monument to the Third International* (1920). (Reconstruction, Düsseldorf, 1993.)

architectural monument he proposes to the Revolutionary cause in 1920 (*see* Outer Fringe box), becoming a hero to the Constructivists (*see page 54*).

But in 1915, the mood lies with Malevich. To get in step with Malevich, get seriously Russian: read Dostoyevsky's *Possessed*, down a bottle of vodka, and play Orthodox plainchant full-blast. His apocalyptic nihilistic spirituality—*ten thousand years have prepared my birth, I have destroyed the ring of the horizon and escaped from the circle of things, the earth is thrown away like a*

z

1916 In Glasgow, there is a rush to buy up supplies of whiskey as rumors spread that Prohibition laws may be enacted.

1917 In Paris, the Ballets Russes perform *Parade* by Jean Cocteau with music by Erik Satie and sets and costumes by Picasso.

1918 Czar Nicholas II and his family are killed by the Russian secret police, along with a number of their servants and their pet dog.

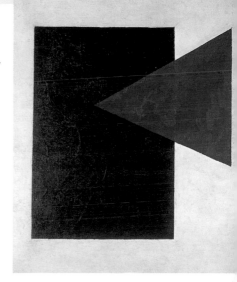

Kasimir Malevich, *Black Square, Blue Triangle* (1915). Amsterdam, Stedelijk Museum.

house eaten by termites—will still seem sheer madness, but you'll start to see there's method in it too. His work for an avant-garde opera production, *Victory over the Sun*, in 1913, has opened Malevich's eyes to the great 20th-century principle that *less is more*. If you paint *nothing*, nothing but a black square in a white field, you have in fact painted *all possibilities*. Hang your nothing painting as you'd hang a religious ikon, and people will start to *really see*; what's more, they'll start to paint like you; in fact you'll be boss of your very own "ism."

"Suprematism" has little to do with the tidal wave of revolution about to crash on Petrograd, but Malevich is able enough to ride that when it comes. He secures himself teaching jobs under the Bolsheviks' cultural umbrella, NARKOMPROS, and despite being marginalized, will die in his own bed. His images of basic shapes in white space—which, strange to say, still remain a painter's paintings, done by someone with a sure feel for pigment and form—do, however, reach their limit. Though he'll return in old age to a wistful, haunted figure-painting, Malevich's *White on White* of c.1918 touches infinity point-blank. After this, what more can be done?

INNER CIRCLE

Three women stand out. Lyubov Popova (1889–1924) makes her own path from Cubism to Suprematism; like Alexandra Exter (1882–1949), she moves into design when the mood turns against painting after 1920 (*see page 54*). Olga Rozanova (1886–1918) is the tragic heroine, her untimely death bringing all its participants together for once to mourn.

OUTER FRINGE

The "Tatlin Tower" has become a Babel-like myth for the utopian hopes of early modern art: the great open-structured giddily dynamic architectural monument to the Revolutionary cause that was destined never to be built. (Probably couldn't be: Tatlin was no engineer.) A spiral of steel and glass designed to soar 437yards into the Moscow sky, it was to combine administrative and media facilities with mathematical symbolism in the spherical, prismatic, and cubic design of its inner chambers.

1915 Edith Piaf is born, the daughter of an acrobat. She will perform in her father's troupe until the age of 15 when her singing career begins.

1916 The loudspeaker is first used, at a convention in New York City.

1917 The word "jaywalk" is first used to describe crossing the street in a reckless fashion at points other than official crossings.

1915~1920

It's Time We Behaved Ourselves
Purism, Picasso

"Picasso's gone straight! He's now drawing like Ingres!" The rumor spreads around war-splintered art circles from 1915. What does it mean? Why would the boss of the avant-garde want to imitate the most classical of 19th-century masters?

One answer is suggested in 1918 by critic Louis Vauxcelles and it's highly influential in France. Picasso's cleaning up his act because, when you look at where we are now, in this time of mass slaughter, you can see that art immediately before 1914 was dangerously self-indulgent. We were losing sight of our national cultural integrity. (We'll call Picasso an honorary Parisian, even if as a Spaniard he's a non-combatant; but wasn't his dealer a *German?*) Cubism made some discoveries, yes; but now we need to restore discipline and the French tradition of reason.

How? By painting bottles, perhaps. *Amédée OZENFANT* (1886–1966) and the painter-architect *LE CORBUSIER* (1887–1965) reckon you can cleanse the mind of all that sloppy excess expression by fixing your sights on everyday examples of rational design. Pretty boring, their "Purism" with its repetitive pictures of these "objets types"; *instructively* boring, they'd probably say. That's probably why *Fernand LÉGER* (1881–1955) likes it.

Léger, having drifted through prewar avant-gardery, finds his feet in the trenches: henceforth he's going to paint the stuff of the common people's experience. It'll be didactic and logical, matching the masses with machinery in bold rounded forms. Cubism? *Tubism.* Male proletarian

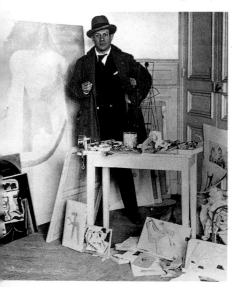

Monsieur Picasso, owner of an Hispano-Suiza, a ballerina trophy wife, and plenty of influential friends, poses in his Paris studio in the 1920s.

1918 Paris comes under attack by "Big Bertha," a German howitzer positioned 47miles outside the city.

1919 A meteorite lands in Lake Michigan causing earth tremors in nearby cities.

1920 Joan of Arc is canonized, on the anniversary of her death at the stake in 1431.

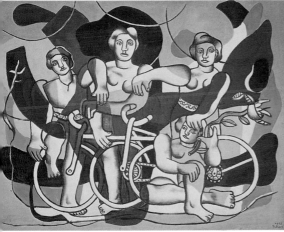

Fernand Léger, *The Cyclists* (1943–48). Biot, Musée National Fernand Léger.

isolated Picasso to paint sets for his ballet *Parade*, thus completing a pretty impressive lineup for the camp young charmer: dance by Diaghilev's Ballets Russes, music by Erik Satie. Picasso's work for the production mixes his newly revived naturalism with Cubism eclectically.

He's going to do things his own way (and marry one of Diaghilev's ballerinas), after all, he's the boss. Apollinaire, reviewing the production (which bombs), coins a new word for its giddy mishmash effect: "surreal."

(heavy black outline with dungarees and mindless grin)[3] + female proletarian (same + circular boobs)[2] + n cogwheels + flower *over* white ground = crashingly banal emblem of socialist solidarity.

Alternately, you could make Cubism the launchpad for a neoreligious art, like *Albert* GLEIZES (1881–1953), or a neomedievalesque one, like *André* DERAIN (1880–1959); but at all costs, get a grip on yourself, artist! The times demand it!

All this "call to order," as Jean Cocteau calls it, might not be Picasso's own take on his activities, however. In 1917, with his friends away at the front, Cocteau lures the

INNER CIRCLE
Back to basics, socialist style: owing something to Léger, but much more sensuous and intuitive, the paintings of Marcel Gromaire (1892–1971) also revolve around the hard grind of working-class life. Like him, Belgium's Constant Permeke (1886–1952) evokes the dour industrial north through earthy impastos and chunky, simplified figures.

OUTER FRINGE
Also painting in postwar France, but light years away from Purism: Chaim Soutine (1893–1943), with his extremo Expressionist urgency to squeeze the flesh of the world and squash it down on the canvas. Great artist, great legend: he is the penniless Lithuanian Jew who lands a fortune overnight when American connoisseur Alfred Barnes buys up his whole studio.

1916 The Stanford-Binet test for measuring IQ is introduced.

1917 Cutex manufacture the first liquid nail polish.

1918 D.W. Griffith makes an anti-German propaganda movie *Hearts of the World* in which Lilian Gish wanders the war-ravaged French countryside clutching her wedding dress.

1916~1920

Mirror Street
Dada

"Herr Ulyanov" has better things to do than enter the dive on the corner of Spiegelstrasse, to join all those Romanian new-agers and German draft-dodgers. He walks up to no. 12 and bolts his apartment door before opening the mail from Petrograd. As he plots the Russian Revolution, is Lenin disturbed by the chanting and drumming eleven doors down the road? The owners tell Tristan Tzara to go easy with his rouge bleu! rouge bleu! *and tell Richard Huelsenbeck the venue will close if there's any more...*

> **INNER CIRCLE**
> Francis Picabia (1879–1953), roly-poly playboy, racing-car enthusiast, restless nihilist, hovers around the Dada art scene action in Paris and New York: he's Duchamp's great friend. Of his facility and wit faint traces remain; among a pile of jokes past their sell-by date, the bio-mechanized reveries painted around 1913, like *Udnie* and *Edtaonisl*, retain a proto-Surrealist air of mystery.

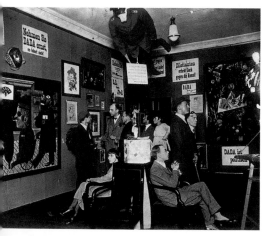

The "First International Dada Fair," Berlin (1920). Leading Dadaists pose in a shot that's a prototype for many a future art event. An Otto Dix hangs on the left.

Dada, dada, dada... What is Dada? No straight answer to that. Primarily, Dada's whatever happened in Zurich's "Cabaret Voltaire" in 1916, and it must have been a magic scene while it lasted. We're not there, though people in a thousand venues afterward have tried to restage that subversive moment. Because what happened at Spiegelstrasse 1 forms a backward image to what was happening at no. 12. It's the other side of opposition to the modern world: not seize the controls, but loosen the screws. Poets Tzara and Huelsenbeck and the club's founder Hugo Ball opened up a whole new set of spiritual attitudes with which to shake off the modern

1919 The Nazi party is founded in Germany and Mussolini founds the Fascist party in Italy.

1919 During a solar eclipse, Einstein's theory of relativity is proved when scientists observe that a star's light is bent by the Sun's gravitational field.

1920 Agatha Christie introduces Hercule Poirot, mustachioed detective supremo, in *The Mysterious Affair at Styles*.

Jean Arp, *The Flower Hammer* (1916). The Hague, Gemeentemuseum.

world order—starting of course with the insanities of the ongoing world war.

What had their hilarities to do with art? Nothing and everything. This wasn't primarily an art club, but art, being tied up with that modern world order, was up for dismissal. Smack in the firing line was that look-how-I-really-feel-for-things Expressionism that had recently proved so very collectable in Germany... Bah! We piss on it! (Literally: *see page* 48.)

Sentimental self-importance, good taste, cultural tradition—they're frauds! The real stuff lies beneath all that. You get it through chance or automation or spontaneity. If you've got something to show, just show the thing itself. If you've got something to say, stick stuff from photos together. (Call

it *montage*.) All these implications, crucial for subsequent art, unraveled as Dada upgraded from a local buzz into an international phenomenon, helped by the descent on Zurich of Francis Picabia (*see* Inner Circle box). Through this connection, his activities with Duchamp and their American accomplice Man Ray from 1915 became known as New York Dada; the same team, visiting Paris, would back Tristan Tzara as he launched the vogue there from 1920 to 1922. Meanwhile, Dada hit Berlin from 1918 to 1920, where the montagists *Hannah Höch* (1889–1978) and *Raoul Hausmann* (1886–1971) gave the movement its most fiercely political edge. While in Cologne, *Jean (Hans) Arp* (c.1887–1966), an original from the Zurich gang, dada'ed alongside the soon-to-be-Surrealist Max Ernst, developing his distinctive new thing: the biomorph, the art of the blob (*see page* 63).

OUTER FRINGE

Great Dada Gestures: (1) The Dada Fair, Cologne, 1920. Max Ernst exhibits wooden sculpture with axe attached: go on, viewer, smash it! (2) Berlin Cathedral, 1918: Johannes Baader, "Oberdada," grabs the pulpit to announce that Jesus Christ is a sausage; (3) Prime stuntman-provocateur Richard Huelsenbeck emigrates and ends up practicing as highly respected New York psychoanalyst "Charles R. Hulbeck."

1916 The boll weevil, which migrated across the Rio Grande in 1899, reaches the Atlantic coast of the US, wreaking havoc in the cotton crop of the southern states.

1918 The government grants money to drain the Zuider Zee and by 1932, the land area of Holland has increased by 7 per cent.

1922 The term "bimbo" is coined to denote young women who are decorative but not overly bright.

1916~1930

Don't Mention Diagonals
De Stijl, Mondrian

So, what's the main story about modern art up to 1925? Remember (see page 22), artists came into the 20th century with ideas about cutting free from bourgeois mindsets; about reconnecting with human roots, expressing the spirit; about opening the eyes to new visions. So how did they do?

INNER CIRCLE

The slowly growing interest in redeveloping abstract art after WW1 reaches Ireland before it hits England, with the 1923 return of Mainie Jellett (1897–1944) from Paris. Having imbibed a Catholicized doctrine of abstraction from Albert Gleizes, Jellett bids to paint the missing link between Kupka and the Book of Kells, in the process establishing a foothold for modernism in Dublin.

OUTER FRINGE

A very different severity: the scrupulously impeccable portraits and still-lifes of Meredith Frampton (1894–1984) are the most daunting English response to Purism, with their tensely drawn forms and smoothly polished surfaces. Like the paintings of Dod and Ernest Procter (1892–1972, 1886–1935), full of sexy idealized figures, Frampton could be seen as an exponent of Art Deco (*see page 57*), but possesses a dignity the style otherwise lacks.

W*ell, something* took off between the 1905 outbreak of the Fauves and the 1914 outbreak of war. Artists all over Europe stepped away from the commonplace look of things. To get at—what? To tell people "You look at things wrong"? To give them new things to look at? To look at the act of looking itself? Or was it all just a new *look*, a repackaging of the same old art scene?

Look around war-bruised western Europe in the early 1920s, and you'll mostly get the last of those answers. The boss, Picasso, is painting classical one day, Cubist the next, because he reckons "there is no past or future in art." But turn to unwounded, noncombatant Holland, and they'll tell you that those guys in Paris have lost the plot. They're too shattered to realize that Cubism was the stepping-stone towards a *truly* modern art. Time to make way for "neoplasticism"!

You are being told this by a group of high-minded ideologues with a magazine to push, *De Stijl*. The loudest of them, *Theo van* DOESBURG (1883–1931), takes their concepts about the rational reshaping of human culture abroad, liaising with the

1925 Frederica Evelyn Syilwell leaves the world's longest will, comprising four volumes containing 95,940 words, mostly concerning property worth around $35,000.

1927 Lotte Lenya sings in what was to become the first modern opera by Kurt Weill and Bertold Brecht, *Mahagonny Songspiel*.

1930 More than 300 films are suppressed by the British Board of Censors because they depict fornicating clergy, marital infidelity, rich criminals, or drunk women.

like-minded *El Lissitzky* (1890–1941) but getting people's backs up at the Bauhaus (*see page 52*). The architect *Gerrit van Rietveld* (1888–1964) proves to have a more persuasive line in idealistically geometric design. But the demonstration pieces for "the style" are the paintings of *Piet Mondrian* (1872–1944).

THE RIGHT LINES

In an almost-too-logical-to-be-true sequence of works from 1911 to 1920, Mondrian, prompted by the Cubist example, moves forward from doing stodgy late Symbolist landscapes, through spare drawings of trees and still lifes, to whittle everything he's looking at down to two elements of line, vertical and horizontal. With these minimal means and with basic colors, he then builds up little models of balance and harmony, pictorial microcosms. You've got to stick to the correct lines, though; Mondrian will fall out with Theo van Doesburg over the latter's wicked impudence in painting diagonals.

Which makes Mondrian sound a dogmatic bore. But look again: he only *looks* logical. The way he gets his pictures to live is by finding the arrangement of parts that defies logic, that continues to generate a visual surprise that's virtually poetic. In fact, the more Mondrian plows his narrow furrow through the interwar period, the more a wit and dandy peeps out from behind the programmatic proceduralist. The jazz-lover emerges into full flower when he flees Holland for New York in 1940, to end his career on the high major chord of *Broadway Boogie-Woogie* (1944).

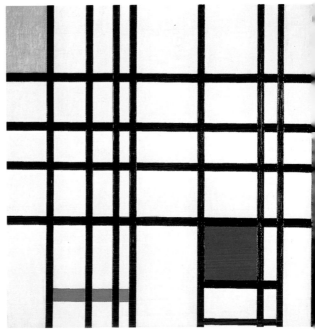

Piet Mondrian, *Composition with Yellow, Blue and Red* (1937–42). London, Tate Gallery.

1918 Inflation begins in Germany and by 1922, the value of the mark has dropped by 99 percent against the gold standard.

1921 Watts Tower is constructed in Los Angeles using only hand tools and a range of materials including shells, glass, and found objects.

1924 Denmark is the first Western country to appoint a female prime minister, Nina Bang.

1918~1933

Lavatorial Altarpieces

Neue Sachlichkeit

The German Empire collapses in chaos in November 1918. As the defeated army fights revolutionary uprisings, artists make rat-runs through the rubble of Europe's most educated society.

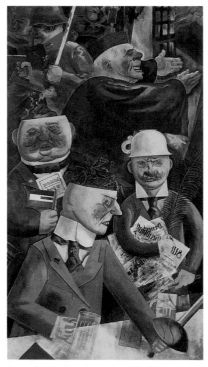

George Grosz, *Pillars of Society* (1926). Berlin, Nationalgalerie. The tasteless, the stupid, the ugly, and the fat: his own particular view of contemporary German society.

Weirdly, their business is humming: anyone with marks to spare is investing in pictures, because those marks are going to be worthless tomorrow. Which may be one reason why, while post-WW1 French art tends to be glumly evasive, that of France's beaten rival is full of brutal vitality—if at a high cost in contradictions.

OUTER FRINGE

Max Beckmann (1884–1950) paints the post-WW1 face of German Expressionism *(see page 45)*: a face with a harsh and heavy scowl, whether seen through endless self-portraits or in his claustrophobic, grotesque but humorless allegories, with their jarring black and acid-tinted palette. For some, though, he is the great spiritual chronicler of his age.

Take *George GROSZ* (1893–1959), Berlin's prime Dadaist of 1918–20, angrily spitting "German means tasteless, stupid, ugly, and fat": doing drawings to show as much, styled on toilet stall graffiti; lining up Expressionist canvases on stage so as to piss on them. Screw that "individualist crap," just communicate the politically necessary facts, goes his 1920 line. But

1928 James Warner and Harry Lyon become the first pilots to cross the Pacific, flying from San Francisco via Honolulu and Fiji to Brisbane.

1930 It is reported that worldwide 250 million people go to the movies every week.

1933 At the age of 44, the so-called "Bohemian corporal" Adolf Hitler is sworn in as Chancellor of the German Reich and his triumph is marked by torch processions of brown-shirted stormtroopers.

Otto Dix, *War* (1929–32). Dresden, Gemaldergalerie, Neue Meister.

extravaganzas of putrescent flesh. The public had never previously confronted the face of war in the way he exposed it. Yet through his 1920s heyday as Germany's most mordant, most ruthlessly physical social commentator, Dix is modeling his technique on 15th-century altarpieces— above all those of the awesomely grim Grünewald. When the Nazis close down the Weimar Republic's frenetic raves and burn his "degeneracies" (*see page* 68), he will retreat into nostalgic old-masterliness.

Neue Sachlichkeit—"the new objectivity"—is the label these guys receive, tagging them along with the exacting scrutiny of *Christian SCHAD* (1894–1982) and Georg Schrimpf. The latter, though, is coming from a different base (*see page* 39).

how do you do that? Ah—by learning your craft well. So from a radical Dada anti-art line we swiftly switch to a demand for good solid Old Master techniques. And certainly, Grosz's stingingly incisive mastery of line makes sure of communicating. People love it: it lines his pockets. Print editions, big gallery shows... By 1926 Georg Scholz—an equally hard-hitting satirist—says Grosz has sold out to an art-for-art's sake, petty bourgeois individualism. Fleeing the Nazis for the US in 1933, Grosz himself concludes that somewhere he lost the plot.

Or *Otto DIX* (1891–1969), heading to the Western Front from Dresden's Die Brücke, he returns to Düsseldorf in 1919 a fired-up Dadaist. Paints imagery of outrage —war cripples and prostitutes; gets known as the hardest, most dangerous young man in art. In almost no time, museum curators are beating a path to his door. (Wised-up to history, these scholarly Germans: aware that *avant-garde* is bound to end up *Art*.) They face down the scandals and prosecutions provoked by Dix's

INNER CIRCLE

John Heartfield (1891–1968), a Berliner who anglicized his name to annoy his compatriots, is the Dadaist who makes the most pointed politics out of photomontage. Hannah Höch and Raoul Hausmann paste up sardonic cacophonies of modernity; Heartfield uses the technique through the 1930s to outflank the Nazi enemy with mordant wit.

1918 Beer runs out in England due to a shortage of the basic ingredients.

1921 Johnson and Johnson introduce adhesive plasters known as Band-Aids.

1923 Interpol is founded in Europe to track down criminals around the world.

1918~1930

Ooze and Angels
Nash, Spencer, Gill

There's the Machine Look: tons of harsh dynamic lines, found all over European art preceding WW1. And there's the post-machine look: what you get when tanks and bombs have done their stuff, flobbery, supine.

P*aul NASH* (1889–1946) defined it brilliantly with *We Are Making a New World* (1918). Trained as a fastidious landscapist, he had his vision turned around in the trenches of 1917, giving visual form to the tone of tragic indignation that ran through the work of Britain's war poets. (He would go on, via a phase of Surrealist landscapes, to picture the air battles of WW2, as an Air Ministry artist.)

How else to approach the world-transforming experience? Make memorials. Sculptors, kept busy by civic committees, must choose whether to reach for loftiness with angels of victory and risk absurd unreality, or to keep things low-key. *Charles SARGEANT JAGGER* (1885–1934), who dominates the field with his Hyde Park Memorial, in London, opts for the latter with his tersely designed reliefs, bringing home memory-tugging details from the Tommies' trench life he had shared. The paintings of *Henry LAMB* (1883–1960) likewise pick clarity out of the combat. In Stanley Spencer's Burghclere Chapel paintings, however, symbols of faith physically tangle with the fighters.

Paul Nash, *We Are Making a New World* (1919). London, Imperial War Museum.

1926 Princess Elizabeth is born in London and is described as "a little darling with a lovely complexion." No one thinks she will ever come to the throne, but she will be crowned Elizabeth II in 1953.

1929 D.H. Lawrence has an exhibition of paintings in London, which reflect his theories on the role of the penis.

1930 Vita Sackville-West and Harold Nicolson begin planting the quintessential English garden at Sissinghurst.

Stanley Spencer, *Christ Carrying the Cross* (1920). London, Tate Gallery.

elastic niche for the artistic eccentric, a role he plays to the hilt—the self-declared holy polygamist, pushing his paint around Cookham, Berkshire.

Crumpet for Christ is an obsession he shares with another of interwar England's pet visionaries, *Eric GILL* (1882–1940). Gill's crisp, spare typography and stone-carving—"archaic" in look, like so much in the Europe of its time—share his reputation uneasily with his Catholic doctrines of art and all too catholic sexuality (sisters, daughters, dogs...). In his Ditchling commune, he becomes mentor to a seemingly frailer, yet equally ambitious Christian artist, David Jones (*see* Inner Circle box.)

RUDE AWAKENINGS

SPENCER (1891–1959) carries this off because he's the ultimate Christian materialist. For him, the "Resurrection of the Body" is happening now, in his own southern English village, angels rubbing shoulders with tweed-jacketed gardeners and hefty lady mailcarriers in dowdy dresses. Every physical detail is plugged into place: everything's visualized in a powerfully consistent vocabulary of volumes and tensed-up, bulging edges. (The idea that because Spencer's provincial, he's outdated in the post-Cubist era is itself outdated.) He also carries off his singular act because he discovers that even if English culture has no very defined sense of visual style, it has a wonderfully

OUTER FRINGE
Deep in Ireland and its land's and folklore's continuities, Jack Butler Yeats (1871–1957; brother to some poet or other) paints his oils small but wild, playing his brush on edge where figures dissolve into paint, stirring up complex evocations, mesmerizing his viewers. Expressionism? Not as Germany knows it. His subjects are life in Ireland, Irish and Celtic myth, and Irish nationalism.

1921 The population of Germany is 30 million; Britain's is 42.7 million, France's is 39.2 million and Russia has 136 million inhabitants.

1923 French scientists suggest that smoking is good for you because it counteracts the effects of certain bacteria.

1925 A year after his death, Kafka's *The Trial* is published, about the injustices of German society.

1919~1933

The Fun of Functionalism
The Bauhaus and Klee

Should art do anything? Should it just sit there and be beautiful and aesthetic in some gallery? Or when we think of art, oughtn't we to think about the whole way we shape and build the world around us? Doesn't learning art really mean learning how to change the world?

> **OUTER FRINGE**
>
> In the no-man's-land where the Bauhaus meets Neue Sachlichkeit meets *pittura metafisica*, the paintings of Oskar Schlemmer (1888–1943) take de Chirico's dummies for a walk round the stark disorienting perspectives of modernity, almost prefiguring the graphics of M.C. Escher (*see page* 93). Schlemmer also developed Triadic Ballet, in which characters were defined by their colors and shapes.

The Art Nouveau generation (*see page* 12) certainly thought so; and their thinking had more lasting impetus than their stylisms. A generation of German art educators onward, *Walter GROPIUS* (1883–1969) launched the Bauhaus in Weimar in 1919 aiming to lock together art and craft, creativity and functional purpose, in a single process of constructive activity. That was the outline of his "build-house"; the staff gave it a sometimes strident coloring. For all their supposed unity, the "Werkmeisters" and the "Formmeisters," the technics and the creatives clashed; then, among the latter, *Johannes ITTEN* (1888–1967), a dogmatic Swiss mystic who would urge his students to roar like tigers before drawing the beasts, had to go, making way for the ultra-dry Hungarian Constructivist *László MOHOLY-NAGY* (1895–1946), famous for creating

Moholy-Nagy's cover for a book explaining the manifesto of the Bauhaus school (1928).

1927 A new kind of lipstick is launched, called Rouge Baiser, that supposedly adheres to women's lips without leaving traces on any man they might kiss.

1930 At the age of 13, violinist Yehudi Menuhin plays for an audience of 5,000 people in the Albert Hall in London.

1933 Gertrude Stein writes *The Autobiography of Alice B. Toklas*, telling of her life with her companion and lover.

a genuine hands-off artwork by dictating instructions to an operative down the phone. M-N's techno-social ideas came to the fore when the school moved to Dessau.

Paul Klee, *La Belle Jardinière* (1939). Berne, Kunstmuseum.

Nonetheless, through the fourteen years before the Nazis closed it down, the Bauhaus established not only its own functional design style but a lasting example of purposeful art practice. At the heart of its creative teaching, apart from Feininger and Albers (*see* Inner Circle box), were the friends Kandinsky (*see* page 30) and *Paul KLEE* (1879–1940). Kandinsky's now neatening up the splotches of his earlier abstractions and setting them orderly Constructivist assignments. The ideas of Klee, however, seem as many in number as his pictures—some 10,000. Each little watercolor, each drawing, oil, or print develops its own logic, bearing out his teachings about the need for the work to emerge organically—and reflects his own knowledge of musical composition.

Coming from his Swiss base, Klee had got to know his way around contemporary European manners, but his stuff never seems imitative or portentous. Rather, it comes over as a humble invitation: let your mind wander in quirky company, exploring what happens when we play with the signs of art. This ramble can be funny, can also touch on surprising depths of feeling. The writings are rewarding, too: "Painting does not reproduce the visible, it makes visible." But with Klee, we move away from the ethos of the masterpiece, the object on the gallery wall. Art's seen not as a product, but as a process.

INNER CIRCLE

Hausmates: Lyonel Feininger (1871–1956) is a constant presence under Gropius's roof. Older than his colleagues, he uses the glazier's offcuts of Cubist style to conjure up poetic townscapes and landscapes. Joseph Albers (1888–1976), Bauhaus trainee then teacher, heads to the US to meditate on square upon square upon square through long sequences: is he a late color mystic or an early Minimalist?

1920 Exiled Russian composer Igor Stravinsky writes the music for *Pulcinella*, which premieres in Paris with scenery and costumes by Picasso.

1921 Famine kills 3 million Russians and corpses are piled high in the streets because they can't be buried until the ground thaws.

1922 Robert Flaherty fakes a documentary movie, *Nanook of the North*, about the Inuit people.

1920~1925

Concrete Mixers
Constructivism

Vitebsk, a provincial town three hundred miles west of Moscow, in the marshlands of present-day Belarus, has a special place in the annals of modern art.

Getting the message across.

Once a center for the country's now-exterminated Jewry, it was the birthplace of Marc Chagall (*see* Outer Fringe box), who founded its art school in 1917. Chagall invited Malevich, supremo of Suprematism (*see page* 40), and *El Lissitzky* (1890–1941), a fellow artist from the *shtetl*, to join the staff. The latter, encountering Malevich's abstract imagery and the demands of the 1920 civil war crisis, switched from his earlier exercises in Jewish folk art to produce a fresh artistic formula for new times. Take Malevich's jobless shapes of black and red and *get them working*. Get them to spell out revolutionary messages; get them geometrically correlating as blueprints for the future Communist society, designs for a rationally based humanity. Call your canvases (which seem to show perspex blocks in limbo) PROposals for Urging on the New, or, PROUNS. From his Vitebsk initiative, Lissitzky will move forward to become the Soviet state's most visually forceful propagandist.

His version of post-Suprematism is one response to a situation in which all self-contained aesthetics stand to be condemned. "Down with art as a means of escaping a life that is not worth living!"

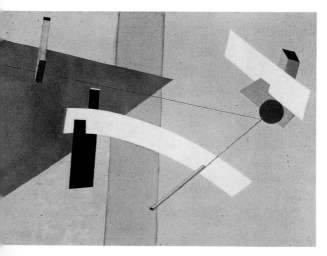

El Lissitzky, *PROUN 12* (1923). Harvard University, Busch-Reisinger Museum.

1923 The Siberian gold rush begins after Mikhail Tarbukin finds a rich stake near Aldan. It will provide hundreds of tons of gold a year for the next 50 years.

1924 Chicago florist and bootlegger Dion O'Banion is shot dead in his flower shop.

1925 It is discovered that rats don't see very well in dim light if their diets are lacking in Vitamin A.

Naum Gabo, *Linear Construction in Space no. 2* (1957–58). A development from his 1920s work with plastics.

Alexandr RODCHENKO (1891–1956), in Moscow, is carrying the day to the thinking of Malevich's rival Tatlin. To the Suprematist's *White on White* canvas he returns, in rebuttal, a painting of *Black on Black*—then abandons painting. His "Constructivism" demands that artists give up just picturing the world and knuckle down to change it. *Material* structures, *concrete* effects are where it's at. Design buildings, textiles, propaganda; use cameras; modern times require modern media. In his photos as in his statements, Rodchenko's dynamic pursuit of "the concrete" gets to feel almost abstract in itself.

It promotes an atmosphere, though, in which there's no room for the modern beauty of the constructions of *Naum GABO* (1890–1977). Gabo experiments with transparent plastic sheets and wires to transmute Futuristic thinking about form into a new set of sculptural possibilities. With his motor-powered "kinetic" pieces, he displays solidity arising out of lines in space cohering as you experience them in time. All of this was a bit too aesthetic for revolutionary Russia in 1922; Gabo heads off to work in Berlin, Paris, London, the US. The irony is that as he does so, his statements become the West's main idea of Constructivism. In this version, it's "Up with art!," as long as art means creativity spilling fresh new forms out into the world. Do "concrete reality" a favor—be abstract.

OUTER FRINGE

Eastern Europe yields a great generation of Jewish artists in the early century—Soutine (*see page 43*), Archipenko, Lipchitz, Zadkine, Lissitzky; Marc Chagall (1887–1985) is the commemorator of the vanished world they emerged from. His luminous, fantastical visions of angel-visited villages arrive in the Cubist Paris of 1910 and will replay lyrically through 75 further years.

INNER CIRCLE

The artists who stretch Soviet Constructivism furthest are the Poles Wladyslaw Strzeminski (1893–1952), ex-Vitebsk pupil, and his partner Katarzyna Kobro (1898–1951), both based in Lodz. Her poised metal constructions match his "Unist" canvases of 1930 as attempts at a totally forward-facing art. In the latter, no lines, no colors—none of that corny old Suprematist imagery!—just monochrome, corrugated paint. Minimalism arrives!

1921 The lie detector test is pioneered by California medical student John Larson.

1924 The Caesar salad is invented in Tijuana, Mexico, by Caesar Cardini.

1926 The first liquid-fueled rocket is launched at Auburn, Massachusetts and reaches an altitude of 41ft, traveling 184ft.

1920~1930

The Planes of the West
Precisionism, Davis, Hopper

1920s America sees "modernity" when it looks in the mirror and mostly it likes what it sees. It's our century. "Europe is finished"—Duchamp has told us so. Back in the war-shattered Old World, modernity's a tortuous, fractious hassle; over here, it presents a sleek, stripped-down face, modeled on those recurrent national yearnings for the transcendent and sublime.

Charles Sheeler, *Upper Deck* (1929). Cambridge, MA, Fogg Art Museum. His earlier career as a commercial photographer had an influence on his painting.

From the heights of Manhattan to the breadths of New Mexico, *Georgia O'KEEFFE* (1887–1986) exalts the unitary and elemental in her scale-vaulting watercolors, just as her lover *Alfred STIEGLITZ* (1864–1946) exalts her own body in his photography. The mighty turbines of American industry, with all their clean lines and planes, demonstrate to *Charles SHEELER* (1883–1965) (as to the French Purists) that modern reality is truly turning Cubist.

One limitation on these transcendental pioneers: no humor. (Why can't O'Keeffe take it when people compare her images of flowers to vulvas?) You could make the same complaint about the decade's most fashionable sculptors, *Paul MANSHIP*

(1885–1966) with his slickly mannered neoclassical Art Deco and *Gaston LACHAISE* (1882–1935) with his bombastic paeans to femininity. But step sideways. *Charles DEMUTH* (1883–1935), later to be designated Sheeler's partner in "Precisionism," kneels to the worship of modern industry with a sneaking sense of its absurdity. *Gerald MURPHY* (1888–1964), a businessman studying art with Léger in 1920s Paris, adds a wit his teacher completely lacks in his proto-Pop arrangements of products and packaging.

1927 The Dumbarton Bridge is the first to carry traffic across the San Francisco Bay.

1929 Bertrand Russell writes *Marriage and Morals* and is banned from teaching mathematical logic at New York City College in case his sexual immorality corrupts his students.

1930 William van Alen designs the Chrysler Building in New York, with the stylized metal sunburst at the top and chevron patterns of the Chrysler logo.

Packaging likewise features in the boldest visual emblems of the Jazz Age, the post-Cubist canvases of *Stuart DAVIS* (1894–1964). A painter for whom *well-made* always seems to mean sassy and bouncy, Davis juggles street signs into up-tempo compositions in a bold variety of color keys; one of the rare artists who have the chutzpah to deliver a consistently good time.

The social curiosity that marked New York painting before the Armory Show (*see page 36*) finds a home in the Jazz Age in the hot-hued, high-humoured depictions of black life in Chicago by *Archibald MOTLEY, JR.* (1891–1981). In New York, in Duchamp's

> **INNER CIRCLE**
> "Art Deco"—the glitzy elopement of Salon Cubism with classicism, sexy allegories with flanged planes—is the Roaring Twenties' most glamorous, least earnest style. Apart from Paul Manship, the artist who best epitomizes it is Tamara de Lempicka (1898–1980), the Polish polysexual cynosure of rive-droite Paris; see also the Procters and Frampton in England (see page 46).

> **OUTER FRINGE**
> The backwoodsman, out in the American landscape seeking visual equivalents for its essence: Arthur Dove (1880–1946), who back in 1910 painted America's first abstractions. Witty, gawky, solitary in his art, he hopes through allusive shapes to arrive at synesthesia: as a critic put it, "To paint the pigeons would not do/ And so he simply paints the coo."

circle, it takes an arch turn in *Florine STETTHEIMER'S* (1871–1944) fantastical interiors. But is there any place for social interaction in this cleansed modern world, with its wide open planes and voids? "I only want to paint the light," *Edward HOPPER* (1887–1967) protests against overinterpreters; but it's a light of agoraphobia, isolating his stoic office-workers and stiff-shouldered blondes in an achingly hopeless endtime. Echoing the harsh economy of the Swiss *Félix VALLOTTON* (1865–1925), whose work he may have seen in Paris, Hopper paints the most poetic—that is, the most unforgettable—images of his era.

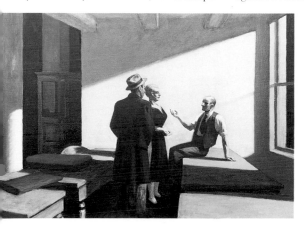

Edward Hopper, *Conference at Night* (1949). Wichita Art Museum.

1920 Edith Wharton wins a Pulitzer Prize for *The Age of Innocence*, little knowing that it will become a film starring Daniel Day Lewis and Michelle Pfeiffer in 1993.

1933 Air France, the national carrier, is founded.

1937 Charles Schulz (aged 12) submits a cartoon to Ripley's *Believe it or Not* featuring a dog that eats razor blades.

1920~1950

Portrait of the Artist as an Old Man
Matisse, Bonnard

… As a fusty old irrelevance, in fact. What a pompous figure Matisse cuts in his sixties, preening himself as the founder of modern art while he basks on the French Riviera in a compliant world of curvaceous ladies and oriental drapes. Sure, all those loose-brushed colors and loping lines are nothing if not hedonistically agreeable, but what's his art really got to do with the 1930s?

Escaping from his wife, whom he's leaving for his secretary, the grand old man is chauffeured down the Corniche to fraternize with another old has-been over a pastis. But very likely *Pierre BONNARD* (1867–1947) won't show. The mild and mimsy last of the Impressionists, that "potpourri of indecisions' (Picasso), is being held prisoner in his bungalow by his neurasthenic companion Marthe.

Strange. Somehow the late works of these two anachronisms nowadays look more immediate than those of any of their younger contenders in 1930s France. Why?

With Matisse, it's his sheer dedication to the internal dynamics of form that makes him a continuing inspiration to generations of later artists. Moving from drawing to sculpture to the grand project of his murals (1929–32) for American art collector Alfred Barnes, his thinking about how to reconcile signs and patterns with the world they denote remains dynamic, setting itself new challenges. And there's the thrilling denouement

OUTER FRINGE

Little known outside Venezuela, Armando Reverón (1889–1954) is, with Bonnard, the most exciting 20th-century translator of Impressionism. Working in isolation, he streaks a minimal palette of white and sepia over the coarse burlap of coffee-sacks to create a revolutionary, emotional evocation of tropical light.

INNER CIRCLE

Raoul Dufy (1877–1953), in the 1900s a Fauve and a superb graphic artist, becomes, through the interwar period's "long weekend," the acceptable formula for Modernism Lite. Chic ladies in desirable locations, nonchalantly sketched in over jaunty color-tints (though Dufy's line always runs out on him too fast); a bit of joie-de-vivre, nothing too demanding; the poor man's (i.e. the less than discriminating rich man's) Matisse.

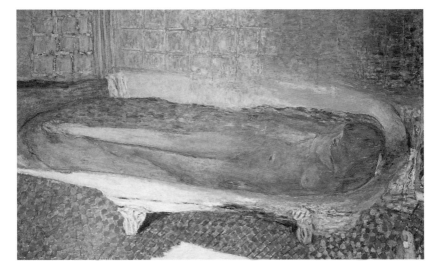

of his career in the 1940s, when, after illness leaves him largely bedridden, he takes to scissoring shapes from colored paper—"drawing with color"—to produce the staggeringly lively artist's book *Jazz* and the final, iconic *Blue Nude* (1952).

With Bonnard, that imprisonment in a Costa Geriatrica villa becomes a unique artistic liberation. The "indecision" of an artist who'd belonged to the 1890s "Nabis," with their bold quasi-Symbolist stylizations of Parisian life, and had then seemingly turned to Impressionistic portraiture, turns out to be a way of staying true to the elusiveness of experience. What is it like to look at the woman you have known daily through 40 years? Is she presented to your vision by sunlight, or rather by the light of memory?

Pierre Bonnard, *Woman in the Bath* (1937). Musée d'Art Moderne de la Ville de Paris. An "intimiste" painting of an intimate subject.

How does the stretch of canvas relate to the stretch of your vision? The answers are embedded deep in Bonnard's bizarre and complex paintwork. Lured in by its tremulous iridescence, you engage with the most contemplative survivor of the old French painting tradition.

Bonnard's fellow ex-Nabi *Edouard VUILLARD* (1868–1940) is also painting "intimiste" interiors, with a cooler, more abstracted sensibility but an equally beautiful touch. While *Matthew SMITH* (1879–1959) hits on his own vision of Matisse's Fauve nudes and landscapes, with a world of hot, sensual continuities, utterly dissimilar to his native Yorkshire.

1923 Mexican revolutionary leader Pancho Villa is assassinated.

1926 Mae West is arrested after the New York premiere of her play *Sex*; she is charged with corrupting the morals of youth.

1929 Nestlé introduce do-it-yourself hair colorings in ten shades.

1922~1939

Giotto and the Gringos
Muralists, Regionalists

Artists often dream that society needs them, but does society ever agree?
"Yes!" comes the answer, at one moment at least in 20th-century art—a
moment the artistic left will often look back to. After the Mexican revolution and civil war (1910–20), the government fixed on painting as a means of unifying the largely illiterate populace.

David Alfaro Siqueiros, *Victim of Fascism* (1944). Mexico City, Palacio de Bellas Artes.

on workmen's wages—the walls of Mexico's public institutions with an imagery that will tell the dispossessed peasantry their own history, from their Pre-Columbian roots to their present-day struggles. They re-employ the fresco techniques of Giotto's 13th-century Italy in packed, boldly massed figure compositions. The sheer inventive energy of the results, whatever it does for the illiterate viewing public, works wonders for Mexico's international image.

We're just wild about those socialist muralists of yours, says the indulgent capitalist US. Come and paint here. Orozco takes his slash-stroke, stark designs to the gringos' college foyers; Siqueiros brings his dark, agonized, grippingly powerful imagery to the US's Hispanic quarters, inspiring the young Jackson Pollock (*see*

Drop your guns, *José Clemente OROZCO* (1883–1949) and *David Alfaro SIQUEIROS* (1896–1974), and fight injustice with your brushes. Come home from Paris, *Diego RIVERA* (1886–1957), forget all that super-clever Cubism of your youth and return to serve the people's needs. Through the 1920s, the three set to work to paint—

1932 Harbour Bridge opens in Sydney, carrying four railroad lines, a road, and a footpath.

1935 An underground railroad opens in Moscow with stations designed by some of the country's best-known architects using more than 20 different types of marble.

1939 The Poles send out their cavalry to try and resist the advance of German tanks.

page 72). Rivera, the most versatile and resourceful, is hired in 1933 to decorate New York's Rockefeller Center with the lofty theme of "Man at the Crossroads." Uh-oh. This is where that indulgent liberalism runs out. Rivera is discovered to have painted a head of Lenin in the heart of his composition: John D. Rockefeller pays him off and has the whole thing destroyed.

The Mexican example, however, prompts Roosevelt's government the following year to get their own artists out and decorating. The "Federal Arts Project" pays thousands of them, all across Depression America, $23 a week to churn out murals, statues, and posters by the truckload. The project has no stylistic dictates, but its devolved structure tends to favor "Regionalism"— that is, the depiction of country folks and ole country ways, a manner given iconic dignity by *Grant Wood* (1892–1942, famed for *American Gothic*, 1930) and bombastic vulgarity by *Thomas Hart Benton* (1889–1975). Of the eight-year experiment, little now survives, but maybe that wasn't the point. The art world's chock full of talk about "quality." Let's hear it for "quantity" for a change!

OUTER FRINGE

Frida Kahlo (1907–54), Diego Rivera's second wife (and third; they split then remarried), probably leaves a stronger influence on the later 20th century than he: the great icon of feminist self-consciousness, the painter who treats her sorrowing face, with its trademark unbroken eyebrow, like Monet treats his waterlilies or Morandi his bottles. Her often agonizing self-portraits cross-reference with her history of injuries, whether medical or amatory (namecheck here for Trotsky, who was assassinated while under her roof).

INNER CIRCLE

Worldwide regionalism: Jean-Paul Lemieux (1904–90), Quebec's answer to Stanley Spencer (*see page 50*), records the religious life of a conservative culture in spatially inventive compositions. Gerard Sekoto lyrically interprets township life around Johannesburg, then flees South African racism to turn to an ugitprop manner in Paris.

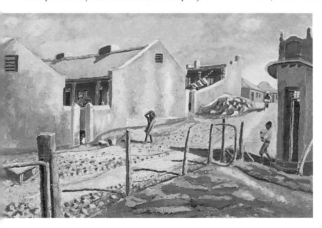

Gerard Sekoto, *Yellow Houses: A Street in Sophiatown* (c.1940). Johannesburg Art Gallery.

1927 A woman complaining of "slight abdominal pain" is found to have 2,533 objects in her stomach, including 947 bent pins.

1929 The Ogino method of birth control is invented after a Japanese gynaecologist discovers that women ovulate halfway through their menstrual cycles.

1934 Hit toy of the year is the XZ31 Rocket Pistol from the Buck Rogers comic strip.

1924~1940

Too, Too Marvelous
Surrealism (1)

Eyes balefully leering out of compost-heaps, birdcages and bananas adrift over foggy horizons, kooky little assemblages with dolls and wires and blades ... has there ever been an art movement to beat Surrealism for filling up the world with such an odd selection of images?

Surrealists dreaming.

The intention, in poet André Breton's "First Manifesto of Surrealism" of 1924, is to co-opt Apollinaire's recent buzz-word (*see page 32*) to launch a replacement movement for the now exhausted Dada. Something more provocative, something more visionary... summoning up "the marvelous," the formless lava of the unconscious, to blurt its way out into our midst ... There are heavy namechecks to Freud and moreover to Marxist revolution: Parisian intellectuality at its most impossible.

Yet Breton's charisma and his concept of "automatism" draw in ex-Dadaists in Paris like *Man Ray* (1890–1977) and *Max Ernst* (1891–1976). Neither artist is great with a brush, but each is an inventive technical improviser. The Philadelphian Ray's experiments with direct-exposure "rayographs" and the Cologner Ernst's montages of Victorian engravings and *frottages*, woodgrain-rubbing images, all seem to show Breton's "marvelous" revealing itself in preexistent materials.

INNER CIRCLE
René Magritte (1898–1967), another early member of Breton's circle, uses de Chirico's example to create one of the century's great deadpan performance acts. Off to work in Brussels every day of his life (bowler-hatted, he'd have you believe), rendering rocks and windows and nudes and fishes forever in the same neutrally banal facture: "Painting bores me, like everything else." A brilliantly constructed persona, in fact, within which to explore how you can conjure poetic mystery out of the most commonplace elements of representation.

OUTER FRINGE
Unknown to "the Pope of Surrealism," two painters demonstrate the possibilities of a Breton-free, *intuitive* Surrealism. In Chicago, Ivan Albright (1897–1983) works decades on the matchlessly unnerving super-realism of his *Poor Room*. In Moscow, former avant-gardist Pavel Filonov (1883–1941) develops a delirious, decentered intensity of marking in his 1930s mazes of multiple heads.

1936 R. J. Mitchell designs the Spitfire, which will be the mainstay of the RAF during World War II.

1937 Jean Arp and Sophie Taeuber produce their first *Conjugal Sculpture.*

1940 Arno Rudolphi and Ann Hayward are the first couple to have a parachute wedding, surrounded by minister, witnesses and musicians, in a combined jump over Flushing Meadows Park in New York.

Max Ernst, *The Embalmed Forest* (1933). Houston, Menil Foundation. One of the *Forest* series which uses *frottage* to evoke contradictory images.

If the image isn't willful, maybe it can escape being the "Art" that the movement's manifestos condemn. Yet the art scene remains the place to be. Ray consorts with its most glamorous women; Ernst gets to marry art magnate Peggy Guggenheim. Through his long career, he keeps upping the ante, pushing his imagery of birds and moons and forests to meet his increasingly challenging demands.

A different visual lead on "the marvelous" comes from another ex-Dadaist, Jean Arp (*see page* 45). Not much anti-art about Arp—he turns to sculpting his biomorphic blobs in elegant marble. Their nearest relation in paint comes from *Joan Miró* (1893–1983). Miró, starting from obsessive depictions of peasant Catalonia, has his hand liberated by the Surrealists' games with "automatism." He opens up his canvases to a graffiti-like shorthand of bodies afloat in indefinite spaces of color, creating a lively phantasmagoria. He was the leading figure of the organic-abstract wing in the Surrealist movement.

Very *important*, of course, this new informal pictorial space: seminal for Pollock (*see page* 72), among others; and at least Miró can paint, which is more than can be said for *André Masson* (1896–1987), with his programmatic automatism. (Want more Surrealism? Turn to page 66.)

1928 Harry Ramsden opens a fish and chip shop outside Bradford in northern England.

1929 Margaret Bondfield becomes the first woman to hold a cabinet position in the British government when she becomes the Minister of Labour.

1930 Amy Johnson is the first woman to fly solo from Britain to Australia and it takes her just three weeks.

1928~1933

Progressivist Polo
Hepworth, Moore, Nicholson

In whitewashed apartments from London's leafy Hampstead to Helsinki, the future is being forged. On the black-stained plywood tables, copies of Cercle et Carré *stand out among the coffee cups and ashtrays, identifying the true forward-thinkers of 1929.*

INNER CIRCLE

With Ben Nicholson in the "Seven & Five" group (seven painters and five sculptors opposed to the emphasis on "academic" art): his first wife Winifred Nicholson (1893–1981), with her keen, expressionistic response to flowers and light; and their friend Christopher Wood (1901–30), a charismatic sophisticated naive who paints the iconically mysterious *Yellow Man* before falling beneath an express train at the age of 29. Founded in 1919, Seven & Five was still going in the 1930s, when they got more abstract.

If not exactly uniting them. How on earth is the rational rigor of Bauhaus design supposed to relate to Surrealism's wibbly-wobbly jellies? What happens when you put Constructivist Naum Gabo into bed with ex-Dadaist Jean Arp? Ideological dichotomies abound for the editors of *C&C*: function-intuition, geometry-biology, *Abstraction-Création* as they come to name their outfit in 1933.

Yet from all this international avant-garde airiness, substance emerges. Arp and Gabo's offspring—creatures of curving mass and taut wire—grow up with Yorkshire accents, reared by two Leeds Art College students. *Barbara HEPWORTH* (1903–75) is the more abstract in sensibility, working a spare and

exacting finesse of line around the type of form that naturally gets you thinking about inside and outside (ovoids, *eggs*, to put it plainly). *Henry MOORE* (1898–1986), whose stuff resembles hers in the early

Henry Moore,
Reclining Figure (1951).
Boston, Pucker
Safrai Gallery.

1931 The "Watch Tower Bible and Tract Society" changes its name to "Jehovah's Witnesses."

1932 Forrest Mars covers nougat in caramel and chocolate to create the first Milky Way bar.

1933 The English cricket team use the controversial tactic of Bodyline bowling against the Australians in the fourth Test at Brisbane.

1930s, is also possessed with this agenda of space/mass reciprocity that really originated with Cubism. He comes at it through "the pierced form," the void entering the body; but combines this with a deeply respectful response to the statue tradition—wanting to combine the compact force of Mexican sculpture with the dignity of Michelangelo.

The formula he hits on *c.*1935 proves one of modern art's all-time most popular, top brand-recognition lines. The chick with a hole in it—sorry, *Reclining Figure*—is a creation capable of indefinite development through differing media, of multiple interpretations whether formalistic or psychological, above all of acting as an anchor-weight to viewers in the choppy waters of modernism. It instantly reassures with its suggestion that the human body possesses residual dignity; you just know, without reading his biography, that Moore was a thoroughly decent guy; you can't even feel too bad about the chronic overproduction in which his career got mired as he became a British national institution. You can intuit that as an unpretentious, hardworking carver, his credo would lie in "truth to materials"—working with the grain, letting the log or block suggest its own image— even if, on reflection, it's hardly logical. (Wouldn't it be "truer" not to carve at all?)

OUTER FRINGES

The American Alexander Calder (1898–1976) makes a delightfully original contribution to the Abstraction-Création scene of 1932 with his cantilevered constructions of wires and colored panels, awaiting a breeze to waft them where it will—christened "mobiles" by Duchamp, who admires the way that chance becomes an intrinsic part of the art.

Hepworth's partner in avant-garde 1930s Hampstead. *Ben NICHOLSON* (1894– 1982). matches her elegance in paint and in his 1933 invention of the abstract relief, bringing to circles and squares some of the exquisite good taste his father *William NICHOLSON* (1872–1949) had brought to still-life. His idealistic probity will give abstraction its first firm foothold on British soil. Where? On the island's southernmost shores (*see page 82*).

1929 Painter Seiji Togo and his lover decide to commit suicide by cutting their own throats; she dies but he lives and falls in love with a writer.

1933 George Orwell writes *Down and Out in Paris and London*.

1935 Christo and his future wife Jeanne-Claude are born on the same day, June 13.

1929~1939
Advent of the Mustachioed Masturbator
Surrealism (2)

If ever it strikes you that the career of Picasso presents a less than attractive display of egotistical Spanish genius, you could always examine that of Salvador DALÍ (1904–89). Scanning the biography of this fathomlessly cynical creature, the inconsistencies of the original rey del mundo artístico *will shine in contrast with a saintly glow.*

The thought then occurs that this may be what Dalí intended: to forge a career of being the Anti–Picasso. Possessed of wit, drive, invention, and facility, he could take it on himself to expose the

> **OUTER FRINGE**
>
> Surrealism becomes modern art's most approachable language for many Latin Americans (note the surrealistic tinge of the region's post-Borges "magic realist" fiction): among them, the Cuban Wilfredo Lam (1902–82), the Chilean Matta (b. 1911), the Argentinian Xul Solar (1887–1963) and the Mexican Remedios Varo (1908–63).

Such an artistic personality! Dalí on his fiftieth birthday.

corrupt self-indulgence lurking beneath every façade of artistic integrity ... maybe. At all events, his path to fame in 1929 lay through Breton's Surrealist Movement (*see page* 62). With his copious stock of imagery and his high-definition deliquescence ("Such a disturbed mind ... but he paints like an Old Master!"), Dalí took the Paris group by storm, mesmerizing Breton before he was finally thrown out in 1939 for Hitler-worship. By that time "Avidadollars" (Breton's anagram) had established himself from London to New York as the maestro of outrage, the media's favorite frontman for crazy modern art.

1937 A choir of 60,000 singers sing together at a choral concert in Breslau, Germany.

1938 Circus trainer Clyde Raymond Beatty handles 43 lions and tigers simultaneously.

1939 Barbara Hepworth and Ben Nicholson move to the Cornish fishing port of St. Ives, famous for its long hours of sunshine.

INNER CIRCLE

In the Freudian age ("If I dream about sex, am I unconsciously worried about umbrellas?"), Surrealists insistently probe the imagination's orifices: Hans Bellmer (1902–75), with his pedophile mutilations of dolls; Leonora Carrington (b. 1917), with her more poetic fantasies; Paul Delvaux (1897–1994), with his repetitive reveries of witless, voluptuous nudes. Perhaps surprisingly, the Parisian movement was distinctly homophobic; but then, it prided itself on its irrationalism.

Delving into the unconscious.

Through Dalí's dominance (and with Duchamp's spasmodic assistance), a movement with confused revolutionary aspirations resolved itself into a style accessory for the rich and chic. Its psychobabble, its paradoxical installations, and its risqué allusions (culminating in *Meret OPPENHEIM'S* [1913–85] famous fur-lined teacup of 1936) helped lend a rococo, whimsical air to many a fashionable 1930s soirée. Yet Surrealism had serious weight: it's what Mr. Modernism himself was currently gravitating toward. Anxious to keep abreast of the scene, Picasso had since 1927 been cheating on his wife with a compliant teenage blonde and picturing the extravagance of his passion in a code-language of blown-up biomorphs.

At the same time, he moved on a grand scale into sculpture, thinking as ever of new signs to represent bodies but now shaping them up in gross masses of modeling or else in weightless configurations of wire. The possibility of realizing these designs came through his old friend *Julio GONZÁLEZ* (1876–1942), who had devised a welding technique which, as he put it, allowed him to "draw in space." González's own ironworks also deconstruct figures into the spiky sign-languages of Surrealism, but often restore to them a sense of pathos and dignity.

Pathos and dignity are nowhere in the ingeniously sadistic prewar sculptures of *Alberto GIACOMETTI* (1901–66), which is what makes *Woman with her Throat Cut* (1932) and *Suspended Ball* (1931) Parisian Surrealism's most compelling monuments. Giacometti, however, will come to a change of heart (*see page 76*).

Julio González, *Small Sickle* (1937). Private collection.

1932 "Babe" Didrickson makes the highest jump at the Texas Olympics but the judges penalize her for her unorthodox style of jumping head first.

1933 The Nazi government in Germany bans opposition parties and aerial photography of the country.

1934 Donald Duck is introduced in the Disney movie *Wise Little Hen*.

1932~1939

Political Realities
Socialist and Social Realism

Normality, from the Crash of 1929 onward, equals constant crisis. The outlook is economic depression, Hitler and Stalin. One way or another, sooner or later, even the head-in-the-clouds art world is bound to confront "the devil's decade."

Stalin becomes an artistic director.

One way is for a dictator to grip it by the throat. In 1932 Stalin clamps down on the subversive diversity of the revolution. "Socialist Realism" is henceforth the approved policy of Soviet art, with the avant-garde driven underground. Knowing Stalin, we're disposed to despise this turn-back to academic values, now employed to portray "The Great Leader" etc—just as we shudder at its equivalents in Germany, where the works of the Expressionists are held up for public mockery by the Nazis in their 1937 exhibition of "Degenerate Art."

Yet knowing how few of us would face the gulag rather than *adapt, just a little ...* isn't there room, perhaps, to admire the talents who actually throve under Stalin's regime?

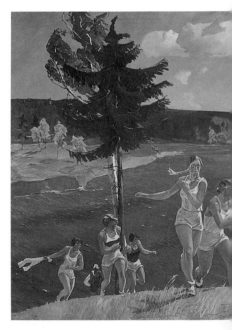

INNER CIRCLE

Does painting for the people mean painting "what the people like"? If the clever, high-resolution Americana of Norman Rockwell (1894–1978) reaches the widest public, does that make him the era's greatest figure? If the horses of Alfred Munnings (1878–1959) and the gypsies of Laura Knight (1877–1970) are the Royal Academy's favorites over the same period, are they the authentic face of interwar British art? Some postmodernist revisionists would have you believe so.

1936 200 unemployed men from Jarrow, near Durham, march to London to highlight the devastation wrought on their area by the Great Depression.

1937 150,000 people are made homeless when the Ohio River floods.

1939 James Joyce writes *Finnegans Wake* in the form of a series of interrupted dreams by the character Humphrey Chimpden Earwicker.

Alexandr DEINEKA (1899–1974), Moscow's favorite artistic ambassador, designs figure compositions for the proletarian age with an arresting lighthearted flair.

In fact his fit youths share a graphic sharpness with Western politicos like New York's *Ben* SHAHN (1898–1969). But here we're talking "Social"—not Socialist— "Realism." In the democracies, the 1930s see an argument about priorities: can we afford the ivory-tower luxuries of abstraction and Surrealism? Don't we need an experience-based imagery to serve the fight against Fascism that's being coordinated through America's Artists'

Union and Europe's AIA? Shahn's colleague *Raphael* SOYER (1899–1987) gives a tender, lugubrious tinge to this accountability to the workers; in England, disenchanted modernists move toward a respect for observation. *William* COLDSTREAM (1908–87) and *Graham* BELL (1910–43) paint the northern grime of Bolton, "Worktown"; together with *Claude* ROGERS (1907–79) and *Victor* PASMORE (1908–98), they form the "Euston Road School" in 1937–39. All four make exquisite subdued poetry out of their political preoccupations; later, their methods come through Coldstream to dominate British art education, dampening its sympathies with international modernism.

But politics is modernism, in 1937. Proof: Picasso is painting a 20-foot wide canvas for the embattled Spanish Republic. Adroitly redirecting his private surrealized mythologies to address the Fascist bombers' onslaught on his native land, he brings off what must remain the century's greatest single public painting. *Guernica*.

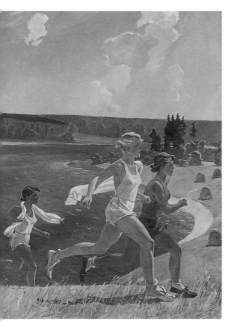

Alexandr Deineka, *Carefree Life* (1944). St. Petersburg, Russian Museum. What are they running from?

1935 George Gallup founds the American Institute of Public Opinion to carry out market research and political polls.

1937 Spaniard Cristobal Balenciaga opens a fashion house in Paris.

1938 The movie *Bringing Up Baby* stars Katharine Hepburn, Cary Grant, and a leopard called Baby.

1935~1948

Ruined Reputations
Neo-Romanticism

Surrealism, the imagery of private dream, is strangely well poised to become public commentary when history itself is accelerating into nightmare. Apart from Guernica *(see page 69), the 1930s' greatest "history painting" may be* Expectation *(1933) by the German Surrealist Richard OELZE (1900–80): a crowd looking up at clouds giving onto blackness, a truly portent-filled image.*

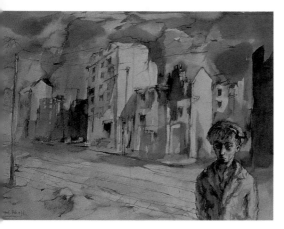

John Minton, *Liverpool* (1942). Leeds, City Art Gallery.

it, the barbarians are in our midst, our souls themselves are corrupt, it's enough to turn anyone possessed of poetic sensitivity to despair. Such is the "neoromantic" pitch adopted from Paris by England's up-and-comers of the late 1930s. The bombastic *Michael AYRTON* (1921–75) and his charmingly melancholy friend *John MINTON* (1917–57) set the tone: its real moment comes in 1940, as bombs fulfill those prophecies of ruin. Minton's nervy penmanship and the tempestuous staining and scratching of *John PIPER* (1903–72) latch onto old England's shattered walls and cracked timbers as to the deserted manor born. Forget the 1930s avant-garde debates: the time is right for nostalgic nationalism. The prize exhibit for such arguments is *Graham SUTHERLAND* (1903–80),

Paranoia likewise makes a pulpit for *Pavel TCHELITCHEW* (1898–1957), a Dalí-style virtuoso moving between the glitterati of Paris and New York. His declamatory world-gone-wrong extravaganzas, alongside the mournful reveries of another Russian exile, *Eugene BERMAN* (1899–1972), reanimate de Chirico's picturesque visions of ruins and long evening shadows. Civilization has had

1940 Londoners shelter in subway stations as the city is bombed by German planes.

1943 Joe Sheridan invents Irish coffee, with a slosh of whiskey and a mound of fresh cream on top.

1946 Earl Tupper of Berlin, New Hampshire, launches his Tupperware products in the US.

INNER CIRCLE

Foreboding British townscapes of the 1930s: see the minor but masterly Algernon Newton (1880–1968), "the Regent's Canaletto." Romantic British pastorals of the 1940s: see Ivon Hitchens (1893–1979), out in the dewy Sussex woods with his panoramic canvases and his brushy transmutations of visual response—the only artist on this spread (apart from Nolan) likely to leave you feeling upbeat.

OUTER FRINGE

At the fringes of Neo-Romanticism and Surrealism, angels hover, opening doors between the subconscious and the supernatural: notably in the drawings of Cecil Collins (1908–89) and the dappled arcadias of Harold Hitchcock (b. 1914).

phenomenon: *Russell* DRYSDALE (1912–81), who brings a more classically tinged sense of melancholy to his images of aboriginal life; and *William* DOBELL (1899–1970), whose expressive figure-style resembles that of Britain's most black-humoured neoromantic, *Mervyn* PEAKE (1911–68).

epitomizing in the writhing branches of his Pembrokeshire landscapes and in the acid palette of his portraiture the 1940s yearning for emotionality.

Upturn the globe, and this zeitgeist of nationalistic expressionism gets a more invigorating spin. A host of talents converge on the magazine *Angry Penguins* in 1940s Melbourne, seeking more urgent definitions of "the Australian experience" than the cool bush-hued modernism of *Margaret* PRESTON (1875–1963). *Sidney* NOLAN (1917–92) seizes on the potential for a national myth with his 1945–56 narratives of the bushranger Ned Kelly; his bold, cannily gawky renditions of landscape and of figures lost within it will become international flagbearers for the nation's art. Whereas with *Arthur* BOYD (b. 1920), an achingly personal repertory of impassioned, boss-eyed, blundering figures reaches out to touch on humanity's tragedies in general: Bruegel takes to the bush. The accent on angst is equally kept up by Sydney's other artistic

Sidney Nolan, *Ned Kelly in Spring* (1956). London, Arts Council Collection. Note the distinctive headgear.

1941 The huge stone heads of Washington, Jefferson, Lincoln, and Roosevelt are completed on Mount Rushmore.

1942 Sell-by dates are first stamped on food products.

1946 New England doctor Benjamin Spock gives advice to parents; his book will sell 40 million copies in 38 languages.

1940~1952
The Passing of the Torch
The "New York School"

The Statue of Liberty, herself constructed in Paris, holds her torch aloft, offering Europe's dispossessed the shelter of America's dreams. Mondrian, Ernst, Breton, they all come flocking as the Old World collapses in 1940. In Manhattan they meet up with earlier arrivals.

There's the Armenian *Arshile GORKY* (1904–48) whose paintings turn the body-shorthand of Miró's Surrealism into something finer-tuned and also more open-ended—full of subtle lines and ambiguous washes, wavering between fleshy presences

and airy memories. His 1948 suicide leaves a gaping rip in the Cedar Tavern, the NY artists' hangout. The Dutch *Willem De KOONING* (1904–97) picks up his researches in the ferocious abstracted tussle between object and space, fat creamy paint and thin black line, of *Excavation* (1950). In 1952, however, he has to surmount a new kind of antagonism (before starting his lengthy, luxuriant, critically cushioned descent into flaccid witlessness), because with his *Women*—slashy semblances of Mrs. Thatcher on acid—he's daring once again to paint figures.

For by now, the dauntingly authoritative criticism of Clement Greenberg (*see also page 84*) has dictated to the US its artistic destiny. The figure-free "Abstract Expressionism" of the "New York School" is deemed the single necessary historical development of the era. The torch of Modern Art has followed that of Liberty across the Atlantic. The mythic hero is, of course, *Jackson POLLOCK* (1912–56).

Willem De Kooning, *Marilyn Monroe* (1954). Private collection. This is what she looked like before Andy Warhol got to do his makeover.

1948 There are riots in Hollister, California, when 3,000 Hell's Angels riding Harley-Davidsons descend on the town.

1951 Muddy Waters has a hit with the song "Rolling Stone."

1952 Richard Nixon goes on TV to deny embezzling Republican party funds, and he weeps openly.

Let's not mess with myths here: Pollock's career as "the best fucking painter in the world!" (in his Cedar Tavern small talk) is unchallengeable. Though brief. An extremely unpromising, alcohol-prone youth from the Midwest pulls himself up, with muscle-clenched determination, through adaptations of Miró's archetypes and Picasso's figure-drawing, to deliver great explosions of liberated energy.

First the dancing-stickmen extravaganza *Mural* (1943), literally painted overnight to fulfill a long-delayed commission. Then, from 1947, his recourse to the can of enamel, the canvas laid flat and the stick that weaves dancing between them opens up an imaginative space without precedent in the history of painting. Creating the delirious intensity that streaks from *Full*

INNER CIRCLE

Hans Hofmann (1880–1966) is in New York teaching his doctrines of color dynamics and the importance of the picture plane (and putting them into thumpingly heavy practice), while "John Graham" (Ivan Dombrowski, 1881–1961) from Poland, holds forth with Jungian psychobabble.

OUTER FRINGE

David Smith (1906–65), macho metal-welder, is the Abstract Expressionists' sculptural associate. Picking up on González's "drawing-in-space" techniques (*see page 67*), he translates figures into forceful, forbidding iron "totems," before turning to the chunky allure of his final Cubi series, with its glinting blocks of stainless steel: sculpture that draws on, and reflects on, the brutal dynamism of industry.

Jackson Pollock, *Mural* (1943). Iowa City, Museum of Art. Influences included Navajo sand paintings. At its full 20-foot stretch, the impact is devastating.

Fathom Five to 1950's *One*, Pollock stays free from the bottle. The strain of recreating his drip-wielding as a superstar for the cinecamera that year sends him back on to it. The resulting decline is inexorable and cruel, ending in the 1956 drunken car crash that releases him to join America's pantheon of burned-out geniuses. (Turn to page 84.)

1931 Auguste Picard ascends to the stratosphere in a pressurized gondola with one side painted white and the other black.

1935 Actress Vivien Leigh signs a $82,500 contract with film producer Alexander Korda.

1939 Christopher Isherwood publishes *Goodbye to Berlin* and moves to California.

1930s, 1940s

Mad, Sad, Bad

Outsider art, Schwitters, Dubuffet

Some suffer from schizophrenia. Others from a sense of their own irrelevance. Some rejoice in a pretence of their own incompetence; others blithely bask in an innocence of it. All of them have major roles to play in the development of 20th-century art.

OUTER FRINGE

England's Edward Burra (1905–76) is no outsider to artistic sophistication—far from it—but he's landed on this page because we don't know where else to insert the 1930s' wittiest, wickedest, most eccentrically louche observer of dockside bars and Harlem lowlife. Surrealist? Not quite. Realist? Not that, either. Just a genius of camp sensibility. . . .

INNER CIRCLE

Dubuffet's prize exhibits: Antonin Artaud (1896–1948), an extremist of 1930s Surrealism with his "Theater of Cruelty," gets locked up and electroshocked in an asylum where he draws radically unsettling portraits and mutilated figures. Alfonso Ossorio (1916–90), a wealthy Filipino, combines insider status as an erudite friend of Dubuffet's with creating obsessive outsider imagery.

Simon RODIA (1921–54), the unnerving illustrated epics of self-taught *Henry DARGER* (1892–1973) in which orgies of cruelty are visited on sweetly beribboned, male-genitaled little girls.

The private world of the "outsider artist" is sometimes akin to that of the difficult, misunderstood modernist in its seeming futility and pathos. Witness the self-mockery implicit in Duchamp (*see page 36*), or in the work of *Kurt SCHWITTERS* (1887–1948). Schwitters, branching out from Dada in 1920s Hanover, starts to redeem trash in exquisitely composed collages bearing his distinctive brand name of "Merz." He then transforms two successive houses into bizarre, disorienting mock-Constructivist "Cathedrals of Erotic Misery," each time being forced to flee the Nazis, forever the

It was an enlightened German psychiatrist, *Hans PRINZHORN* (1886–1933), who introduced the public in 1922 to the extraordinary art that mental patients may produce. The mazily complex private worlds of the drawings in his collection compare with great eccentric monuments produced outside asylum walls: the "ideal palace" of French postman *Ferdinand CHEVAL* (1879–1912), the "Watts Towers" of construction worker

1941 It becomes a crime in Germany for Jews to appear in public without a yellow Star of David sewn to their clothing.

1946 Launch of the Vespa scooter, brainchild of Italian industrialist Enrico Piaggio.

1949 In New Jersey, 28-year-old Howard Unruh goes berserk and guns down 13 people.

Kurt Schwitters, "Merz" Construction (1921). Philadelphia Museum of Art.

creative loner against the derisive world. Or peer into the glass-fronted boxes in which *Joseph* CORNELL (1903–72), working in Queens, NY, on a long limb from the European Surrealism of the 1930s and 1940s. His quizzically assembled curios seem to bear some oblique and haunted relation to his own isolation.

RAW ART

Yet it is not outsider art's sadness, but its compulsive creative energy that leads *Jean* DUBUFFET (1901–85) to exalt it above the produce of the art schools. Unlearn, risk stupidity, risk incoherence for the love of creating is this Frenchman's highly stylish, articulate teaching. Promoting the work of genuine "outsiders" at the same time as he launches his own, Dubuffet becomes a major force in Paris from 1947 with his Art Brut, "raw art," a movement to which the Surrealist guru André Breton (*see page* 62) lends his name. In many senses, Dubuffet has remained an inspiration to other artists: a generous-spirited advocate of a democracy of creativity, a mark-maker of enormous panache, above all a genuinely *funny* artist. His ability to combine graffiti-style draftsmanship with a sensuous love of textures is irresistible. In another sense, to look over his collected works is to confront, depressingly, the syndrome of celebrity overproduction: endless assembly-line assemblages, idea after idea flogged to inanition.

And then there's another side to his subsequent influence. It's one thing to *pretend* you can't draw...

1945 Turkey, Egypt, Finland, and Argentina declare war on Germany. Good timing, chaps!

1948 Vittorio de Sica's movie *Bicycle Thieves* tells the story of an unemployed man who is robbed of his bike.

1950 Robert Doisneau takes his famous photo of two lovers kissing in the streets of Paris.

1945~1955

Thin Men, Fat Paint

Giacometti, *Art informel*

How to commemorate a victory that opened the world's eyes to Belsen and the A-bomb? The shattered yet rearing figure symbolizing the Destruction of Rotterdam *(1953) by the most flamboyant of Cubist sculptors, Osip ZADKINE (1890–1967), is one of the very few pieces that seem to catch the public tone.*

Mostly, Europe's mood in the aftermath of war is rueful and grim. The Parisian penchant for the "misérabiliste" painting of lugubrious *Francis GRUBER* (1912–48) and *Bernard "black-spikes" BUFFET* (1928–2000) is hardly lightened by the cartoon-canvases of *Jean HÉLION* (1904–87) who has shifted from De Stijlist abstraction to a stylized, sardonic figuration. Well, if you can't feel good, perhaps you could try feeling *intensely* bad. What could be less joyful than the paintings of *Alberto GIACOMETTI* (1901–66)? Scratching and scribbling his way toward the appearances of his sitters, the Swiss former Surrealist (*see page 67*) is, as he'll explain

over cognac in the Deux Magots, on Mission Impossible when he attempts to represent another human being. We are what we aren't; look how the void presses in on us from all sides, rebuffing our willful efforts to establish personal identity. (Across the table, his philosopher friend Jean-Paul Sartre concurs.) The contention, however you rate such existentialism, makes for astonishing sculpture. The individual is worn away to a frail vertical thread of being, descending from a flounder-flattened head to the distant ground. Put three or more such human filaments together on one base, and you have an image for "the lonely crowd," the alienation that contemporary intellectuals consider to be humanity's lot.

Giacometti's touch is broken and clotted. To fumble openly, to let the crumbliness and gunkiness of the raw basic *matière* speak for itself, these are principles that pervade

Alberto Giacometti, *Walking Man* (1960). St.-Paul-de-Vence, Maeght Foundation.

1951 John Wyndham publishes *The Day of the Triffids* about some bad-tempered plants.

1952 Flip-top cigarette packets replace the soft pack.

1955 In London, Ruth Ellis is hanged for murdering her lover David Blakely

Nicolas de Staël, *Composition* (1950). Private collection. He used a palette knife to crush the thick blocks of paint.

enticing, suffusing the canvas with great weights of vibrant pigment that obliquely relate to observed landscapes. In other hands, the school of gunk becomes in the early 1950s what the critics call "tachisme" —splotchism—or simply *Art informel*. (As opposed to *art formel—see page* 92.) Referring

much postwar European art. (They develop from the Surrealist notion of releasing what lies beyond the conscious will—*see page* 62.) The fractured facture of the ominous statues of *Germaine Richier* (1904–59), or the terse chunky forms in the *Horses and Riders* of Milan's *Marino Marini* (1901–80) are instances. (Picasso's sculpture of the time likewise takes on this "rough" look, but much more lighthcartedly.)

In 2-D, the hauntingly featureless, fatly impastoed heads in the *Hostage* paintings of *Jean Fautrier* (1898–1964) set the tone. Slab that paint on! The Russian emigré *Nicolas de Staël* (1914–55) is one artist who makes the process seem

to the exploration processes of Klee's and the matter-and-space fusions of Braque's later work, painters ranging from *Roger Bissière* (1886–1964) to the French Canadian *Jean-Paul Riopelle* (b. 1923) develop a dappled and rippled version of abstraction, attractive, honorable, and virtually free of any meaning.

OUTER FRINGES

Existentialist Paris is enlivened by the presence of two German emigrés. Hans Hartung (1904–89) is a pioneer of "gestural abstraction" with his touchy, erratic, almost Chinese brushwork. Yet more intuitive, the legendarily drunk Wols (1913–51), whose obsessive messing in various media seems to quest after mystical discoveries.

INNER CIRCLE

The Englishman Stanley Hayter (1901–88), teaching in New York and Paris, did more than anyone to open up printmaking to modernist possibilities. He is also the teacher of the Paris-based Portuguese María Elena Vieira da Silva (1908–92), whose beautiful paintings dapple checkered perspectives to open up indefinite imaginative spaces.

1948 Four Russian explorers are the first people indisputably to reach the North Pole overland.

1949 Hank Williams makes a guest appearance on the Grand Old Opry radio show in Nashville and takes them by storm.

1951 Floods in Missouri leave 500,000 people homeless.

1946~1960

Achieving Liftoff

Fontana, CoBrA, Klein

"The peaceful, gentle life has come to an end. Speed has become a constant in the life of mankind... Plaster and paint on canvas are no longer meaningful." In 1946, Lucio FONTANA (1899–1968) is trying to get the measure of modernity in Buenos Aires, a metropolis backing onto a vast agrarian hinterland. Out among the poor of its barrios live the folk myths given saucy, Dubuffet-like vitality in the collages of Antonio BERNI (1905–81). But here in the Escuela Altamira, he and his latter-day Futurists are dreaming up their dynamic, dimension-busting "spatialism."

When he returns the next year to the Milan of his training, the sometime ceramicist takes canvases and punches holes in them. No—better, don't punch them; slit them with a knife. No—best of all, get the viewer into a totally white space, with nothing to look at but a slit giving onto blackness. It's a literal breakthrough. Into a new space!

In its context, the cleancut radical violence is startling. So much in the postwar European avant-garde is turbid, history-tethered, obsessed with materiality. The southerners with their masterly presentation of the stuff of heavy memories: Rome's *Alberto BURRI* (1915–95) with his stretchings of war-evocative charred sacking, Barcelona's *Antoni TÀPIES* (b. 1923) executing his terse aesthetic decisions in earthy ochers and the black that's the Spanish artist's national color. And then the northern avant-garde, who are trying to forge a new, truly "materialistic" expressionism under the influence of Dubuffet (*see page 75*),

1952 Jacques Cousteau discovers an ancient Greek ship off the coast of Marseilles containing 3,000 urns full of wine.

1954 France withdraws from Indochina, surrendering it to the Communist forces of the Viet Minh.

1958 Max Miedinger and Edward Hoffman design the Helvetica typeface.

psyching themselves up on folk myths from Europe's own Nordic hinterland. Wild goblins spill out of the paint pots of the grouping CoBrA—triangulated from 1948 on the *C*openhagen of *Asger JORN* (1914–73), the *B*russels of *Pierre ALECHINSKY* (b. 1927), and the *A*msterdam of *Karel APPEL* (b. 1921). At their best, their tongue-poking kindergarten riots rip up the rulebook with an uproarious vitality. But the grouping in turn soon tears itself apart, with the ideologue Jorn converging on Paris in 1957 to found, with Guy Debord, "the Situationist International."

WE HAVE LIFTOFF

The Situationists' stance shares something with Fontana's: art in every form we know it has become irrelevant. Real creativity has to express itself otherwise—chiefly, through people twisting their relations with their environment into new forms. This idea of "détournement" will set the agenda for the avant-garde of the 1960s and the "events" of May 1968 (not to mention the punk phenomenon of 1976–77): in the late 1950s, it's mesmerized by the charisma of *Yves KLEIN* (1928–62).

From far outside your usual parameters, this mystic-mouthed judo-fighter invites you to open your eyes to monochrome canvases, covered with his patented, celestially intense "International Klein Blue"; to step inside an entirely empty gallery— "The Void"; to witness paint-smeared naked women being used as living brushes to make body prints to the strains of a string quartet.

Is this "immaterialism" a joke, or what? But hey, it feels good: like liftoff, like Sputnik. The Space Age has arrived.

Yves Klein, *Leap into the Void* (1960). Klein improves a boring French backstreet with a touch of trick photography.

1947 Scientists at Columbia University discover that sexual reproduction occurs in bacteria.

1949 In Berlin, Jews protest at the portrayal of the character Fagin by Alec Guinness in the film version of *Oliver Twist*.

1951 In the south of France, 3 people die and 50 go insane after eating bread made with ergot-infected grain.

1947~1964

Masterful Profiles
Balthus, Bacon, Freud

It's not enough, in the modern art world, to put out product. You've got to watch your profile. Fine-tune it, preen it. Especially if your own product-line seems to lie against the modernist grain. "Enigmatic... Rarely gives interviews... lives in a château in the Juras... Did you know he's a Polish count? And that rather disturbing imagery... Do you think he's a pedophile?" The image management of BALTHUS (b. 1908) is masterful from the outset, appealing both to the snobbery of neoclassicists like his mentor Derain (see page 18) and to the prurience of his Surrealist contemporaries in 1930s Paris. His veneer of dandyism allows him to develop his mastery: the loading of the canvas with as heavy a weight of color, texture, and nostalgic association as it could bear, or (to put it modernistically) the creation of a totally charged space.

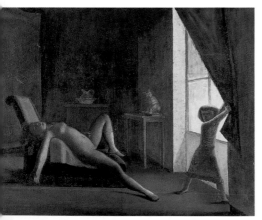

Balthus, *The Room* (1952–54). Private collection. His erotically charged interiors often seem to contain a narrative but they never explain what that narrative might be.

Equally, it helps to keep up a *dangerous* persona if you'd love to paint Velázquezes but have never developed the requisite drawing skills. Also learning his style in interwar Paris—but firstly as a gambler and interior designer— *Francis BACON* (1909–92) launches his line in Old-Masters-for-the-godless-age in 1945 London. Orders consignments of seven-foot-by-five finest linen canvases from Roberson's, then heads

1956 When Soviet tanks move into Budapest, the last words heard on the rebels" radio station are "Help, help, help."

1958 A budgerigar called Sparkie has mastered 531 words, 383 sentences, and eight nursery rhymes.

1964 Richard Burton and Elizabeth Taylor get married for the first time.

Francis Bacon, the right-hand canvas of *Three Studies for Figures at the Base of a Crucifixion* (1945). London, Tate Gallery. Bacon denied there was a connection with the public horrors of the era.

will lose the whole game and ruin that pricey canvas, for all the fastidiousness of his designer-violence presentation. Yet the gamble, very often, pays off: screaming mouths and flurried sodomizing, set in the imposing spaces where human dignity once made its stand, make compelling public art for a God-disappointed generation.

REAL HARD LOOKING

By Bacon's side in the Colony Room of the 1950s is another dandy possessive of his own mystique. *Lucian FREUD* (b. 1922), "the Ingres of existentialism" in the critic Herbert Read's phrase, brings from the Germany of his childhood a harsh intense passion for the specifics of the people and objects he draws, weaving fine-wired traps for their likenesses.

Though this firmly figurative, seemingly antimodernist art is well liked in England, it's hardly close to the figuration of another Colony habitué, *Michael ANDREWS* (1928–95; *see* Outer Fringe box)—the most speculative, open-minded, and lyrical English painter of his generation. Let alone to the systematic investigation of observation practiced through the 1950s by the alumni of William Coldstream's "Euston Road School" (*see page 69*), such as *Lawrence GOWING* (1918–91). If you want to know what else is happening in Britain during the 1950s, *see page 82*.

down to Soho's Colony Room to queen it up over champagne as the art scene's louchest, sharpest conversationalist. Stumbling sloshed back to the studio, he jiggles with the figure in the photo he's painting from, trying almost literally to open up its guts, risking an overload that

OUTER FRINGE

Unlike his Colony Room friends (whom he memorably portrays), Michael Andrews keeps a very low personal profile, and manages to avoid a "signature style"—which is why his work has remained relatively unknown. But with his technical fluidity and his sensitivity to a diversity of zeitgeists and landscapes, he delivers some of the richest masterpieces of later 20th-century British painting.

1950 Norman Norell designs "divided skirts" that move just like trousers.

1953 Lita Rosa is number 1 in the UK charts with the song "How Much is that Doggie in the Window?"

1954 Rationing ends in the UK and Smithfield market opens at midnight so that people can buy their fresh meat.

1950s
Scenes from Provincial Life
St. Ives, Kitchen Sink, Bomberg

Behind every British artist before the 1990s there lurks a demon (or a critic, same thing) whispering, "You're provincial!" Before WW2 your fault was not having been born French; now, come the 1950s, you are failing because you're not American.

We do like to be beside the seaside.

How do you deal with it? One way's to gather on the island's Atlantic shores, shaking your fists westward and shouting *"We'll take you on any day!"* Artists had flocked to St. Ives since the 1880s, but the little Cornish seaport took on a new eminence after Ben Nicholson and Barbara Hepworth (*see page 64*) made it their base for British abstraction from 1939, attracting other circle-and-square types like Naum Gabo (*see page 55*). Further arrivals included *Terry Frost* (b. 1915)—also of the few-lines-but-beautiful persuasion—the rather rowdier *Roger Hilton* (1911–75), and *Patrick Heron* (1920–98), stronger as a critic with his "Yah boo! We got there first with color field painting" ripostes to the US than in his actual samples of same.

The colony's patron saints, however, were Cornish: *Alfred Wallis* (1855–1942), the self-taught old sailor whose scruffy but wonderful cardboard seascapes of St. Ives had first endeared the town to Nicholson, and *Peter Lanyon* (1918–64), the most dashing exponent of the gestural, metaphorical response to Cornwall's blue, gray, and green that was the grouping's artistic trademark.

OUTER FRINGE
Joan Eardley (1921–63), passionately responding firstly to Glasgow tenements and then to the blasting North Sea bleakness of Aberdeenshire, is British painting's most heroic figure of the 1950s. Her Polish-born friend Josef Herman (b. 1911) also paints with a dark gut-realism in his views of Welsh mining life.

INNER CIRCLE
Elisabeth Frink (1930–93), with her powerful, obsessive men and horses, is the most distinctive figure to emerge from British sculpture of the 1950s, a scene dominated by the influence of Giacometti and Picasso. There's more to say about Lynn Chadwick (b. 1914), Reg Butler (1913–81), and Kenneth Armitage (b. 1916), but not here!

1956 Heavyweight champion, Rocky Marciano, retires from boxing, after winning 49 professional fights and no losses.

1957 There is a fire at Windscale nuclear plant in Cumbria. No one dies but over 100 cancer deaths are directly attributed to it.

1959 The first helicopter crossing of the English Channel takes place.

THE WORKING CLASSES

Looking east from Cornwall, it's London that looks provincial. They're still stuck in muddy old British realism back there, as if modernity were merely a matter of garbage cans and teacups and washing your baby in the "Kitchen Sink"—the label invented in 1954 by critic David Sylvester in response to a painting of that subject by *Jack SMITH* (b. 1928).

The label will cover not only Smith's painter friends *Derrick GREAVES* (b. 1927), *John BRATBY* (1928–92), and *Edward MIDDLEDITCH* (1923–87), but the whole 1950s push to represent working-class life in drama, fiction, TV etc. Sylvester hates it; rival critic John Berger rates it. But Berger's putting his money on rickety horses.

The group contains one banal self-promotionist, Bratby by name, Bratby by nature, while the subtler Smith and Middleditch, like so many others in late 1950s England, slink away to "go abstract." Following the 1948 defection of Victor Pasmore (*see page* 69), England's most lyrical landscapist of the 1940s now becomes an austere "constructionist."

But if you are determined to get bogged down in the mud of provincial views, get truly stuck in: that's one message from this period. Like you were swimming into a reedbank and groping for a foothold; and like the river was the world around your body, and yet the river was made of paint. Take this as a broad paraphrase of the way the elderly David Bomberg (*see page* 35) might exhort his London pupils in the early

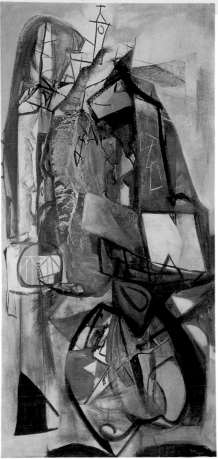

Peter Lanyon, *Porthleven* (1951). Best go to the Tate, St. Ives, to see the Cornish crowd's work in situ.

1950s to search for "the spirit in the mass": among them, *Frank AUERBACH* (b. 1931) and *Leon KOSSOFF* (b. 1926). This river will keep on running (*see page* 113) through British art to the present day.

1950 The world's first kidney transplant is carried out in Chicago.

1952 Gene Kelly's *Singin' in the Rain* raises the spirits of thousands of movie goers.

1953 At the University of Iowa, a woman is impregnated with sperm that has been frozen.

1950~1960

The Brushstroke That Saved the World
Rothko and Abstract Expressionism

So what happened when "Jack the Dripper" dripped (see page 73)? Was this a trance in which Pollock's inner integrity could emerge? Was it "Action Painting," as critic Harold ROSENBERG (1906–78) put it, no longer product but event, art fusing with life? Was it, as rival critic Clement GREENBERG (1909–94) would have it, a declaration of paint as pure paint and canvas as pure canvas, a breakthrough into "flat," figure-free abstraction?

Ingenious new painting skills.

The questions have big implications for later 20th-century art, because all sides recognize that in some way—but which?—Pollock's achievement was epoch-making. His own drinking companions in the Cedar Tavern might have preferred the first version, or something like it. "Authenticity" was their back-up ethos. They sure as hell wanted their painting to be, not so much flat, as *full* of something. But what?

For *Mark ROTHKO* (1903–70), "basic human emotion" is the nub of it. He wants a painting that somehow includes what everyone feels about everything. "I paint very big to be very intimate." Rothko, a Russian immigrant, comes to his high from a very low base, like Pollock. Until wavery surrealistic figures straighten themselves up into fuzzy color rectangles around 1949, his canvases have little outreach. They then stay aloft, like magic doors into the unsayable, through a narrow

OUTER FRINGE

It ain't all abstraction in 1950s New York. Holding the fort for Matissean responses to nature—but adding a cool, demure New England sense of chic—Fairfield Porter (1907–75), and the older Milton Avery (1885–1965), an artistic loner whose sparely drawn, subtly colored landscapes were an inspiration for Rothko.

INNER CIRCLE

Ad Reinhardt (1913–67), Mondrian's chief American disciple, is at once the hardest-line proponent of abstract "painting as painting and nothing but," with his totally black canvases—dauntingly absolute, or teasingly absurd?—and, through his cartoons, a stinging, adversarial satirist of his fellow abstractionists' pretensions.

1955 Disneyland opens in California, and visitors are able to meet their favorite cartoon characters.

1958 The Tokyo Tsuchin Kogyo Kabushikakaika Co. changes its name to Sony. Can't think why.

1960 American pilot Gary Powers is found guilty of spying in Moscow and sentenced to 10 years in jail.

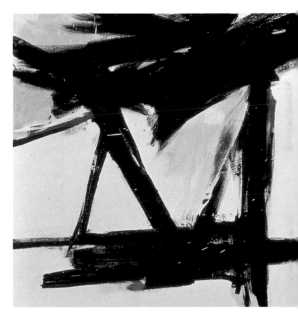

Franz Kline, *Ballantine* (1948–60). Los Angeles County Museum of Art. His black and white shapes resemble calligraphy.

set of changes until the downturn into blackness that presages the slitting of his wrists in 1970.

PLUMS AND ZIPS

Rothko delivers on his promises; he has become for most viewers the embracing, soul-stirring, non-denominational "religious experience" he aimed at, a high point in the century's art. Can the same be said for his colleagues in "the heroic generation"? *Franz KLINE* (1910–62)—like all of them —goes for size; the blown-up projection of a little gestural drawing across a wall prompts him with the idea of slashing six-inch brushloads of black across six-foot squares of white, attractively if rather vacuously. Turn his pseudo-Chinese-characters into plum shapes and you've got the look of *Robert MOTHERWELL* (1915–91), if not his literate caption-making: "metaphors of the contrast between life and death, and their interrelation."

Here we touch on a notorious problem zone of modern art. We step right inside with *Barnett NEWMAN* (1905–70), who paints a thin dry line on a field of drab color, and claims that if "read properly" this "zip" "would mean the end of all state capitalism and totalitarianism." No! Please! Don't mention those emperor's tailors! As for *Clyfford STILL* (1904–80), nothing about his jagged abstract melodramas could ever match the pathos of his arrogant boast that "a single stroke of paint... could restore to man the freedom lost in 20 centuries of apology and devices for subjugation."

In the face of such talk, you might prefer to turn to the critics' versions. The up-and-coming generations do: for what happens to Rosenberg's Action Painting, *see page 86*, for the destiny of Greenberg's destiny of art, *see page 90*.

1952~1960
Life! Everything!
Rauschenberg, Happenings

"(Oil on canvas with nails, tacks, buttons, key, coins, cigarettes, matches, etc.)" You only have to check the caption to Pollock's Full Fathom Five *to see this wasn't some purist abstraction. It was an action, sweeping up life's low detritus and art's high ambitions together in a single creative swoop.*

Robert Rauschenberg, *Canyon* (1959). New York, Sonnabend Collection.

on it—that's what Cage's teaching suggests to him. It's a fateful moment in artistic thought; with his exuberant energy and multimedia productivity, Rauschenberg will be a leading figure in 20th-Century Art, Part 2.

IT'S ALL HAPPENING

Moving to New York, RR opens his studio to the junkyard. Bring them all in—not just buttons and cigarette butts, but old clothes, radios, publicity material, hey why not stuffed eagles!—and he'll stick them together in his "combines," simply to sit side by side being what they are (he doesn't want to have to imitate the look of anything with anything else). Or rather, not simply being themselves but joining together in a paint-slashed celebration of the riotous multiplicity of this world we now live in, this raucous urban chaos.

Thus critic *Harold Rosenberg, c.*1952. And now, John Cage, modern music guru of Black Mountain College, NC: "What we need is curiosity and awareness, not value judgments." Sitting at Cage's feet in the same period is *Robert Rauschenberg* (b. 1925). An art *open to life*, an art opening out the stuff of the world itself, not imposing hierarchies

1957 Berry Gordy invests $700 to start a recording company called Motown Corp.

1958 41 million American households have TV sets; in 1950, it was only between 5 and 8 million.

1960 Convicted kidnapper and rapist Caryl Chessman dies in the gas chamber at San Quentin; he has had nine stays of execution since sentence was first passed in 1948.

Arriving in the po-faced, high-minded heyday of Rothko-style Abstract Expressionism, Rauschenberg's is a rude new sensibility, and when he shows his stuff in 1958 it brings him that cherished proof of artistic arrival, critical outrage. He's a man for the new age, although his reaction to the abstractionists of the 1950s isn't exactly unique.

Allan KAPROW (b. 1927), critic-cum-impresario, reads a comparable message into Pollock about blurring the line between art and life. He enacts it from 1959 through his "Happenings." Get people to come together somewhere and somewhen; get some of them to do something (what? oh, clap hands, strike poses, whatever), the others will respond, and—that's it. Ephemeral creativity, stuck bang in the texture of the real world. For "the young artist of today need no longer say 'I am a painter' or 'a poet' or 'a dancer.' He is simply an artist. All of life will be open to him."

Art no longer means looking inside a frame where you can weave your imagination around illusory objects—it means creatively handling whatever's around you. (If you're

OUTER FRINGE

Far left-field of Abstract Expressionism is the mystical mark-making of Mark Tobey (1890–1976). With his first-hand experience of Japanese Zen teachings, Tobey unfolds gestural drawings of a singular quiet intensity and meditative beauty. Their modest scale finds a more sympatheitc audience in 1950s France than in the US.

INNER CIRCLE

Larry Rivers (b. 1928) has a different irreverent take on Abstract Expressionism from Rauschenberg's (who first makes his mark by erasing, with de Kooning's permission, one of the elder artist's drawings and exhibiting the blank result). Rivers uses its gestural manner to paint—of all things!—an old-fashioned history painting with his *Washington Crossing the Delaware* of 1953.

the artist, that is. Viewers are obsolete, by this argument.)

Hey, isn't this what that old Parisian prankster was getting at with his signed urinal? Suddenly, in this era of "Neo-Dada," Marcel Duchamp (*see page 36*) is enjoying old-age fashionability.

Mark Tobey, *Head* (1964). Private collection. A convert to the Baha'i faith, he got his inspiration from meditation.

1956 Rock paintings found in the Tibesti Mountains are dated to 3500 BC and prove that the Sahara was once fertile.

1958 The American Express card is launched and consumers decide "That will do nicely."

1959 Frank Lloyd Wright's Guggenheim Museum is completed in New York with a dramatic inner circular ramp.

1956~1965

Chewing-gum Wrappers
Pop Art (1)

What are the emerging trends of the postwar world? Let's ask leading figures in the arts, the sciences, the humanities. Let's get dialogue going. Let's bring them all together in an "Institute for Contemporary Arts," founded in London in 1947 by Sir Herbert Read, apostle of modernism to the English. Then let's see what happens next . . .

Richard Hamilton, *Just What Is It ...* (etcetera, etcetera) (1959). Tübrügen, Kunsthalle.

Reel-to-reel recorders! Ah, the period charm! Bright, cheap, fast, gimmicky, and American.

Independent who steals the show with his Dada-style collage *Just What Is It That Makes Today's Homes So Different, So Appealing?* He has latched onto a gap in the representation market: why aren't British artists, instead of cold-shouldering the Yanks (*see page 82*), responding to the way most of an increasingly affluent British public currently longs to look—bright, cheap, fast, gimmicky, i.e. American?

Well, a few British artists have been: Edinburgh's *Eduardo PAOLOZZI* (1924–2000) compiled pulp collages back in the 1940s before moving into monotonously upbeat totemic sculptures; *Peter BLAKE* (b. 1932) winsomely applies his sables to the schoolboy's pocket souvenirs of Americana. However it's Hamilton, whose worship of Duchamp reflects his own cool analytical wit, but who's also instinctively a rather *pretty* painter, who pens the manifesto "For the Finest Art, Try Pop!"

The ICA will usher in the leading innovatory art movement of the 1960s when it invites the artist-intellectuals of the "Independent Group" to stage the 1956 exhibition "This is Tomorrow Today." Only, this won't be a movement you'll welcome, Sir Herbert. It will seem to betray everything about modernism you hold dear. *Richard HAMILTON* (b. 1922) is the

1961 David Hockney shows some paintings based on the carton of a British tea company, Typhoo, at a "Young Contemporaries" exhibition.

1964 A cow named "Lyubik" gives birth to a record litter of seven calves in Belarus.

1965 US troops begin to bomb Vietnam in Operation Rolling Thunder.

David Hockney, *Pacific Mutual Life* (1964). Litho edition.

In favor of the love note argument, you could adduce another artist who emerges out of Pop *c.*1962, *David Hockney* (b. 1937). But who could really hold against the media's favorite art-world personality his invariable sweetheartedness? The variable quality of his output—so often dodgy when he strays from his graphic, blandly flattened forte—is another matter. Yet even when picturing the LA to which he migrated from Bradford at its most banal, Hockney's good nature is never mindless. Via pastiche, his work hangs together as a set of meditations on the multiple possibilities of representation.

His rapid-growing movement has echoes in Paris in the thinking of the Nouveaux Réalistes (*see* Inner Circle box). But is its lingering over publicity and packaging some kind of critique of modernity, like that of Parisian semiotician Roland Barthes? Is some kind of scorn, like that of original Dada, being visited on all this trash? Or is Pop really just a love note to mindlessness? It's the latter suspicion that enrages Read: is he watching Modernism going down on Mammon? Against him you could bring forward *Pauline Boty* (1938–66), a feminist in this boys' club world, and *Richard Smith* (b. 1931), whose Rothko-sized cigarette-packets relate Pop to London's other big new thing of 1960, the abstraction of the "Situation" group (*see page* 93).

OUTER FRINGE

For Food Pop: try the gross-outs of the Icelander Erró (b. 1932). For EuroPop: sample the jokey Spaniard Eduardo Arroyo (b. 1937), or France's Martial Raysse (b. 1936). For pseudo-porno Pop: the ingeniously unpleasant Allen Jones (b. 1937). For Pop relief: turn to the thoughtfully witty woodcarver and printmaker Joe Tilson (b. 1928).

INNER CIRCLE

Torn posters, polythene, and Coke cans: Paris's Nouveaux Réalistes share an imagery with London Pop, but not a medium. Arman (b. 1928) and friends present you with the things themselves—notably at their 1960 show "Le Plein," where they stuff a gallery "full up" with junk from the streets, in a riposte to Yves Klein's show "The Void" two years before (*see page* 79).

1958 It is revealed that Jerry Lee Lewis's wife Myra is also his second cousin and is only 13 years old.

1959 Sir Christopher Cockerell designs the hovercraft after constructing a model in his kitchen from two coffee tins and a hair dryer.

1960 South African police shoot dead 69 demonstrators in Sharpeville and wound at least another 200.

1958~1965

Formalism for the Foyer

Postpainterly abstraction, Caro

"The Painted Word" was how middlebrow America's favorite smartass, Tom Wolfe, labeled it in 1975: the way a generation of painters some fifteen years before seemed to tailor their art to the critical dogmas of the pope of formalism, Clement Greenberg. How, asked Wolfe, had a school of painting determined to shed every trace of representation ended up itself depending, ultimately, on written texts?

Not quite fair, but there's something in it. Greenberg's pronouncements on painting's destiny—that it must henceforth refer to itself alone—did get read by painters: they made them feel important. To his ancestry of this development Greenberg enlisted in the mid-1950s an artist few had recently thought about, Monet (*see page* 16). The old Frenchman's engulfing, open-brushed waterlily ponds looked prescient when set beside Rothko, suggesting that you could organize painting purely around color fluctuations. It's not coincidental that by 1958 you are seeing a watery, tremulous "Abstract Impressionism" coming from the likes of *Sam FRANCIS* (1923–94) and *Philip GUSTON* (1913–80; *see also page* 107).

Anthony Caro, *Early One Morning* (1962). London, Tate Gallery. He trained as an engineer then worked as an assistant to Henry Moore.

OUTER FRINGE

Phillip King (b. 1934) is, alongside Caro, the most distinguished sculptor to come out of London's St. Martin's School in its 1960s heyday. Emerging slightly later, he like Caro creates radical new forms—notably the big cloven cone of *Rosebud* (1965)—but using the new material of fiberglass, and with a cheeky wit that's absent in Caro coloring it outrageous pink. He taught at the Slade and became the Royal College of Art's Professor of Sculpture.

1961 Mathematician Milton Babbit uses the theories of Arnold Schoenberg to compose music on his computer.

1963 The Colombian bandit Teófilo "Sparks" Rojas, who is believed to have killed 592 people, dies in an ambush.

1965 The Rolling Stones are fined $10 for urinating against the wall of a gas station.

STAINS AND STEEL

And then, come 1962, Greenberg announces "Post-Painterly Abstraction." Let the hot, emotive brushiness of Pollock and de Kooning make way for the cool, it-just-happens-to-be-that-way look pioneered by Newman. (Lost? Check pages 72–3 and 84–5.) His candidates for this style-shift share a certain look—one that happens to be ideal for very big plateglass and whitewalled company foyers, where executives check out each other's modishness. (For "formalist," read "politically unchallenging.") That look comes partly through new technical opportunities. *Jules OLITSKI* (b. 1922) starts doing lineless color, "paint as paint," with an airbrush. *Helen FRANKENTHALER* (b. 1928) gets there by staining the

canvas with polymers and acrylics— a development followed in the arid symmetries of *Kenneth NOLAND* (b. 1924) and in the vast white canvases across which the colors of *Morris LOUIS* (1912–62) flow and soak. In fact Louis, the painter who has the best rapport with Greenberg, is his finest advertisement: the most lyrical and inviting exponent of "color field painting," and indeed of this whole era of "high abstraction."

Or defendants of Greenberg (if any are left) could cite his championing of the British sculptor *Anthony CARO* (b. 1924). Caro finds fresh ways to concentrate on the physical prerequisites for sculpture— gravity, uprightness, jointedness, openness or enclosure—and on the ways the viewer intuits them; and does so in a bold new language of aluminum tubes and steel plates, brightly painted for uplift. Naked— look, no pedestal!—and starkly surprising, his abstract sculpture is recognized as a groundbreaking achievement from its arrival in 1963, opening possibilities he will explore with growing emotional complexity over the decades to come.

1958 Australian inventor David Warren pioneers the black box flight recorder.

1961 Audrey Hepburn plays Holly Golightly in *Breakfast at Tiffany's*.

1962 In England, Basil Spence's new Coventry Cathedral is consecrated and Benjamin Britten's *War Requiem* is performed there.

1958~1965

New Illusions
Op Art

European art in the 1950s was full of grunge. Call it matière, *call it* haute pâte *(thick impasto), call it expressive abstraction or materialist expressionism or* art informel *or what you will. It tends to clog up your eyes, after a while.*

INNER CIRCLE

Go on, pull the lever! Jean Tinguely (1925–91) has an absurdist line in kinetic art: great lumbering machines that cater to all the senses (clanking, ponging, executing abstract drawings); his ultimate gesture being 1960's *Homage to New York*, a vast junk construction at MOMA which completely destroyed itself in 28 minutes—starting a fire at the museum in the process.

But there was also *art formel*—"hard-edge" or "geometrical" abstraction, in the tradition of Mondrian. You had ex-Bauhauser *Max Bill* (1908–94) in Ulm, thinking rigorous thoughts about topology with his sculptures, and the

Zuricher *Richard Lohse* (1902–88), sharpening up your vision with equal mathematical logic. And in Paris, *Victor Vasarely* (1908–97), an egghead Hungarian emigré in the mold of Moholy-Nagy (*see page 52*): intent on scientifically exploring new conditions for art, and trying to establish its social purpose.

Vasarely digitalizes vision into a basic binary logic—black/white, line/point, mass/void. Then plays at combining these elements in such a way that they generate a whole new factor of illusion. Like the moiré patterns produced by crisscrossing meshes, the lurches and shimmies emerging from his grids buzz around the viewer's retina like a conjuror's trick that still dazzles even when you know how it's done.

Jean Tinguely,
The Avant-Garde (1988).
Basle, Tinguely Museum.

1963 The first hover lawnmower is produced in Britain.

1964 Nelson Mandela is sentenced to life imprisonment after an eight-month trial in South Africa. He says the ANC campaign is "a struggle for the right to live."

1965 Winston Churchill dies and is commemorated with a state funeral.

ART AND THE VIEWER

Vasarely loves the way that it's your eyes that are completing the effect, and that it doesn't need to be his handiwork at all. The painting? Oh, leave that to assistants. More democratic! Maybe then it's irrelevant to mention his name, or that of fellow research-workers *Jesus Rafael SOTO* (b. 1923), or *Yaacov AGAM* (b. 1928), or *Richard ANUSZKIEWICZ* (b. 1930)—one of the few Americans involved in this scene that hits the headlines at the turn of the 1960s. Maybe more important to note the way that their optics interrelate with kinetic art (e.g. Gabo *page 55*, Calder *page 65*), another field where the viewer's attention is—as it were—"designed into" the work.

Nonetheless, the most powerful eye-tingler of them all, *Bridget RILEY* (b. 1931), does think of her work as a continuation of the old painting tradition. A youthful success in 1965—the year some wit coins the formulation "Op Art" on a backflip from Pop Art—she is dismayed by the way her trademark black+white=color/motion effects are instantly converted into the

Bridget Riley, *Movement in Squares* (1962). London. Arts Council Collection. The abstract optical components are not good for hangovers.

packaging clichés of "Swinging London." For her, these perceptual effects serve as materials, to be harmonized and resolved in a classically satisfying experience. She is aiming at museum-standard masterpieces for an age when representational painting's become irrelevant.

Maybe that age, though, was really the 1960s. The positivity and brightness of the decade's early years show in the abstractions of her London colleagues like *Robyn DENNY* (b. 1930), *Bernard COHEN* (b. 1933), and *John HOYLAND* (b. 1934), at the "Situation" shows of 1960 and 1962. Natty, hard-edged, self-assured in its nods to the New York school, their manner seems in retrospect to brim with a kind of pre-Kennedy-assassination innocence.

OUTER FRINGE

Also exploring perceptual riddles in black and white, the Dutch printmaker M.C. Escher (1898–1972). But unlike the Opmen, this most ingenious and most reproduced of all 20th-century artists prefers to base his surrealistically influenced mindteasers on identifiable figures.

1962~1966

Campbell's Superficial
Pop Art (2)

Making good use of the groceries.

Flag, by Jasper Johns, 1955. Mr. Johns replicates the design and colors of the American national symbol, but in a framed format that renders it useless for outdoor public display. Do the drably tasteful hatchings of his paintbrush in some way compensate for this shortcoming?

Andy Warhol, *Big Electric Chair* (1967). Stuttgart, Froelich Collection.

"Pop Art" that swept the American market from 1962. (The name's taken from Britain, *see page* 88, but the mood's different.)

It's the beneficiaries of this vogue who make the question about signs and aesthetics into an arresting pictorial proposition: *Roy LICHTENSTEIN* (1923–97), he of the blown-up strip cartoons, and *Andy WARHOL* (1928–87), a dapper draftsman and sure-eyed stylist with the silkscreen who takes to the role of public icon like a rubber duck to a bubble bath. His Campbell Soup Cans, his Elvises and electric chairs and his mesmerically monotonous movies offer a mirror for the 1960s' queasy self-fascination, the decade's yearning for dazzling surfaces and its lurking terror of death.

Do signs for something else become objects in their own right when they are placed in an aesthetic context? You will gather that this *Crash Course* has little interest in the answer. *JOHNS* (b. 1930) is a giant among those who have attempted just such efforts. We mention him partly because he was Rauschenberg's lover in the 1950s, but more because his pictorial conundrums set the conceptual agenda for the

1965 A power cut blacks out the east coast of Canada and the United States for more than 9 hours.

1965 Ralph Nader publishes *Unsafe at Any Speed*, claiming that car manufacturers are careless about safety.

1965 The TV series *Star Trek* is aired for the first time, described by its creator Gene Roddenberry as "a kind of space western."

Wayne Thiebaud, *Pie Table* (1963). Private collection. Would you say it's just humble pie, or is he having his cake and eating it in the bargain?

15 MINUTES TOO LONG

The best thing about Warhol, actually, is *Songs for Drella*, a song cycle recounting his life by two of his protégés, Lou Reed and John Cale. The great music issuing from the 1960s was passionately imaginative; not so the art. Warhol was one of a generation who took Cage's and Rauschenberg's message (*see page 86*) about dropping metaphors and simply looking at things with "curiosity and awareness" and toned it down into camp attitudinizing. When asked what Pop Art was all about, he blandly answered "It's liking things."

For *things*, read their surfaces; which are fascinating, but leave you edgy, because what may lie underneath?

The great angsty masterpiece of the whole era is James Rosenquist's *F-111*, an 86-foot sensurround of gross commercial imagery structured around a death-delivering bomber. California's *Wayne Thiebaud* (b. 1920) looks on the surface like yet another painter of surfaces, with his rows and rows of cupcakes and hot dogs; the difference from Pop Art being that Thiebaud is passionate about the process of transmuting the look of things into a compelling interrelation of colors and forms.

Awkwardly for the cultural pigeonholer, this obsolete tradition persists...

INNER CIRCLE

Claes Oldenburg (b. 1929) is a Rauschenberg-style all-purpose animateur hitting the headlines in 1960 with a loudmouth manifesto and his "Store," full of fake plaster commodities and site of many a "Happening." He expands to produce a long line of giant "soft art" sculptures of hot dogs, clothespegs etc, tackily executed and banal; the missing link between Dalí and Jeff Koons (*see page 129*).

OUTER FRINGE

Not everything over here works over there, and vice versa. The English cognoscenti just didn't get excited about the *Twentysix Gasoline Stations* (1962) of Ed Ruscha (b. 1937). Or the formica mock-furniture of Richard Artschwager (b. 1923); where's the art in that? Too dry, too matter-of-fact for hopelessly romantic limey tastes, perhaps.

1965 Judy Garland is found dead in London after taking an overdose of alcohol and drugs.

1966 Frank Sinatra has a hit with the song "Strangers in the Night."

1967 Israel gains the West Bank, Sinai peninsula, Golan Heights, and Gaza Strip during the Six Day War.

1965~1970

463 Words Consecutively Arranged
... on Minimalism

"What you see is what you see." Frank Stella's tautology, promoting his stripes-within-stripes paintings of the early 1960s as the last word in no-illusions factuality, is something of a paradox. For a start, once you've heard him, it's more like what you see is what he says. *For a second, his pictures are still* of *something; it's simply that he's made them, frame within frame within frame, pictures of themselves.*

Frank Stella, *Newbury Port* (early 1960s). Private collection.

goes from here: the next step, they decide, must be getting into 3-D.

The plywood boxes arranged on walls by *Donald Judd* (1928–94); the bricks laid on the floor by *Carl Andre* (b. 1935); the L-beams hung

S TELLA (b. 1936), with his tough-minded pose, is a young man taking Greenberg's obsession with "flatness" (*see page 84*) to its maybe illogical conclusion. (In fact he'll launch off from this, in later creations, to work up swirly-whirly rococo psychedelic extravaganzas—still talking them up with the same macho bullishness, however.) But his hardline ethos offers cues for a bunch of ideasmen thinking where art

from the roof by *Robert Morris* (b. 1931) capture the New York art crowd's imagination in a 1966 exhibition. Or "tease" it, maybe that's a better word.

1968 A 328-foot tall figure is discovered carved in a hill above Tarapacá, Chile.

1969 After a police raid on the Stonewall Inn, drag queens, gay men, and lesbians riot in New York.

1970 The astronauts of *Apollo 13* survive an explosion on board by switching to their lunar landing module

INNER CIRCLE
Minimalism's 2-D ally: Agnes Martin (b. 1912), with her meditatively empty drawings of grids. Later painters of less is more: Robert Ryman (b. 1930), exploring the mileage you can make out of white-on-white; Sean Scully (b. 1945), lyrical devotee of the colored stripe; and maybe Brice Marden, though his monochromes hanker after Rothko-style explications— "equivalents for your body experience," etc.

There's nothing inside those boxes; those are just ordinary bricks; you either like this stuff or you don't, period, "because there is no more in it than what you have already seen" as Stella's wife, Barbara Rose, a critical ally, explains. You can't beat a good challenge to the art crowd's intelligence. I'm crazy about the *intervals* between those boxes! Look at the way those bricks are *sitting* on the floor, the sheer physical weight of them!

OUTER FRINGE
Minimalism is the flipside to the psychedelic age's visual excess. (Stella sessions on both tracks.) Scrabbling to create a world fit for acidheads, hippies draw on the vibrantly colored post-Klee reveries of Fritz Hundertwasser (b. 1928), also taking up the developing light and kinetic technologies from the Op movement (see page 92).

And why not look, eh, cynical reader? Why not open our eyes to as many different qualities of experience as art makes available to us? But note that this, like many new factors in 1960s art (Op, performance, etc.), is an explicitly interactive experience. It works by putting you, the viewer, on the spot; forces your sensibilities into action by getting you into a gallery. For this reason, critics find fault with it. They want an art with an inside, with internal relations to contemplate.

Judd makes his terse art out of not giving in to that demand; so does his friend *Dan FLAVIN* (1933–96), who places neon tubes here and there with an equal absence of hidden agendas. Andre, though, is a dippy old poet, empathizing with those bricks in their supine trod-on-ness, dreaming up metaphors made out of the commonplace. While Morris's engagement with "Minimalism" (they all hated that label) is one phase in a lifelong effort to command the cutting edge—whether that means formal hardness, or formless softness (*see page* 106), or heading for the great outdoors. This way lies "land art" (*see page* 108). And Sol LeWitt, another Mini-man, will shift from showing structures to making his art the ideas behind them. That way, "Conceptualism": turn to page 102.

Donald Judd *Untitled* (1990). New York, Pace Wildenstein Gallery.

1965 Race riots in Los Angeles are sparked when police arrest a black man for drunk driving. Over the next week, 28 are killed, 676 injured, and the damage is estimated at over $175 million.

1969 Gilbert and George paint themselves in metallic colors and become *The Singing Sculpture*, acting robotically to a repeated record of Flanagan and Allen's "Underneath the Arches."

1971 *Jesus Christ Superstar* opens in New York with music by Andrew Lloyd Webber and lyrics by Tim Rice.

1965~1980

Persistent Problems
Golub, Bay Area Figuration

The island of Manhattan should not be confused with the continent of North America. It may be the end of art as we know it in 1970s SoHo (see page 107), but out beyond the Hudson, some people still retain a quaint fascination with the possibilities of painting.

Leon Golub, *Interrogation III*, (1981). Private collection.

In fact this uncool anger of his will soon (*see page* 120) look like the most clued-up artistic impulse of its era.

In Philadelphia, *Sidney Goodman* (b. 1936) delivers a comparable menace in his paintings of the contemporary urbanized landscape, making the jolting disruptions of road schemes and high-rise and waste-disposal units suggest terrible lesions in the communal unconscious. The continuing excitements of realism—as opposed to the secondary "realities" of photorealism (*see page* 100)—are also demonstrated by *Rackstraw Downes* (b. 1939). His close-scrutinized panoramic American landscapes convey a first-hand, first-rate fascination with the spaces and objects he encounters as he looks around him.

While in San Francisco, there's a whole gang still finding stimulus in all those

In Chicago, *Leon Golub* (b. 1922; husband of Spero, *see page* 110) naively holds to that old hope of Goya's that it could tell the truth about power. His ID parade portraits of the world's current bosses—Pinochet, Castro, et al.— are complemented by scenes of their mercenaries in action. He rubs and scores their images into the canvas with a suitable mercilessness, designing his dramas with a spaciousness that has clearly been learned from the great American abstractionists.

1978 Cindy Sherman produces *Untitled Film Stills*, a collection of photographs featuring a female figure (the artist) in a disturbing range of scenarios.

1980 The World Health Organization announces the eradication of smallpox.

painters-workshop problems that arise when you try to get Matisse talking to the Abstract Expressionists on a single canvas. "Bay Area Figuration" as they call it has been developing with its own momentum since the 1950s, when *David* PARK (1911–60) taught *Nathan* OLIVEIRA (b. 1928) and

INNER CIRCLE

Back in New York, the one painter everyone respects in the 1970s—perhaps because she's too individual to pose a threat—is the elderly Alice Neel (1900–84). Peerlessly direct in her expressionistic interest in people, she portrays Warhol as a wounded figure after the 1968 attempt on his life, and an unforgettable self-portrait speaks up for the dignity of the hitherto disregarded, elderly naked female body.

OUTER FRINGE

Realism... ambiguous term. Does it mean classically correct still life, as in the jugscapes of America's William Bailey (b. 1930)? Does it mean scrupulously controlled landscape, as in the airy views of Yvonne Jacquette (b. 1934) or Britain's John Wonnacott? Or what about a sensuous love of the fall of light on the everyday world from John Koch (1909–78) or Spain's Antonio Lopez-Garcia (b. 1936)?

Richard DIEBENKORN (1922–93). There's a look to it: figures, sometimes nude, in semiabstracted spaces of brushwork, sunshiny blues and oranges. The style seems to smile, but with a decision-furrowed brow.

It's those decisions that come to the fore in Diebenkorn's paintings of the 1970s, the best known of the school. His *Ocean Park* series presents a whole archaeology of worries about pictorial space and color values, each new translucent scumbling and iffy little division of the canvas maintaining exquisitely fine taste. For some, prettily pernickety; for others, the masterpieces of their time.

Richard Diebenkorn, *Ocean Park no. 10* (1968). Private collection. He lived in Berkeley.

1966 The private art collection of Claude Monet is discovered.

1967 Albania declares itself the world's first atheist state.

1968 Mia Farrow is impregnated by the Devil in the movie *Rosemary's Baby*.

1966~1975

Under Glass

Photorealism

Why paint reality when cameras can represent more quickly? Is that why 20th-century painters went off and did other things instead? Not quite so simple: remember, photography had been around for seventy years before Kandinsky got abstract in 1910.

Chuck Close, *John* (1971–72). New York, Pace Wildenstein Gallery.

Mesmerizingly strange when seen in its full 8-foot-tall height.

Smile for the canvas please, and hold it!

But the relations of paint and silver bromide were always uneasy. Photographers trying to look arty, and painters sneaking poses from snaps. Sickert in the 1930s was exceptional in explicitly painting from news shots. It took till the Pop era for others to catch up, and declare that painting stood second down the line from reality. Why then? Possibly because TV's takeover as the dominant mode of social existence had only recently become apparent, and you needed some emblem of that new, flattened-out apprehension of the world. The photographic look suddenly seemed *symbolic* of something.

So one might argue for the 1960s photo-paintings of Gerhard Richter (of whom, more on page 128) or *Malcolm MORLEY*

(b. 1931), with their dreamily nullified, distanced surfaces. Alternatively, looking at the gleam on the shop-windows of *Richard ESTES* (b. 1936), you could call this "photorealist" vogue of the later 1960s a demonstration of how paint can trump the camera's bid. Look what we can do with projectors and our new acrylics and airbrushes! Uncanny, eh? The trouble with this appeal to novelty value is that it doesn't cut it with curators. You've got to talk to them about "structure" and "process"— and preferably in the convincing language of *Chuck CLOSE* (b. 1940), with his awesomely rigorous analyses of faces. Or else in the ultraformalized, repellently antierotic female nudes in the canvases of *Philip PEARLSTEIN* (b. 1924).

1969 400,000 people attend a music festival at Woodstock, despite torrential rain.

1970 Four students are shot dead by National Guardsmen after demonstrations at Kent State University, Ohio.

1975 Marlon Brando gives around 2,000 acres of land in California to Native Americans.

Uncanny simulation of surface detail is something the polyester lifecasts of *Duane HANSON* (1925–96) share with these painters, but there's a contrast. Excepting Close, most photorealism is emotionally neutral or archly sentimental; whereas the lifesize losers Hanson leaves around the gallery are not only people you might reach out to touch, but also people you feel for. He shares with *George SEGAL* (1924–2000), who detaches his lifecasts from the everyday by presenting them in white plaster, an interest in the dignity of the human figure that's otherwise marginalized in 1960s America.

Unless you count the angry tableaus of *Ed KIENHOLZ* (1927–94), with their vivid metaphors for human indignity. An Angeleno utterly at odds with most New York notions of art, Kienholz glues lifesize figures into grotesque,

INNER CIRCLE

After Norman Rockwell, the one American painter with universal recognition is Andrew Wyeth (b. 1917); by the same token, universally reviled among modernists. With a fame sealed by *Christina's World* (1948)— the crippled girl in the grass—he evokes rural Maine in tight-assed tempera, a bleak chic irresistible to the national soul.

squalid stagesets. His satirical dramas are partly aimed at American militarism—as in *The Portable War Memorial* (1968)—partly at human hopes in general. Set against photorealism's glittering, ice-cool deli counter, they seethe like scalding gumbos.

OUTER FRINGE

Latecomers to the lookalike mode, but masters of it: the Boyle family, Mark (b. 1934) and Joan (b. 1936) and the kids, who come out of the "Happenings" scene (*see page* 87) into the project, from 1969, of presenting you with flat sections of the world just as it is, selected by throwing darts at the map. 4-foot squares of rough grass, tarmac, paving tiles, all simulated impeccably in colored fiberglass: uncannily magical.

Duane Hanson, *Supermarket Shopper* (1970). Aachen, Ludwig Collection.

1967 Owen Maclaren, an ex-aero-engineer, devises the folding baby buggy, inspired by the way aircraft wheels are folded.

1968 Stuart Brisley stages his first performance in Hyde Park, entitled *Ritual Murder Nodnol* (London backwards).

1969 Followers of Charles Manson murder 8-months pregnant Sharon Tate and write the word "pig" on a wall in her blood.

1967~1974

Keeping Your Hands Clean
Conceptual art

It's hard work, being a conceptual artist. There's the hassle of persuading some outfit to give space to your concept, without letting your concept get institutionally swallowed. For just that reason, there's usually no money in it, but even suppose there is, doesn't your concept for just that reason end up compromised? Above all, there's the fine line you have to walk between making a gesture so slight that it has no kind of impact at all, and beavering away at something that merely ends up looking like a piece of honest hard work.

INNER CIRCLE
Hans Haacke (b. 1936), head full of processes and systems, has an unerring eye for weak spots in the institutions that are smothering the avant-garde. New York's Guggenheim Museum asks him to show in 1971: he submits shots of the city's slums, plus factual documentation on their ownership. The Guggenheim, seeing the Catholic Church accused of complicity in ripping off the poor, cancels: Haacke proceeds to do an equivalent exposé on the Guggenheim.

OUTER FRINGE
Conceptual artists suffer for you! Your life may be dull, but at least you are not On Kawara (b. 1933), who has been painting the date in exactly the same format every day since 1966, nor Roman Opalka, who has been painting numbers ascending from one toward infinity since 1965, each year getting just a little closer to white on white.

Not to mention the annoyance of cheapskates in instant cultural guides *misrepresenting your position entirely.* How can they possibly relate Robert Barry's 1969 "artwork" consisting of a radio carrier wave emission to Keith Arnatt's 1970 line "Is it possible for me to do *nothing* as my contribution to this exhibition?" under the label "intellectual camp"? Well, that's what it looks like from here: the self-consciously foolish posturings of extremely clever people in the end-of-the-1960s heyday of such stances. (John Lennon and Yoko Ono in bed for a week "for world peace," etc.)

But yes, maybe there's a range of motivations involved. Barry is among a New York gang including the lofty platonist *Sol LEWITT* (b. 1928), who used (*see page* 97) to make things, but after 1967 just has ideas (and gets others to do the handiwork); and the Wittgenstein

1971 London Bridge is moved to Lake Havasu City in Arizona.

1972 Clifford Irving claims to have produced the official memoirs of Howard Hughes, but Hughes phones journalists to deny he's ever met Irving.

1974 Miss World Helen Morgan is forced to resign after it is revealed that she has an illegitimate child.

reader *Joseph KOSUTH* (b. 1945), who wants to expose the way all artworks function as part of a "language-game." But their philosophizing has a social edge to it: they don't want to be sucked up in the system, and having "nothing" to sell helps keep them free of artbiz. Elsewhere, conceptualists get charmingly ludicrous— Belgium's *Marcel BROODTHAERS* (1924–76) with his parody-museums, and California's *John BALDESSARI* (b. 1931) with his one-line canvases: "EVERYTHING IS PURGED FROM THIS PAINTING BUT ART, NO IDEAS HAVE ENTERED THIS WORK." In London, where *ARNATT* (b. 1930)

THINK UP YOUR OWN

CONCEPTUAL ARTWORK

WE CAN'T AFFORD

THE REPRODUCTION

RIGHTS

"works," there's an added touch of provincial ankle-biting at the overweening influence of New York—as in the Pollock-style drip painting (*see page 73*) which turns out to be a heroic portrait of Lenin, a witticism from the conceptual combo "Art & Language."

Art *as* Language is what you're left with, when the high spirits behind this "dematerialization" of art evaporate in the early 1970s, leaving a dismal residue of typewritten sheets and Letraset slogans on gallery walls that reprove viewers foolish enough to seek visual pleasure there. At its strongest, however, Conceptualism is still capable of biting.

Mark Boyle, *A London Study: Concrete Pavement with Dead Leaves* (c.1968). London, Guildhall.

1967 The Beatles release "Sgt Pepper's Lonely Hearts Club Band" with a cover that was the first to feature printed lyrics and a gatefold sleeve.

1968 Ettore Sottsass designs an "Astroide" lamp, which is pink on one side and blue on the other.

1972 A mad Australian called Laszlo Tuth damages Michelangelo's *Pietà* with a hammer.

1967~1977

Beuys and...
Fluxus, Aktionists

One of modern art's great inventions is cave art. The bison extravaganzas of early Stone-Age Europe, rediscovered from the late 19th century onward, became material for a whole new myth about the origins of art. What on earth were those hunter-gatherers doing down those holes? Communing with nature via the spirit world; healing the rifts made by consciousness. Art's roots lie in shamanism.

Art and Capital, a photo of Joseph Beuys worked over in oils by the artist (1979). Note the prophetic message for the future (*see pages* 130 and 140).

Now, after this little agricultural-industrial interlude of 8,000 years, humanity can head back to holism. Think elks! Think bats! Think felt, think hats, think Beuys! (That's *Joseph* BEUYS, 1921–86, sometime sculptor and art school

INNER CIRCLE
Very 1960s: Niki de Saint-Phalle paints jaunty Day-Glo stripes all over *Hon* (1966), her giant recumbent female. Walk right up, in between her legs: there's a cinema inside! Also, there are mirrors that Michelangelo Pistoletto (b. 1933) has half painted with figures in scale with the viewer; hey, guess what, you're really in the picture!

teacher.) Out of Düsseldorf he comes, the Rhineland's great shaman, with his tales of tumbling from the sky (out of a fighter plane, smashing his head, hence the hat, to be rescued by Russians who wrapped him in felt; all great mythic stuff). When he touches down on American soil, an ambulance hurtles him off to commune with a coyote for three days and nights, shrouded in a blanket (in a New York gallery, surrounded by cameras, natch); he is off to meet the Dalai Lama, his mission

1973 Star of martial arts movies such as *Enter the Dragon*, Bruce Lee dies suddenly at the age of 32.

1975 There is a spate of avalanches in the Alps, caused by freak weather conditions, and 40 people are killed.

1976 The cost of maintaining Rudolf Hess as the sole occupant of Spandau Prison is estimated at $420,000 per annum. He is kept imprisoned there for 20 years until his death in 1987.

is TOTAL LIBERATION because EVERY HUMAN BEING IS AN ARTIST even if no other human being can quite come near his own charisma.

Beuys had learned his gesture-making style in "Fluxus," a shambolic international bag in which Dada-style outrages jumbled through the 1960s with Zen-style mysticism and Marshall McLuhan-style nods to mass media. Jetting from one "Aktion" to another, *Nam June Paik* (b. 1932; *see also page* 114) made subversively absurd assemblages of TVs; his companion Charlotte Moorman stripteased with cellos; *Yoko Ono* (b. 1933) and George Brecht put out kooky little mind-teasing koans; while secretary-general *George Maciunas* (1931–78) kept order, or at least the minutes. College auditoriums got high on the glorious, anarchic fusions that seemed on offer; Beuys, always brilliant at seizing the mood of such occasions, got high on his own destiny. His upgrade to transatlantic guru status came after the college at Düsseldorf threw him out for demanding unlimited access to art courses for all comers. With his pronouncements about the transformation of postindustrial

OUTER FRINGE

Sorry: the celebrated rumor that Rudolf Schwarzkogler (1940–69) sliced off his prick on stage, as one of the ultimate artworks perpetrated by Hermann Nitsch's (b. 1938) "Vienna Aktionists," turns out to be boringly untrue. Nonetheless, the blood-and-chocolate performances of this group, with their aspirations to communal catharsis, still set the highwater-mark for avant-garde extremism.

humanity, he became a guiding light to the emergent Green movement.

Oh, yes, what did he actually make? Assemblages of felt and fat arrays of stone blocks with holes in them; blackboards scrawled with mystic formulae, sprayed with fixative; quirky little watercolors. The trail left by his passage through the world is confused, haunted, and uncomfortable. It shares a sorry-if-you-didn't-get-it aesthetic with what's happening in late 1960s Italy. "Arte Povera" is the label slapped on the cracked metal-and-slate igloos of *Mario Merz* (b. 1925), the charred doorways of *Jannis Kounellis* (b. 1936), the arrangements of rags and mirrors of *Michelangelo Pistoletto* (b. 1933).

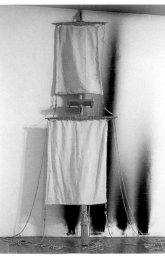

Jannis Kounellis, *Untitled* (1979). More charring than charming going on here.

1969 Pop artist Allen Jones creates a fetish table of a woman in fetish leathers, on all fours, supporting a glass table-top. Feminists hated it!

1970 Palestinian terrorists blow up three Boeing 707s in the middle of the Jordanian desert.

1971 Gene Hackman plays detective Popeye Doyle in *The French Connection.*

1968~1973

Legends of the Fall
Postminimalism, Guston

1973: the king is dead, and there's no successor. Aged 92, Picasso has drawn his last, haunted self-portrait and gone. Though he'd long withdrawn into a private old man's world of half-lyrical, half-furious erotic nostalgia, the moment of his passing marks the death of the idea he epitomized, modernism.

Modernism's story—one largely told by Greenberg (*see page* 90)—of painting and sculpture progressing movement by movement from Paris to New York—has sputtered to a stop with Minimalism and Conceptualism (*see page* 102). From here, art gets diffused into a myriad different media. Or evaporates. Do the ideas of "art" or "painting" or "sculpture" still make sense? We're not sure. This is the late-20th-century condition: yes, it's that dreaded word...

"Postmodernism" first gets talked about in art circles by *Robert Smithson* (1938–73). A young critic deriding the form-obsessed orthodoxies of 1960s New York, he's driven toward the idea of entropy. Systems running down, the crumbling away of structure and order. It's an idea

OUTER FRINGE

Processed by chainsaw: Gordon Matta-Clark (d. 1978) is a major original of the "Postminimalist" scene (as some call this era). Most famously, he zips a one-inch slice through the entire structure of a vacant house, admitting sunlight, dazzling visitors with the new spatial possibilities opened up, and breaking all planning laws (*The Humphrey Street Splitting*, 1974).

Gordon Matta-Clark, *Splitting* (1977). His "anarchitecture" is best suited to sunny weather.

1972 Two black US athletes, Vincent Matthews and Wayne Collet, are sent home from the Munich Oympics for yawning during the national anthem.

1972 Little Jimmy Osmond sings "I'm your Long-haired Lover from Liverpool."

1973 The mountain bike is created in California for riding up the slopes of canyons.

that will drive him out of the city, to create a new "land art" out of the great American wastes (*see page* 108). But this notion of processes running their course also lures ex-Minimalist Robert Morris (*late of page* 97) in 1968. Let's tip a truckload of asphalt down a slope. Let's allow it to fall where it will. Let's call this an art of "anti-form."

INNER CIRCLE

Bruce Nauman (b. 1941), using performance, video and neon signs spelling out halfwit gags to stick his presence in your face, sets a style for forcing the viewer into a confrontation that will be imitated for decades. A style in tackiness, too: whatever the medium, his making remains perfunctory and joyless. If you dig him, the irritation's the point; if you don't, the point is that he's irritating.

Art's a matter of processes and interactions for two others from this generation: Bruce Nauman (*see* Inner Circle box) and *Richard SERRA* (b. 1939), who works up great muscular interventions in the environment —vast hefty slabs of rusting steel, often leaning on one another in such a way you're terrified they'll fall and flatten you. And that's part of their business: to alert you to the fact of your own body and its relation to its environment. (Which is a challenge that'll get him into trouble: *see page* 124.)

Interactive "process art" is one sort of turn away from formalism; another is the late work of *Philip GUSTON* (1913–80). Highly reputed as an "Abstract Impressionist," Guston finds in the late 1960s that sheer painterliness leaves him cold. He dares break Greenberg's crucial taboo: he sticks a big ugly representational boot on his canvas. Then a cigar, a car, and a Ku Klux Klan cipher for himself, and soon he's established a whole new vocabulary. One that comes across as outrageously crude, but one in which he can speak from the heart. Clownishly sad and wise, the best "bad" paintings ever, the stuff Guston exhibits from 1969 is seen as marking the downfall of an artistic ideal.

Bruce Nauman, *Seven Virtues and Seven Vices* (1983). London, Saatchi Collection.

1968~1998

The Great Beyond
Land art

Greatest artwork of the 20th century? Easy. Korczak Ziolkowski and family with their South Dakota mountain carved into the likeness of Crazy Horse: 52 years in the making and still far from finished, over eight million tons of rock dynamited away. Oh, sorry, you were talking about quality…

INNER CIRCLE

Britain's finest contemporary exponent of the land art tradition, Chris Drury (b. 1948) creates structures—cairns and stone shelters, elaborate weavings of willow-boughs, mazes of ditches—that focus and distill the landscape in which they're sited, reflecting to the viewer a new sense of the total environment. He shares Long and Goldsworthy's mission statement: to produce "a more thoughtful view of land… to be a custodian of nature, not an exploiter of it."

W ell, some would go for its converse in terms of environmental impact: *Richard Long* (b. 1945), *A Line Made by Walking* (1967). Nothing but the trace of footsteps in the grass; the humblest of marks with the deepest of implications. He's walked in the earth's wild places and returned bearing stones; look at them and think about the ecosphere. Look at the

Rocks and leaves and plants and things.

evanescent loveliness of the flowerchains and iceworks conjured up by his follower *Andy Goldsworthy* (b. 1956). Let your heart go out to this natural world we so abuse.

Very characteristic of the nation of landscape water-colorists, these sensitive Englishmen. The Americans who catch the same freedom-in-the-wilds hippie zeitgeist get muscular like Ziolkowski: they go for plant, not plants. Leading off with the bulldozers, there is Robert Smithson, whom we last saw heading out of New York worrying about entropy (*see page* 106). Before his untimely death he has turned environmentalist and constructed the linchpin of "land art" with his *Spiral Jetty* (1970), a grand mythic gesture pushed out into Utah's Salt Lake, in whose waters, as he foresaw, it now lies drowned.

OUTER FRINGE

Feminist land art: the Cuban-born Ana Mendieta (1948–85) works the soil of selected sites with her body so that out of it emerge images of the mother-goddess, or fires from vulvalike volcano craters. Also extraordinary: the water-photos of Susan Derges, who has conjured photo-sensitive sheets into seemingly transmitting the flows of English rivers.

1986 There is an explosion at the Chernobyl power station causing the world's worst nuclear accident.

1993 The British-designed Dyson "Dual Cyclone" vacuum cleaner eliminates the dustbag and uses G-force technology to collect dirt in its cylindrical body.

1996 During a dinner at the Japanese ambassador's residence in Lima, terrorists storm the building and keep 74 guests hostage for the next few months.

WISH YOU WERE HERE

Michael Heizer (b. 1944) is another major mover of earth from a to b with his gigantic *Double Negative* trench in Nevada, an idea from the "process art" school explored in test-site conditions. More stirring yet, the *Lightning Field* (1977) of *Walter De Maria* (b. 1935) consists of four hundred upraised steel poles inviting the storms of New Mexico to come and strike them.

Mighty works, these and their like: human mediations between heaven and earth resembling the Stone Age megaliths... or so we like to suppose, walking around galleries or sitting in our chairs looking at the photos. For this is the limitation on land (or "earth") art, whether Longwise or Smithsonesque: that in effect, for the viewer, it's simply a bunch of pretty snapshots causing the city-wearied mind to yearn and wander. Somewhere out there, real artists are enacting wonderful gestures in wonderful places; but what we're actually presented with here and now is a cue for sentimentality.

Two great originals of the grand scale bypass this objection by making works entirely dependent on your personal participation. The American artists *Christo* (b. 1935) and *Jeanne-Claude* (b. 1935), coordinating thousands of workers into short-term works of art, reveal the shape of the world using rural and urban sites. While the American *James Turrell* (b. 1943) makes viewers who enter his magically constructed spaces look at the very light that enables them to look. His art is planned to reach its climax with the still-in-progress hollowing out of an Arizonan volcano cone into a great sky-viewing chamber: mountain-masterwork to rival Ziolkowski and his Crazy Horse carving.

Christo and Jeanne-Claude,
*Surrounded Islands, Biscayne Bay,
Greater Miami, FA* (1980–83).

1970 Alan Hovhaness's *And God Created Great Whales* is a musical score for an orchestra with a solo by a humpback whale.

1975 Margaret Thatcher becomes the first female leader of the Conservative Party in Britain.

1977 Renzo Piano and Richard Rogers design the Pompidou Centre in Paris with all the plumbing on the outside and painted in bright colors.

1970~1985

...GRRRLs

Feminism

It's all been a big boys' get-together, hasn't it? Have you added up the gender ratio in the preceding pages? Believe me, it's pathetic. Picasso, Pollock, the whole modernist ethos—it's all a case of who can piss highest against the wall... Radicalism moves off the streets around about 1970, and into the home. Consciousness-raising starts here.

Juggling career and motherhood.

D rop your brushes and hold the baby; I'm going out to my "group." We're going to ask if the Western artistic tradition has any continuing viability, composed as it is of male gazes objectifying female subjectivity; we're going to run through our alternative agenda. (a) "Her-story" paintings and performances (b) sister-style craft traditions, female-vision forms (c) deconstructing "visuality" altogether.

Notes on the proceedings: (a) Vindicate womanhood! As for instance in the angry mythologies of *Nancy Spero* (b. 1926); or the extreme performances of *Carolee Schneemann* (b. 1939), who writhing naked

Judy Chicago, *The Dinner Party* (1973–9). Her pubis-triangular table serves 39 feminist heroines on plates decorated with what the Italians so nicely call a "butterfly."

INNER CIRCLE

Formative feminist moment: the *Womanhouse* event of 1972, organized by Shapiro, Chicago, and a sisterly team. Hollywood mansion converted with the aim of celebrating domesticity along with self-awareness: breast-molds all over the walls and ceilings. Men: keep out! (A directive that leads to interminable dissensions in the decade to come.)

1979 "In space no one can hear you scream." Sigourney Weaver stars in *Alien*.

1982 Vatican banker Roberto Calvi is found hanging from Blackfriars Bridge in London.

1985 English soccer clubs are banned from playing in Europe because of the behavior of British hooligans.

with snakes and reading from a scroll pulled from her vagina, sets an early (1960s) benchmark in histrionic challenge, one taken up in many 1970s rape-crisis pieces.

(b) Or maybe feminist art should develop organically. Maybe we should take our cue from our grandmothers' quilting, and either stitch away likewise, or paint pattern-wise in pink and pleasurable symmetries like *Miriam SCHAPIRO* (b. 1923). *Judy CHICAGO* (b. 1939) corrals 400 sisters into collaborating on a definitive riposte to standard phallic-looking upright statuary with her *The Dinner Party*. A more intuitive challenge to

> ### OUTER FRINGE
> Feminism in the 1990s... hmmm. Jury out. Is Kiki Smith feminist? (*See page* 132) Is Tracey Emin? (*See page* 131.) The one instance everyone cites is the Guerrilla Girls of New York, protesting female underrepresentation in the museums with ape masks over their heads. Hardly epoch-making. But note that from here on the gender ratio, in this book at least, does begin to improve.

received male sculptural forms, however, had come from a sculptor who wouldn't describe herself as feminist. *Eva HESSE* (1936–70), a German working in the "process art" circles of 1960s New York (*see page* 107), looped lint, wove string, and warped latex into outrageously vulnerable anti-structures. Fame came after her early death; for another feminist heroine, the ex-Surrealist *Louise BOURGEOIS* (b. 1911), it came only in old age. With her macabre mutilated bodies and scary giant spiders, she has now become everyone's favorite naughty granny, an institution in her own right.

(c) Here come *Mary KELLY* (b. 1941) with her documentation of her baby's "socialization," exhibiting his dirty diapers (1976), and the equally theory-minded *Susan HILLER* (b. 1940); then, in the early 1980s, the neon messages of *Jenny HOLZER* (b. 1950) and the posters of *Barbara KRUGER* (b. 1945). Here, in a zone of Postmodern education, between the Beuys with their instant universal artistry (*see page* 104) and the GRRRLs with their distrust of "the Western tradition," we exit the domain of craftsman-like skill altogether.

1971 British showjumper Harvey Smith is disqualified from the Derby after officials misinterpret his two-fingered V for Victory sign.

1973 Motorists across Britain have to line up for gasoline as a result of the Arab oil embargo.

1974 English gambler Lord Lucan disappears after an attack on his wife and the murder of their nanny.

1970s
Modernism Privatized
Kitaj, Caulfield, Hodgkin

R.B. Kitaj, *If Not, If Not* (1975–76). Edinburgh, Scottish National Gallery of Modern Art.

If you want a great, deep, passionate meditation on modernism, read T. J. Clark's Farewell to an Idea. *To reduce a masterwork to a soundbite (since that's our business), Clark sees artistic and political radicalism as two complementary expressions of the grief involved in grinding the sacred world of monarchism down to today's set of commodities—that being what the last two centuries have been all about.*

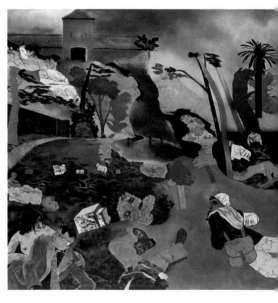

INNER CIRCLE

Mastery through math: Euan Uglow (1932–2000) picks up the observational obsessions of William Coldstream (*see page 69*) and, with an air of arduous authority, sets them up as geometric conundrums in the studio: how the figure's curves relate to the golden section, etc. Strangely, this prissy proceduralism in no way stops his paintings vibrantly conveying the pleasures of gazing at naked women.

OK, so if the political left gradually loses definition in the Postmodernist, post-1968 era, what happens to the forward march of art? We could call it "the privatization of modernism"; and we could observe it in action in 1976 England. *R.B. KITAJ* (b. 1932), American expat painter of leftist hero *Walter Benjamin in Paris* and of the Auschwitz-allusive *If Not, If Not*, who proposes the existence of a "School of London." It's to consist of Bacon, Andrews, and Freud (*see page 80–1*), Frank

1976 Vivienne Westwood's Anarchy T-shirts show Queen Elizabeth with safety pins through her nose.

1978 In England, a maze is opened at Longleat in Wiltshire that has almost 2 miles of paths lined by 16,180 yew trees.

1979 Village People sing "YMCA," and a new dance craze spells out the letters.

AUERBACH (b. 1931) and *Leon KOSSOFF* (b. 1926), his friend Hockney (*see page* 89), himself, and a few others; but he can't quite think how to unite these people under a common agenda. The first two and Hockney are patent oddballs; the next two (*see* Outer Fringe box) are magnificent in their grungy, defiant way, but hardly acts to follow. (Or maybe they are? Dennis Creffield and endless English drawing classes make vigorous attempts to do so.)

And Kitaj himself? Well, those portentous titles turn out to be more than slightly wry. They're attached to whimsically torn-and-scattered figure compositions, looking like exquisite pastel drawings from collages. If they're about anything, it's the impossibility of being coherently radical these days, politically or artistically. And what of his other "School" candidates? Here's *Howard HODGKIN* (b. 1932), with his tellingly entitled *A Small Thing But My Own*. Thick black-painted frame enclosing a few succulent rainbow-bright brushloads. Abstract? No, no, insists Hodgkin, each long-meditated work of mine represents a

> **OUTER FRINGE**
> Both Frank Auerbach and Leon Kossoff develop on David Bomberg's struggle (*see page 35*) with appearances in paint. How can you make the mental act of apprehending a figure or a scene into a totally realized physical performance? Answer: by pushing and hacking your way through an oily goo that may sometimes mount up inches thick. Auerbach's redder, Kossoff grayer.

personal memory. These little parcels of intense private pleasure will be seen as the most treasurable artistic commodities of the Thatcher era. Hodgkin remembers nice boys, largely. *Patrick CAULFIELD* (b. 1936) remembers nice bars. Also emergent from the Pop era he stays hard-edge when Hodgkin goes brushy, ever refining his stylish emblems of doorways that might lead to a delicious aperitif. The pictorial *means* of "classic" modernism—Picasso, Matisse, his own model Juan Gris (*see page* 25)—are being taken by Caulfield and his fellows to a newly sophisticated pitch. The *meanings* have become the property of the "me" generation.

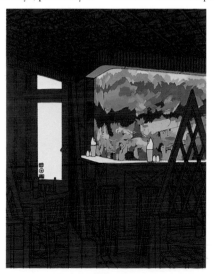

Patrick Caulfield, *Paradise Bar* (1974). Richmond, Virginia Museum of Fine Arts.

1970 IBM introduce the 8-inch floppy disk to replace magnetic tape and punched cards for saving back-up computer files.

1976 A heatwave brings drought across Europe and several countries ration water.

1981 Neville Brody becomes art director of *The Face* and changes the face of typography.

1970~1990

Keep It Running
Video and body art

Ars longa, vita brevis. The video installations in modern art museums give a whole new meaning to that old Latin tag. You can eye up the average picture or sculpture in a jiffy, but ain't life just too short to hang around waiting . . . for . . . the . . . art . . . istic . . . con . . . cept . . . to . . . slow . . . ly . . . e . . . merge . . .

But look at it the other way. Art's small, but life's huge. There's the little world of aesthetic objects, and the vast world beyond of people's non-aesthetic lives. When the ex-Fluxus avant-garde (*see pages* 104–5) takes to video at the end of the 1960s, it looks like a brilliant way to bridge that gap. Nam June Paik, the cheerful Korean prankster and screwer-up of TV sets, leads the way, experimenting with a Sony "portapak" the day the product's released. You can trawl through anyone's and everyone's lives in a way that the mass media (as opposed to this "guerrilla TV") would never dream of. The rougher the reality, the closer to edit-free "real time"; the nearer you get to a total fusion of representation and fact. But there's another side to the end-of-1960s avant-garde, one hung up on form— or rather, on trying to forget form and think about process (*see page* 106); it quickly latches onto video's capacity for exploring systems of perception or action. Frank Gillette and Ira Schneider, for instance, set up a circle of monitors showing the viewers themselves right now; two seconds ago; four; six... (*Wipe City*, 1969.) Or else Bruce Nauman's balls are seen slowly bouncing up and down, weights responding to gravity.

INNER CIRCLE

Video's such a *critical tool*. For video feminist critique, see Joan Jonas (b. 1936) and Dara Birnbaum (b. 1946). For video urban planning critique, consult Dan Graham (b. 1942). Video systematic image critique: Woody and Steina Vasulka (b. 1937, 1940). Video metanarrative linguistic critique: Gary Hill (b. 1951).

OUTER FRINGE

London's pet performance men: Gilbert & George (b. 1943, 1942), inseparable suit-and-tie chums, the comedy duo of the city's vapid 1970s "avant-garde" with their nonstop tabletop rendition of "Underneath the Arches." Later tailorings for the emperors of art-collecting consist of grandiose scatological photomontages, their upfront banality resembling that of Fernand Léger (*see page* 42).

1984 Svetlana Savitskaya becomes the first woman to perform a spacewalk.

1988 An Aboriginal man moons Queen Elizabeth and the Duke of Edinburgh when they visit Canberra.

1990 Viewers tune in to "Twin Peaks" to try and find out who killed Laura Palmer.

Bill Viola, *Nantes Triptych* (1992). London, Tate Gallery. Birth, death, and skinny-dipping: a 1990s version of the eternal verities.

For this is the "just do it!" generation, when heavy intellectual agendas are getting remorselessly and absurdly translated into heavy-duty physical performances. In gallery performances, fellow theorist *Vito Acconci* (b. 1940) lies jerking off beneath the floor that visitors walk on, his fantasies transmitted for their hearing (*Seedbed*, he calls it); *Gina Pane* (1936–92) runs razors into her belly; *Chris Burden* (b. 1964) has himself crucified across the roof of a Volkswagen, or has a friend shoot him in the arm. There are rationales available for most of these "body art" pieces should you be interested. But do you really need to hear them? Do you need to see them?

The early 1970s are the heroic age for video, harsh pioneers roughing it in the no-man's-land opened up by these attitudes. Is there a geography to it, or is the only guideline to sidestep trodden routes—multichannel the action, computer-modify the image, denaturalize the scenario? Come the end of the decade, serious budgets and "production standards" move in from the contagious world of music biz, and innocence is lost. Increasingly, the monitor protects its integrity inside an attention-controlling gallery installation. Video shifts from challenge to a dreamy kind of transcendence.

Master of this new dispensation, *Bill Viola* (b. 1951), uses his mastery of the medium's strategies to create lofty, lyrical, Sufi-inspired meditations on life, death, and everything in between. (For further 1990s video, *see* page 132.)

1971 American astronauts David Scott and James Irwin go for a drive on the Moon in a "Moon Rover."

1977 A record 80,000 mourners turn up at Graceland for the funeral of Elvis Presley.

1980 Paul McCartney is arrested in Japan for possession of cannabis.

1971~1990

Authentic Indigenous Product
Aboriginal painting, "world art"

Most of the paintings in the shops today probably come from China. In Shanghai and Canton, workshops are hard at it providing the world with Modiglianis, blue-period Picassos, whatever you want: ultra-affordable, frames included. No point in getting snotty about it: an empty wall gets filled at one end of the world, an empty pocket at the other. Export has become the normal artistic condition.

The sincerest form of flattery.

What about artistic intentions, though? Aren't they supposed to be part of the package when you're buying art? Or, in the age when Jeff Koons (*see page* 129) is hustling you a $50,000 "neo-Conceptual" readymade vacuum cleaner, has that all become just a scam? Perhaps you'd prefer something beautifully hand-crafted? (Oh, Jeff'll do that too: he pays porcelain-workers in Bavaria to make you lifesize Michael Jackson models.) No simple answers in this direction: the questions just keep expanding.

In 1971, an Australian named Geoffrey Bardon brought some hardboard and cans of emulsion into a camp near Alice Springs, with the idea that the aborigines "resettled" there

might make use of them. There followed an extraordinary transfer of the world's oldest continuous art tradition (aboriginal cave and bark painting goes back 30,000 years plus) into the consumer-society format of the framed painting. From the original Papunya, the idea quickly spread to other

INNER CIRCLE
The Western world worries itself sick over dieting, but when it comes to pictorial entertainment, it remembers that fat means fun. Hence the popularity of Colombia's Fernando Botero (b. 1932), whose jaunty variations on the adventures of prize-porker provincials have been an international hit for forty years. Hence too the fondness for his witty British counterpart, Beryl Cook (b. 1926).

OUTER FRINGE
'Hey, abo, won't you do us those ethnic dots?" Not surprisingly, the 1990s generation of Native Australian artists does all it can to run rings round the ghettoizers. Switching from a folk tradition to appropriation strategy, Gordon Bennett paints Mondrian-style modern-utopia grids as mouse-cages for grinning golliwogs, in biting parodies of the Australian cultural paradigm. About time, too.

1984 All American nuclear ships are banned from New Zealand waters.

1987 Bruce Chatwin writes the much-acclaimed *Songlines*, describing aboriginal beliefs and ways of life.

1989 President Bush upsets broccoli farmers by saying he doesn't like the vegetable and they respond by sending boxes of it to the White House along with some special recipes.

Goodwin Tjapaltjarri, *Witchetty Grub and Snake Dreaming* (1989). Private collection.

tribes, each with their own trademark motifs: by taking the mapping and story-telling symbols of sacred rituals once drawn with pebbles on the sand and, as it were, prostituting them in paint-dots, you could start to recoup on the settlers who had systematically ripped you off for so long. This was to underestimate settler cunning. As the market grew, Australian national pride stirred by the attractiveness of these strange intermediary products, prices rose from thirty bucks per "dot painting" to Koons-like sums, but the money, as ever, fell into the middlemen's pockets. Oh, give that old gal enough to buy a 12-pack of Fosters lager, she'll keep turning them out: the ironies of the episode are truly evil.

THE USED WORLD

For suchlike reasons, many critics feel wrongfooted by aboriginal painting: their sophistication blinds them to the elegance of its earthy hues, the passion of its patterned designs, the sheer beauty that distinguishes the school in general. *Gloria Tamerre PETYARRE* (b. *c.*1938), *Rover THOMAS* (b. 1926), and *Clifford Possum TJALAPTJARRI* (b. 1943) with his crossover tales-of-my-people compositions, are painting as well as anyone paints in 1989.

That year an artfest in Paris, *Magiciens de la Terre*, tries to address the exchange between sacred, stable-state traditions and postmodern culture-shopping; briefly, the "third world," the *used* world, achieves high profile in the "first." A different, but maybe comparable tale could be told about *Chéri SAMBA* (b. 1956) the Zairean agit-painter; *John MUAFANGEJO* (1943–87) the Namibian woodcutter; about Balinese batik painters, Inuit soapstone carvers, countless more. A tale about new hybrids of hand, eye, and imagination; arguably the tale future histories will tell.

1977 West German terrorists murder the attorney general in charge of the Baader-Meinhof gang prosecution.

1978 Footprints are discovered in Tanzania of a human ancestor who must have lived 3.6 million years ago.

1979 Lord Mountbatten, the Queen Elizabeth's cousin, is blown up by the IRA while sailing off the Irish coast.

1977~1984

Some Guts

Neo-expressionism (1)

A clean slate, that's all postwar Germany asked for. Bauhaus business resumed with Max Bill (see page 92); Günther UECKER (b. 1930) did kinetic and "light art" when not making his nail-bristled

OUTER FRINGE
Unsung geniuses of the GDR: we don't hear much about Wolfgang Mattheuer (b. 1927) of Leipzig, but his *Cain* (1965) is one of the era's strongest images. Nor is Werner Tübke (b. 1929) an international household name, yet his cooption of Van Eyck's and Bosch's techniques to paint a panoramic commentary on German history is an extraordinary achievement awaiting a commentary.

monochromes, Rothko-like in their imageless sublimity. Contemporary-looking, dignified. Not so much as a bloodstain visible.

In 1963, the West Berlin police closed down a disgusting exhibition. Two young painters, *Georg BASELITZ* (b. 1938) and *Eugen SCHÖNEBECK* (b. 1936), had taken it on themselves to pull down Germany's pants and expose, with emetic force, the mutilated mess of guilt beneath. Schönebeck turned his back on painting

three years later; Baselitz hacked on in his hack-and-slash manner, refuelling his contrariness from 1969 onwards by painting all his figures upside down.

But it was only in 1972 that a young pupil of Beuys's (*see page* 104) brought the Third Reich back into the forefront of art world attention. *Anselm KIEFER* (b. 1945) first came to notoriety in photos showing him making the Nazi salute at various history-hallowed locations—provocative acknowledgments of complicity. What's extraordinary is the way he launched off from this to become a weirdly but charismatically graceful maker. In his earlier prints and paintings and books, challenging Germans to consider suppressed gut

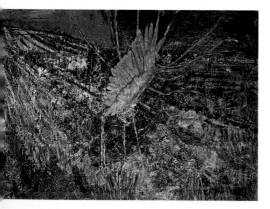

Anselm Kiefer, *Song of the Wayland* (1982). Just over 13 feet wide.

1980 Lech Walesa, an electrician employed at the Gdansk shipyard, leads 17,000 colleagues out on strike.

1981 BMW invent the first in-car computer, which monitors engine performance.

1984 The Turner Prize is inaugurated to publicize new British art.

feelings, he reaches out for the raw materials of their folk identity: the grain of forest pinewood, the grit and straw of the fields. He slaps them together recklessly in pursuit of his concept, and—abracadabra—magic happens, a rough unprecedented beauty. "Alchemy" might be his word for it: as his work has developed, taking on an increasingly cosmic scale of reference and operation (30-yard-square canvases), arcane allusions and symbolic materials like lead and gold have added to its massive looming weight.

Mimmo Paladino, *Untitled* (1988). Private collection.

avant-garde (*see page* 105) rediscovered the pleasures of conjuring up figures with paint. *Sandro CHIA* (b. 1946) did baggy-suited youths prancing through the empyrean; *Francesco CLEMENTE* (b. 1952) jetted around the globe, fancifully mixing Hindu, porn, and self-portraiture; *Enzo CUCCHI* (b. 1949) slathered the canvas with terse, ominous symbols. *Mimmo PALADINO* (b. 1948), the strongest of this more-mouth-than-trousers "transavanguardia," invoked a world of archaic ghosts and masks; something like a Mediterranean equivalent to Kiefer.

MEANWHILE, IN ITALIA

The Kiefer phenomenon over the last two decades (compounded by his no-photos, no-interviews mystique) is over-the-top ludicrous in its pretensions, but it's also genuinely awesome: it has delivered some of the masterpieces of the age. It rather overshadows the efforts of the other German painters who came to international prominence *c.*1980, as the art world tired of Conceptualism's nouvelle cuisine. This development interrelates with what was happening in Italy. There, four ex-sympathizers with the "Arte Povera"

INNER CIRCLE

The German condition: let's think about our split and guilty nation. Jörg Immendorff (b. 1945) thumps away at the theme in his panoramically, manically, desperately banal *Café Deutschland* series (from 1978); his friend A. R. Penck (b. 1939) confines his commentary to pictograms, doing a kind of archaic-stroke-graffiti style that connects to that of Keith Haring (*see page* 127).

1979 Michelle Triola wins "palimony" from Lee Marvin after breaking up with him.

1980 Saddam Hussein sends his troops into Iran to set fire to the oil refinery at Abadan.

1981 Reagan says "Honey, I forgot to duck" after being shot by John Hinckley Jr.

1979~1990

Bull Markets and Bullshit
Neo-expressionism (2)

Susan Rothenburg (b. 1945), the most gifted and enigmatic painter to emerge in Reaganite America, revolves her moody brushwork around images of horses. It's hard to determine what she is emblematizing with these dim-witted leisure accessories; but their aura of grand mythic emotion connects her work to the "Neo-expressionist" vogue that swept the international art scene circa 1980, from Italy and Germany to the US.

INNER CIRCLE

The Vancouverite Jeff Wall (b. 1946), well versed in the art-historical theories of Krauss's *October* magazine, adapts them to produce photo-works that are striking for their generous-spirited humor and humane curiosity about the world. Lightbox transparencies like *A Sudden Gust of Wind* (1993) may be premised on references to Hokusai, but in their intricate multitake ingenuity and sensuous color, they can be seen as contemporary equivalents to the Salon masterpieces of the past.

Suddenly, Guston and Golub (*see pages* 90 and 98) are in from the wilderness. After Conceptualism's emotional drought, dare to paint again! Dare to tell stories! Dare to feel!

Dare to rake it in. There's more money to be made in pictures than in concepts; and these are the boom years of yuppiedom. Mary Boone, dealer superstar, is mistress of the New York situation from 1980, strategically united in marriage to her German equivalent Michael Werner.

Her protégés are headed by the grandiosely goofy *Julian Schnabel* (b. 1951), who churns out large and witless canvases dominated primarily by his

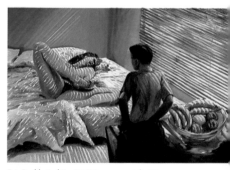

Eric Fischl, *Bad Boy* (1981). Saatchi collection. Similar to the style of Hopper except that Hopper never made anything so pornographic.

"trademark" of painting over broken crockery, and a readiness to offer the media amusing braggadoccio ("My peers are Duccio, Giotto, and Van Gogh"). The paintings of *David Salle* (b. 1952) comes with a more misogynistic tinge, through his

1982 A gene that controls growth is transferred from a rat to a mouse and the mouse doubles in size.

1983 Cabbage Patch Kids are sold with their own personal adoption certificates.

1984 A California security guard shoots dead 20 people in a McDonalds restaurant because, he says, he doesn't like Mondays.

inclusion of blown-up porn shots with more mundane images culled from the everyday. Unlike these two, *Eric FISCHL* (b. 1948), another beneficiary of Boone's boom, has a vision to paint—one of uncomfortable sexual standoffs in suburban interiors and on sullenly clouded beaches. You could call it a contemporary version of Hopper's poetic angst, except he lacks Hopper's confidence in knowing which way to paint it.

But then, what is good painting in the early 1980s? Is it "bad" painting, in fact? What justifies anything, in this profligate image-binge? Scowling suspiciously at the whole scam from across town are a group who have been carrying the theoretical conversation forward from the "process" generation (*see page* 107) but lashing it with French poststructuralism. There's little for critics like Douglas Crimp and Rosalind Krauss to approve of, beyond the 1977 "appropriation" gambits of *Sherrie LEVINE* (b. 1947), who signs other people's photos as her own—and if you think that's unoriginal, that's because originality is

Cindy Sherman, *Untitled* (1990). A pastiche Lady of Poitier complete with flaxen plait and falsie, but in the original she was having a better time.

dead, understand? Yet from this dry-as-dust arena of sub-Conceptualism, with its supertheorized knowingness about art history, there emerge two big, contrasting oeuvres of "photowork." *Cindy SHERMAN* (b. 1954) uses herself in her creations of mock movie stills and mock Old Masters, then moving on to shoot ghoulishly dismembered sex aids and vomit; the results are always bracingly disquieting, poking away at exposed gaps in self-image and body identity. (See also the *Crash Course* on Photography.) While Jeff Wall... oh, no room here; *see* Inner Circle box.

(*see page* 107)

OUTER FRINGE

As German art booms internationally, a bunch of successors to Baselitz and Kiefer who are quite as self-aggrandizingly untalented as anything New York has to offer step forward into the limelight of Werner's promotion. It's hardly appropriate to mention names... oh, they largely come from Berlin, they paint figures very slashy, very sloppy... you may still come across them, here and there.

1980 Half of all married British women have jobs outside the home.

1982 The postmodernist British architect Terry Farrell's TV AM building is decorated with nine boiled-egg finials.

1983 The comedy *Bag*, written by Bryony Lavery, opens at Grantham Leisure Centre, England to an audience of nil.

1979~1990

Polishing the Boot
Painting under Thatcher

Glasgow gets agitprop.

The contemporary canvas (we're talking London, 1979) is a vibrant space of self-sustaining colors, cleared of imagery by a century of modernism. It's probably been painted by John HOYLAND (b. 1934), or maybe Gillian AYRES (b. 1930). No, no, look harder: fissures appear, and out of them crawl snakes and bleeding figures... Ken KIFF (b. 1935) has concluded, like Guston (see page 90), that modernism lies wounded, and can only be rescued by a drastic injection of archetypal images.

His diagnosis convinces many of the younger British painters, trying to redeem their art's integrity somehow after a decade of Conceptual suspicion (*see page* 102). To aim high, you've got to re-establish your footing: reach down to figures and feelings. Risk telling autobiographical stories, like *Timothy HYMAN* (b. 1946). Risk being foolish, like the tweed-jacketed buffoons in the paintings of *Steven CAMPBELL* (b. 1953). The political disenchantment that brought Mrs Thatcher to power coincides with an idealistic mood among such painters, one

INNER CIRCLE

Neoromanticism: a lousy label, but useful to cheapo art journalists when they want to point to the haunted mind-houses of Graham Crowley (b. 1950), the mystical pastels of Tom Walker (b. 1949), the thunderous landscape expressionism of Hughie O'Donoghue (b. 1953), and possibly the heroic transcriptions of landscape by Michael Williams (b. 1936) and John Virtue (b. 1947).

OUTER FRINGE

Working in the mainline traditions of British art-school painting (Coldstream, Bomberg et al, *see pages* 69 and 37), and doing so with great distinction: Paul Gopal-Chowdhury (b. 1949) and Celia Paul (b. 1959). Further left-field, with a unique haunted poetry of exile and home: Andrzej Jackowski (b. 1947). Seriously on the outside track, with his wonderfully loopy nonsense-script palimpsests: Simon Lewty (b. 1941).

that will connect them to New York (*see page* 120) and Germany and Italy (*page* 118). What happens to it? Campbell's influence at Glasgow's School of Art in the early 1980s leads several

1985 Christian Lacroix designs the puffball skirt; women have difficulty sitting down in them.

1987 Married men rush home to check on their pet rabbits after seeing the movie *Fatal Attraction.*

1989 Ninety-four Liverpool scoccer fans are crushed to death in the Hillsborough stadium disaster.

ways, one into righteous agitprop. *Peter HOWSON* (b. 1958) paints maimed but defiant musclebound proletarians; *Ken CURRIE* (b. 1950) glorifies Glaswegian workers Mexican mural wise. Another path leads into introverted nostalgia, in the hands of *Stephen CONROY* (b. 1964) with his thick-varnished chiaroscuros of boys in bowties.

Defiance and revivalism become trademark rhetorical manners for the bustling picture business of the mid 1980s boom: this isn't quite what the idealists had in mind. *Jock McFADYEN* (b. 1950) paints you sparkily witty inner-city aggro; *Stephen McKENNA* (b. 1939). like Italy's *Carlo Maria MARIANI* (b. 1931). has a faintly perverse line in re-enactments of Old Master classicism. By the time the 1990 recession closes down half the galleries in Cork Street, there's an overwhelming feeling that painting's bid to resume center-stage among art media has been found wanting.

Yet that verdict disregards the richness of individual bodies of work. *Therese OULTON* (b. 1953) works up a lugubrious, abstracted beauty out of extrapolations from Old Master brushwork; *Alison WATT* (b. 1965) is neoclassically elegant in her creamy colors but uses them to explore the

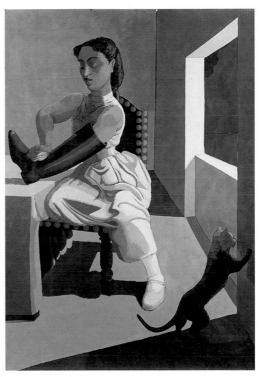

Paula Rego, *The Policeman's Daughter* (1987). London, Marlborough Fine Art.

A narrative of sexual power in a domestic setting.

ways you relate to your own body. Above all. the Portuguese-born *Paula REGO* (b. 1935) turns from abstraction to figure-painting at the turn of the 1980s. with an exultant air of feminist arrival. Her rampaging *Vivian Girls* and her toughly drawn acrylics such as *The Policeman's Daughter* are the nearest Britain gets to a public art for the Thatcher age.

1985 Robin Norwood writes a bestseller about *Women who Love Too Much*, urging them to find the child within themselves.

1988 A bookseller pays $9,000 at auction for a lock of Vice Admiral Lord Nelson's hair..

1995 After 2 decades of lobbying, Christo and Jeanne-Claude finally get permission to wrap the Reichstag in Berlin.

1981~2000
Department of the Environment
Public art/public funding

One of the reasons people practice the discipline of sculpture, with its requirements for gut-deep formal instinct and fingertip-fine-tuned taste, is that the human environment has spaces to fill. Galleries and squares and parks stand empty, waiting for some object to give them focus.

> **OUTER FRINGE**
>
> Downfall of an ideal: 1989, the year the Berlin Wall comes down, sees the final dismantling of *Tilted Arc* (1981), the vast wall of rusty sheet metal placed across New York's Rockefeller Plaza by Richard Serra (*see page 107*). His avant-garde confrontationalism has lost out, after long and bitter public controversy, to the exasperation of the public who live in the neighbourhood and, more woundingly, to the desertion of many critics.

Some sculptors fill them with finely crafted objects that carry political meaning; others address more purely formal concerns. In 1981 the youthful 21-year-old Maya Lin

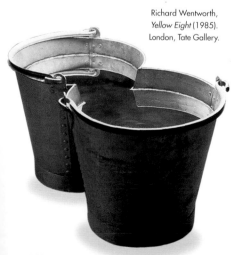

Richard Wentworth, *Yellow Eight* (1985). London, Tate Gallery.

won the largest public design contest in America, beating over 1,440 other entrants to become architect of the first American memorial to the Vietnam War. Her polished black marble gash in the earth aroused vociferous controversy between those who saw her project as a salve to cure the nation's collective grief vs. those who saw it as a salvo attacking governmental policy.

Debates between left and right in America continued, finally coming to a head in 1989 when Republican Senator Jesse Helms began his attack on the NEA. Public funding for the arts was systematically undermined until in 1994 the Republican-controlled House established the elimination of the NEA as a goal. Outrage ensued. Dennis Barrie, Director of the Cincinnati Museum of Contemporary Art, was indicted on obscenity charges, but got off after a jury found him "not guilty."

1996 Jouni Jussila wins the World Wife Carrying Championships for the fourth time. The event, held in Finland, involves carrying her over a 257-yard obstacle course.

1997 Teletubbymania hits Britain as Dipsy, Tinky-winky, Laa-Laa and Po release a Christmas single.

1998 Teenage girls have torn loyalties when Geri Halliwell (aka Ginger Spice) announces she's leaving the Spice Girls.

Richard Serra, *Tilted Arc* (1981).

Meanwhile, in England, the Lisson Gallery promoted "the new British Sculpture." Descendants of the likes of Caro (*see page* 91), they combined an abstract formalism with a conceptual tongue-in-cheek materiality. *Richard Deacon* (b. 1949) thinks in big, curvy abstract lines in space, but he uses the stuff of the commonplace—linoleum, cloth, and old plywood. *Bill Woodrow* (b. 1948) and *Richard Wentworth* (b. 1947) extend on this slightly environmentalist creative-recycling approach. But the guy who catches the public imagination is *Tony Cragg* (b. 1949). Bottles, pallets, even porphyry: each material leads to a distinctive structure. More recently he's taken to making evolutionary organic forms—a bit like the carved stones of *Peter Randall-Page* (b. 1954), only not as dense—with the aid of a computer (*see page* 136).

A Lisson protégé of the later 1980s, *Julian Opie* (b. 1958) does environments turned into objects, toy motorways and modern housing schemes, except you can't play with them: it's teasingly, chillily Conceptual. It also connects back to Land Art via the American "architectural sculpture" of Mary Miss. The most gloriously crazy examples of this were the *Dwellings* built out of miniature bricks in odd corners of New York City by *Charles Simonds* (b. 1945)—tiny cities which the artist then simply abandoned to the streets.

The German *Stephan Balkenhol* (b. 1957) finds that interesting things happen when you carve the presence of a straightforward human being out of a log. His steady-faced standing figures have an uncanny neutral power. There's nothing neutral, meanwhile, about the lifesize carvings of *Ana Maria Pacheco* (b. 1943), a Brazilian working in London.

INNER CIRCLE

From architectural sculpture, a tolerably smooth segue leads us to the paintings of architect Zaha Hadid (b. 1950), since the visionary designs of this London-based Iraqi are among the frighteningly few images in Prime Minister Blair's Britain that actually make the future look enticingly "futuristic." For sadder, funnier, more ironic architectural painting, turn to the imaginary interiors of Dexter Dalwood (b. 1960).

1986 American F-111 planes bomb Tripoli, killing up to 130 Libyans.

1988 Goldfish get eaten in the comedy movie *A Fish Called Wanda.*

1990 Martina Navratilova wins Wimbledon for a record ninth time.

1986~1994

One Trap or Another
Graffiti art, "multiculturalism"

Graffiti makes
you famous.

Are you in on the scene? Of course you are, you're reading this book. It's all about people who have got a scene going somewhere or other. We're doing you a précis of the jargon in each, the jargon that persuades people that what they make in those scenes is good. Whether it is, is up to you. But what if you are outside the scene, what if they snigger at you as a hick?

Well then, the art world being what it is, there's a chance—not a fair chance, but a chance—the last laugh will be on you. Because business has to keep moving, shifting its horizons, undercutting preconceived tastes; and somewhere, there may be a dealer waiting for you, one who can sweet-talk your mediocore into magnificent. "Outsider art" (*see page* 74) is material for insider fashion. In the post-modern world, they may even label the process "multiculturalism."

The career of *Jean-Michel B*ASQUIAT (1960–88) rips like a meteor through this atmosphere.

A New York teenager of Haitian parentage (underprivileged, then? yeah, but in a middleclass, art-educated way), he goes out like every self-respecting screwed-up kid to spraypaint the streets. Shrewdly, he chooses streets near SoHo galleries for his logos: there happens to be a big thing in 1980 for "graffiti art." Sign that boy up quick! So pretty, so raw, and yet what an

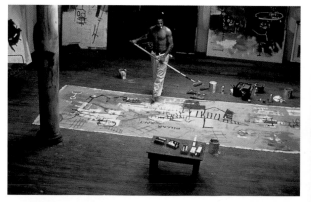

Basquiat, as mythologized in a 1996 movie by Julian Schnabel. David Bowie plays Andy Warhol and Courtney Love is Madonna.

1991 Bret Easton Ellis writes *American Psycho* about a murderous yuppie.

1993 Nick Park makes the award-winning animated movie *The Wrong Trousers*.

1994 American networks clear the decks to run 24-hour news coverage of the O.J. Simpson trial.

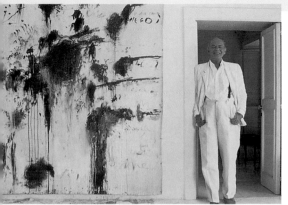

Cy Twombly: look what a naughty boy he's been . . . the original graffiti artist has no shame.

"intuitive" sense of modernist design! At 20, Basquiat finds himself inside the gilded cage. The aged Warhol dotes on him. It's great: he scrawls his sassy staccato faces and messages on 33 × 23-inch sheets in the gallery basement, hands it over, they take him to the cash machine and pour enough cash in his hands to pay for a junkie's eternity. It's shit: the whole scene's bogus, he's seen through it all, trapped rage fires his every brilliant outburst. Burn-out occurs at 27.

A fellow beneficiary of the graffiti vogue, *Keith HARING* (1958–90), with his user-friendly cartoon characters, is white, but gets added significance through being gay. "Representing" minority interests is big on the 1980s–1990s art-institutional agenda, which seeks out candidates for exemplary pluralism.

Most often, these candidates are semi-insiders, adapting a wised-up knowledge of the art scene to fit themselves to the context: *Jimmie DURHAM* (b. 1940), with his stingingly sardonic take on being a Native American doing Native American-style installations in a white man's gallery; or LA's *Mike KELLEY* (b. 1955), with his contention that suburban craft-fair white trash, with their sad raffias and furry toys, are today's real dispossessed. Kelley sets a style in "abject" art that will run through the 1990s.

INNER CIRCLE

Taking up the practice of "appropriating" famous compositions from the earlier (and far more richly enigmatic) African-American Expressionist Bob Thompson (1937–66), Robert Colescott winds up the 1980s art community with a spiky series of "blacked-up" satirizations of Picasso's *Demoiselles*, de Kooning's *Women*, etc.

OUTER FRINGE

So sorry, Cy! "Twombly" (b. 1928); with a name like that, how could we forget you? You were the original graffiti artist, weren't you? You were Basquiat's inspiration; hanging out in the 1950s with Rauschenberg and doing your crazy left-field take on Pollock, your silly but serendipitous scribbles and scrawls, stucked with learned allusions. Then you went off to Italy, and somehow got cydelined . . .

1988 André Dubreuil creates the "Spine" chair, made from a ladder of wrought steel that follows the line of the back.

1991 A corpse found in the Austrian Alps is reckoned to date from around 3350 BC. It is named Ötzi by scientists at the University of Innsbruck.

1993 The World Health Organization removes homosexuality from its list of recognized mental illnesses.

1986~2000

Eminence Grise
Richter, Neo-Geo, etc.

Gerhard RICHTER (b. 1932) is serious about painting, deadly serious. What does painting represent, in the present historical situation? The world out there, or merely a manual activity that is its own raison d'être? What is it to know things in these times; what is it to make marks?

Gerhard Richter, *Ema: Nude on a Staircase* (1966). Cologne, Ludwig Museum. A rare moment of classicism in Richter's work.

He publishes his questionings in a volume adorned with his face earnestly and endlessly captured on camera, a bible to many an art student. The questionings don't deter him from putting marks on canvas with an industrial productivity. Sometimes his marks offer information, relaying a blurry snapshot of some view or some figure, sometimes they offer none—streaks of pigment smeared into a self-cancelling non-image; it all seems one to Richter. Sometimes they are hauntingly compelling; sometimes they are merely null. Always they are methodical, inexpressive, philosophical in intent.

Alongside his fellow German, the darker yet more joyful Kiefer (*see page* 118), Richter is the nearest thing contemporary art has to "authority"—if authority's what you're looking for. Richter's been at it since the early 1960s (*see page* 100), but it's really in the late 1980s, with a sequence reporting the deaths of Germany's Baader-Meinhof gang, that his impact comes through in the English-speaking world. This coincides with a change in vibe. Come 1986, the NY art network is tired with all that hot, messy Neo-expressionist painting (*see page* 118). The focus switches to the cool, sharp, neo-Conceptual attitude kept going by the "Pictures" gang. Hard-eyed heartlessness is so refreshing, don't you think? *Peter HALLEY* (b. 1953) and *Philip TAAFFE* (b. 1955) with their "Neo-Geo" painting—the abstraction of Mondrian and

1994 British Conservative member of parliament Stephen Milligan is killed by self-strangulation.

1996 Alan McKay blows a bubble 105ft long at Wellington, New Zealand.

1997 The ashes of LSD advocate Timothy Leary are launched into orbit

Riley done in postmodern ironic quotes—are the Sheena Eastons of this product strategy, its disposable market-testers; its Madonna is *Jeff KOONS* (b. 1955), the nimble-witted smirkmeister of yuppie opportunism with his neo-readymade vacuum cleaners ('Readymades?' —*see page* 116) and his mass-appeal lines in outsize porno and kitsch. (Like Madonna, what he's after is his own success; any earnest commentary *about* "simulationism" and "commodity sculpture" is really beside the point.) The mood swing does, however, open viewing

> **OUTER FRINGE**
>
> Vija Celmins (b. 1939), an American of Latvian ancestry, shares with Richter a deep, earnest wonder at the nature of marks and their relation to the cosmos. She expresses it in small, fanatically (and beautifully) impersonal graphite drawings, mostly of unpeopled space—ocean waves, desert stones, the galaxies. (In this last, she echoes the astronomic imagery in the turn-of-millennium paintings of Kiefer.)

> **INNER CIRCLE**
>
> Sigmar Polke (b. 1941) is Richter's friskier accomplice in German philosophic quizzicality, painting overlays of very silly kitsch images and polke-dot decors that reflectively mock each other, under a pseudo-alchemical rubric. Aiming at Monty-Pythonesque uproar, he mostly ends up (for my money, at least) as the Francis Picabia (*see page* 44) of postmodernism, its second-rate comedian telling not very funny jokes.

space for people possessed of some integrity. (An uncool word among art networkers, but that's their problem.) The mock abstraction of Halley and Taaffe rubs shoulders with the abstractly designed but evocatively lugubrious canvases of *Ross BLECKNER* (b. 1949)—haunted, darknesses that commemorate the tragic impact of AIDS. (*See also* Robert Gober, page 134.)

In Britain, the abstract procedures of *Ian McKEEVER* (b. 1946) are premised on thoughts about natural processes, but he too opens the by-now fusty old abstract tradition to a fresh spiritual intensity. More upbeat British attempts to revitalize it come from other do-things-this-way-and-see-what-happens "process" people: the lighthearted *Fiona RAE* (b. 1963), the exquisite *Callum INNES* (b. 1962) and *Jason MARTIN* (b. 1970) with his single sweep of the brush across a 6-foot canvas.

Ross Bleckner, *8122 + as of January 1986* (1986). Dark and evocative.

1989 Richard Cobbing of Surrey, England, completes 75 somersaults in a minute.

1990 A scrap metal sculpture entitled *Powerful* is built in India, weighing 27 tons and measuring 56ft tall.

1991 Demi Moore poses naked and pregnant on the cover of *Vanity Fair*.

1988~1997

A Professional Attitude
Young British Artists

Once, there was industrial capitalism and its institutions, and modern art was somehow going to challenge or transcend them. Now, modern art is the institution, and is often to be found nesting and preening itself in the warehouses and factories vacated by industry's move out of town.

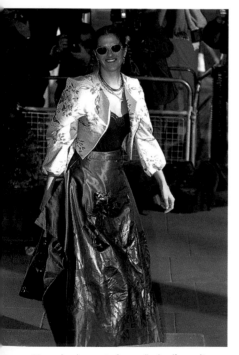

"Go on, hand us a pair of panties, Trace!" A quirky mixture of rude punkiness and self-interest, Emin is endlessly self-regarding. Where she goes the media follow, now that she's famous for being famous.

Brickwork painted brilliant white; old pipes leading nowhere, "features" the architect retained; acres of concrete between the desk where an assistant gets faxes from the Venice Biennale and the chair in which the director lolls, taking a call from a major German bank. The scene is repeated, with variations, across the postmodern globe. Its spaces are populated by sponsors, collectors, curators, and other, smaller fry—art journalists and artists. Such, these last twenty years, is reality. And isn't that what art's supposed to reflect?

The achievement of *Damien HIRST* (b. 1965) is to have focused artists on the real problem of the 1990s: how to play this scene. Qualify that: behind him stands the opportunism of Jeff Koons (*see page* 129). And maybe we should credit Hirst's mentor at London's Goldsmiths" College, *Michael CRAIG-MARTIN* (b. 1941)—a smaller-scale "neo-Conceptualist"—for instilling "professionalism" into a generation whose interests were otherwise scattered: Gary Hume (*see page 139*), *Sarah LUCAS* (b. 1962) and *Tracey EMIN* (b. 1963), Jenny Saville (*page 139*), Rachel

1993 Douglas Gordon makes *24 Hour Psycho*, a showing of Hitchcock's movie slowed to two frames per second so as to last a whole day, projected onto a freestanding screen that the viewer can walk around.

1996 6,654 tap dancers dance a single routine outside Macy's department store in New York to break the existing record.

1997 AIDS kills 2.5 million people worldwide, according to a UN report.

Whiteread (*page* 135), and *Jake* and *Dinos CHAPMAN* (b. 1962, 1966). But it was Hirst's initiative in organizing the "Freeze" warehouse show of 1988 that attracted the respect of Britain's main—nay, sole—major-league collector, Charles Saatchi. Watching Hirst hassle the right people into coming to his events and lesser people into making the Damien Hirst installations (*see page 135*) to fill them, the advertising king evidently felt a synergy, a rapport: here's someone on our level.

> **OUTER FRINGE**
>
> Controversial artwork! Should we "remove this threat to the public!"– or resist this threat to art? 1990s media morsels of this type include the child-handprinted portrait of child-murderer Myra Hindley by Marcus Harvey (b. 1963), an inane exhibit at the 1997 "Sensation" show that, like an earlier pickled lamb of Hirst's and a later unmade bed by Emin, drew some equivalent fool from the public to rise to the taunt and deface it.

> **INNER CIRCLE**
>
> "Venice Biennale": every two years, everyone who's anyone converges on the national pavilions in the city's Giardini Pubblici to gawp at each country's committee-approved artist, or resort to the subsidiary, fringe "Aperto," there to mull over the current state of the international "avant-garde." (Please note ironic quotes.)

Charles Saatchi and Damien Hirst. They've got a lot to be pleased about.

Is there any irony in the fact that the man who helped the British Conservative party win four elections should also preside over the rise of "Young British Art" in the following decade, sealing his success with the Royal Academy's "Sensation" show of his collection in 1997? Or isn't there simply a symbiosis with the Tate Gallery's annual "Turner Prize" for top artists under 40 acting as publicity catalyst? Shock helps launch a culture product; personalities sustain it. The Chapman brothers with their mutated mannequins of penis-nosed kiddies offered the former, with the cheery goodwill of a Friday-night drunk ramming a broken glass in your face "just because." As they and Hirst got grandiose in the later 1990s, Emin, winningly rude, winsomely cute, became the new personality of BritArt; this story may run for some time yet. The YBA package, however, is well past its sell-by date.

1992 Petra Kelly and Gert Bastian, of the German Green Party, are found dead from gunshot wounds. Police claim it was a double suicide but friends of the couple suspect a conspiracy.

1994 Sumo wrestler Takanohana becomes a *yokozuna* (grand champion), weighing 313lbs.

1996 Leslie Ibsen Rogge is the first man to be arrested as a result of his picture appearing on the FBI's website.

1990~2000

Extended Mix
Installation and video

Kiki Smith, *Tale* (1992).
Private collection.
Does this count as feminism?

So who's this "me" that the "me generation" are so keen on? In the late 20th century, people seem less communal-spirited, more atomized; and by the same token, increasingly uncertain how to define themselves. Blame science: male and female, life and death, all of them turn from categories to blurs on a spectrum. Blame the media: multinationals, the internet, and MTV erode local identities. Blame also the humanities, with their deconstruction of every conceivable cultural essence.

You can even blame the artists, if you like, with their installations, a form-of-no-forms that tends to reflect on or simply reflect this predicament. Rising in importance with the new professionalism of the 1990s, installation is partly an effort to ape the curators who run the art scene,

by determining the conditions in which you place your own exhibit. Videos now have to be seen in a specified context; photoworks, assemblages, and other made components are put in quotes inside a total scenario.

But the means of control are often being employed to deliver meanings of lost control. The melange of media interacts with the viewer, challenging the coherence of his own self-image. *Ilya KABAKOV* (b. 1933) conducts you on magical misery tours of tawdry, absurd interiors that convey the collapse of the Soviet dream for humanity. *William KENTRIDGE* (b. 1955) stages his drawings so as to place you inside the mind of a fictional South African businessman, the better to open up its contradictions.

> **INNER CIRCLE**
>
> "Am I coherent?" as a question for sculpture: the broken nudes of the American Kiki Smith (b. 1954), here leaking with blood, there hung up dismembered. "Is sex the way we are?" as a question for painting: see the lewd nudes in the watercolors of South African Marlene Dumas (b. 1953).

1997 There is a joint US-Russian spacewalk by astronauts Jerry Linegar and Vasily Tsibliev.

1999 Ted Hughes wins the Whitbread Prize posthumously for *Birthday Letters* about his marriage to Sylvia Plath.

2000 London's Millennium Dome gets off to a bad start when hordes of celebrities have to line up for hours to get into the New Year Party.

DELIBERATE DISORIENTATION

Often the subversion strikes at a level deeper than cultural identity. *Yayoi* KUSAMA (b. 1941) offers you enticing, threatening environments of psychedelic delirium. *Richard* WILSON (b. 1953), an inspired player of this game, sends you off to lose yourself on a walkway through a lake of shoulder-high unfathomably dark sump oil. Bubbling chocolate fountains and disturbingly pretty intertwinings of golden hair with pigs' guts helped *Helen* CHADWICK (1952–96) undermine your categories of permissible pleasure; *Anya* GALLACCIO (b. 1963) surfeits them with rotting strawberries. Both of them built on the search for new forms in 1970s feminism (*see page* 110), as does *Cathy* de MONCHAUX (b. 1962) with her uneasily sensuous extendable structures of labia-like weaving. *Mona* HATOUM (b. 1952)

> ### OUTER FRINGE
> Is-this-really-my-body-art for the 1970s: the filmed performances of horned and feathered and strapped Rebecca Horn (b. 1944), who has since gone on to devise ingeniously irritating squawking and clicking machines. For the 1990s: Orlan (b. 1947), whose face and body shift from one publicly staged plastic surgery to another, carved or remodeled to resemble the beauty standards of old masterpieces.

pulls you in further, on a minicamera-videoed journey through the passages of her own body. *Tony* OURSLER (b. 1957) also plays with smart technology, mini-video projectors, to lure you into disorientation: his creepily poignant trick is to run isolated talking-head sequences on the faces of little puppets or motionless paperweights.

In fact video, drawing partly on the process-and-system abstract thinking of the 1970s and partly on the up-market digitalized production standards and sexual upfrontness of the 1990s, is the most focused strand in this sprawl of possibilities. Turner Prize winner *Steve* McQUEEN (b. 1969) gives you the former sensibility; the bizarre phantasmagorias of *Matthew* BARNEY (b. 1967) the latter.

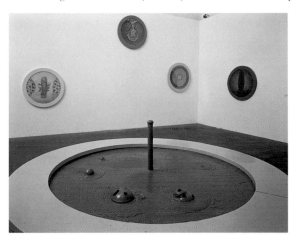

Bad Blooms, installation by Helen Chadwick and Edward Woodman at the Serpentine Gallery, London (1991).

1990 Van Gogh's *Portrait du Dr Gachet* is sold at Christie's, New York, for a record $75 million.

1992 Russian serial killer Andrei Chikatilo is found guilty of murdering 53 people over a period of 12 years, although someone has already been executed for one of these murders.

1994 Cindy Crawford and Richard Gere take out a full-page advert in *The Times* in London, proclaiming their love, but divorce the following year.

1990s
Spent Breath
Recent sculpture

"Spirit" is a tricky word: no-one's quite sure how or whether to use it when talking about art, not least because few people these days know how or whether to attempt some sort of religious life. Let's just define it negatively. It's what leaves your body when you're dead.

Christian Boltanski, *Reliquary* (1990). Madrid, IFEMA Collection.

INNER CIRCLE

Conceptual monument to mortality: the reddish-brownish rather messy cast of a head inside the misty case turns out to consist of the blood of Marc Quinn (b. 1964), kept frozen in the form of his likeness by a refrigeration system. That power had better not blow! If this is this YBA's only bid for immortality, it's a bloody good one (pun intended!).

Whatever it is, it matters: enough to keep sculptors busy in a score of different ways through the 1990s. One prompt for this theme is the AIDS plague. *Robert GOBER* (b. 1954), in his delicately judged, deeply distressing models of plug-and-tapless washbasins, unsleepable beds, trousered legs disappearing into walls, madonnas drilled by drainpipes, finds an eloquent new language in which to mourn the gaping absences in the gay community. The attempt to bring to mind the century's mass murders provides another occasion. *Christian BOLTANSKI* (b. 1944) installs light bulbs before blurry shots of people who you feel—though you'd apparently be wrong—might be Holocaust victims. You're left in a disturbing limbo of ever-insufficient memory. Or the grief may be

1996 Thomas Hamilton kills 16 children aged five and six years old in Dunblane primary school, together with their teacher.

1997 Nintendo launch a mini-camera and printer that can be plugged into GameBoys.

1999 A British university offers a course in Fashion (sportswear and streetwear).

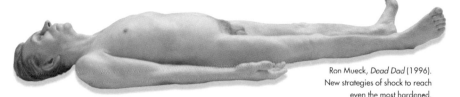

Ron Mueck, *Dead Dad* (1996). New strategies of shock to reach even the most hardened.

entirely personal: *Ron MUECK* (b. 1958), in the most haunting work of the "Sensation" show (*see page* 131), finds a metaphor for it by shrinking a flawless, clothing-less, hair-by-pore simulation of his *Dead Dad* to half-life-size.

In fact death is the subject-matter of that show's presiding influence. Damien Hirst (*see also page* 131) combines his entrepreneurship with thoughts on doom when he has his sharks and halved carcasses pickled or when, in his most ferocious concept, he encases a calf's head and a swarm of flies in a sealed case and lets nature "take its course."

The theme extends to the other success story of BritArt, *Rachel WHITEREAD* (b. 1963). She plugs away at her single but

OUTER FRINGE

While we're remembering: let's speak up for Michael Sandle (b. 1936), a British sculptor whose unfashionable wish to express outrage at 20th-century barbarities in grand, indignant bronzes—reviving the tradition of Jagger (*see page* 50)—left him long on the outside critical track. Also for the American Walter Martin (b. 1953), whose mordant tableaus stand halfway between his and Gober's.

powerful idea, the solid casting of the insides of evocative spaces (famously, in the short-lived *House*, 1994, on a street in London's East End), as another attempt to materialize "the feel of not to feel it." (Thanks very much, Keats.)

But what is "it"? Two older sculptors, from the Lisson Gallery lot of the 1980s, are willing to think about spirit more positively. *Anish KAPOOR* (b. 1954) moves from a sensually inviting art of compact objects smothered in gorgeous powders of pigment, to issuing equally attractive invitations to surrender to the richness of the void, conjured up by hollowed stones or in magical installations.

Anthony GORMLEY (b. 1950) also has quasireligious aspirations when he creates a sculptural system out of hollow standardized lifecasts from his own body, positing the air within as his spiritual breath. A prime example of the pompous megalomania that's an occupational hazard of sculpture, Gormley has nonetheless devised one participatory artwork of genius with his *Field*, thousands of little clay-lumps prodded with eyes by thousands of hands and gathered together to unforgettable effect.

1975 The Sex Pistols play their first live concert together, swear on British TV, get a record deal with EMI, and get fired by EMI; their only single begins with Johnny Rotten yelling "I am an antichrist!"

1981 "You cannot be serious!" John McEnroe, the bad boy of tennis, finally beats his rival Bjorn Borg in the Wimbledon final.

1986 The term Mexican wave is coined to describe an activity popular among sports fans.

1970~2000

Is God a Geek?
Computer and holographic art

Writing this, I'm looking straight into the pure light of contemporary reality—the computer screen. Reading it, you're stuck back with that quaint old business of pigment. Printer's ink, art objects—what still makes you linger in the world of solidity?

G. Sams, *Fractal.* An image developed from the mathematical thinking of Benoit Mandelbrot.

offshoots in many a screensaver and pop video. Then there's the rococo of Benoit Mandelbrot's fractal forms, a new and enticing picturesque for the 1980s. But equally, the Cubist revolution in thinking about the relations between objects and spaces (*see page* 24) demands to be tackled—and here the laser holograms of *Margaret* BENYON (b. 1940) lead the way, converging and fusing separate forms in the same virtual space back in the 1970s.

For that matter, there's a new need to tackle that old Constructivist vs. Surrealist argument (*see page* 64) about rational

Art—if you buy one account—is a phoenix burning away its material bonds in the 1960s transition from Yves Klein's leap into space (*see page* 79) to the bonfire of Conceptualism (*page* 102). Reborn in cyberspace, it is obliged to re-enact its former history, only fastforwarded on all fronts simultaneously. Computer mapping of object coordinates reruns the drawings of Renaissance perspectivists like Leonardo and Uccello. It opens possibilities for the Baroque image-spectaculars of computer artists like *Michel* BRET (b. 1941), which find their still-life or anecdotal

OUTER FRINGE
Unmentioned so far in this book, but inspirational to many 20th-century artists working at the interface of art, biology, and math: Wentworth D'Arcy Thompson's book *On Growth and Form*, published back in 1917. Stimulates computer explorers like William Latham, whose virtual topologies are matched by solid bronze lookalikes in the late 1990s sculpture of Tony Cragg (*see page* 124).

1993 High-fashion houses offer ripped sweatshirts for $350 each, for those who want their grunge look readymade.

1997 British nanny Louise Woodward is found guilty of murdering a baby in her charge by shaking it.

1998 Nelson Mandela marries Graca Machel, widow of the president of Mozambique.

design vs. wobbly biomorphism, as Artificial Intelligence researchers trying to program computers for creativity (*see* Inner Circle box) choose between tree-structure and organic, "fuzzy" strategies. This whole progressive history, art ascending alongside science on humanity's upward path, fires up many a positive-minded neo-Darwinian. Forward with the information evolution! Let new life-forms emerge, e.g. the virtual mollusks that *William LATHAM* (b. 1961) topologically rotates. Empower the human subject to creatively transform his own reality: *Christa SOMMERER* (b. 1964) and *Laurent MIGNONNEAU* (b. 1967) devise an installation (*Trans-Plant*, 1995) where the viewer, stepping inside to see his own image relocated in a widescreen jungle, can change its flora through his every body movement. Shape your universe: true interactivity. . .

Hmmm. Back in the solid world where some unfortunates have been left stranded since 1970 or so, there's been a kind of wising up on that old modernist notion of progress. Yes, things keep on getting more complex, if that's what you mean by evolution, but exactly what does that make better for whom?

> **INNER CIRCLE**
>
> A-grade AI: hacked off with the arbitrary willfulness of his practice as an abstract painter in 1960s London, Harold Cohen (b. 1928) gets into writing programs that will generate imagery creatively, but from logical principles. Rethinking the nature of lines, closed forms and figure recognition, he touches fascinatingly on the bases of art and delivers offprints of strange, gawkily evocative imagery.

And do you call that interacting, slumped before the screen and deaf to all enquiries? Get a life! Geekdom gets its ironic come-uppance in *The Helpless Robot* (1990) of *Norman T. WHITE* (b. 1938)—a movable plastic structure whose only capacity is to utter voice-synthesized demands: "Excuse me... have you got a moment? Could you please turn me just a bit to the right?... No! Not that way... The other way!" You've got it: you've been enslaved.

The new organicism: one of the computer creations of William Latham.

1991 Vulcanologists Maurice and Katia Krafft are killed on the slopes of Mount Unzen, Japan, by a cloud of gas.

1994 In Mona Hatoum's *Corps Etranger*, the exterior and interior orifices of the artist's body are projected in a viewing drum accompanied by the sound of her breathing and heartbeat.

1996 Rap star Tupac Shakur is killed in a drive-by shooting while on his way to a party.

1990~2000

And Kicking
Recent painting

Tony Scherman,
À Kim Phuc (1999)
Toronto, Bruce Mau Collection.

"Painting is dead" is a line that hovered around between the Minimalism of 1965 (see page 96) and the "Neo-expressionist" rogue of 1980 or so; for that matter, Duchamp had hit on it long before (see page 36). It then returned to settle like a gray sky over painters in the 1990s, until the critics noticed breaks in the clouds around 1998.

This second spell of low pressure was a reaction to the overheated idiocy of the intervening Schnabel phenomenon (*see page 121*). The late 1980s and 1990s also saw "theory" riding high—that is, an often garbled melange of Foucault's and Lacan's suspiciousness about all matters visual, together with a feminist dislike of "the Western tradition," generally insinuating that painting amounted to an evil plot against humanity. It's not surprising that some of the best painting of the 1990s had a harried, backs-to-the-wall feel to it.

The Belgian *Luc TUYMANS* (b. 1958) strips commonplace images of people and objects down to their essentials, worrying what he needs to keep if it's to deliver the unique charge of painting. Not much in the way of color or gesture, he concludes; but what remains is grippingly punchy in its mean, sure pitch of delivery. In England, meanwhile, *Thomas NEWBOLT* (b. 1951) also paints figures as if the continued life of painting depended on each stroke, though more flamboyantly. The dark, deep encaustic within which enticing half-images emerge in the paintings of the Canadian *Tony SCHERMAN* (b. 1950) is

1997 Tiger Woods is the youngest ever winner of a Masters title and the first black player to win a Grand Slam golf tournament.

1999 President Clinton is acquitted of perjury and obstruction of justice by the Senate following the Monica Lewinsky scandal.

2000 In Britain, the Queen Mom celebrates her 100th birthday.

OUTER FRINGE

One strand in 1990s painting kept up the cool, conceptually determined attitude of Richter and Neo-Geo (*see page* 128). In London, the large, photo-based, very Canadian-looking paintings of Peter Doig (b. 1959), the suspiciously empty interiors of Paul Winstanley (b. 1954), and the optically imposing, computer-organized paintings of furniture and landscape by Dan Hays (b. 1966).

INNER CIRCLE

Painting, wised up to its own history: back in the 1980s, the masterfully witty Mark Tansey (b. 1949), with his WW2 battlepiece of Picasso signing Paris's surrender to Generals Greenberg and Pollock, *The Triumph of the New York School*. In the 1990s, the clever-clever Glenn Brown (b. 1966) with his fine-brushed *trompe l'oeil* of clotted gunk, *The Day the World Turned Auerbach*.

On other paths out of the YBA bracket, *Jenny SAVILLE* (b. 1970) makes arresting paintings about women's self-images; while the most exuberant painter of the generation, the Nigerian-born *Chris OFILI* (b. 1968), allows room for self-mockery with his super-dude "Captain Shit" imagery and his trademark inclusion of elephant dung-balls, but delivers delirious, exquisitely crafted fusions of the aboriginal dot techniques (*see page* 116) with the immediate concerns of everyday life in contemporary London.

assigned titles making bold claims on history, in a dare taken on the notion that painting might still deliver meaning. *Terry WINTERS* (b. 1949) scales up the AbEx style so that it visually engulfs the viewer: Expressionism marries Conceptualism.

Such people are, as it were, the philosophy department, the contemplators. It's the fact that others have *done* things with painting that demonstrates that this weird, old practice is still alive. With his mentholated brio and his language of pastel shades, *Gary HUME* (b. 1962) has staked out a new territory in turn-of-millennium London: whole aspects of the culture stand reflected in its distinctive enamel gloss.

Terry Winters, *Color and Information* (1998). New York, Matthew Marks Gallery.

2000 London's Tate Modern gallery opens in an old power station and is an immediate success with critics and public, but the Millennium Bridge proves a little shakey.

2000 Families are rescued from trees as severe flooding sweeps Mozambique.

2000 The race for the White House, between George W. Bush and Al Gore begins in earnest.

2000

The Truth About Modern Art
Criticism and the future

You're aware that the interpretations of modern art in this book are all incredibly contentious, aren't you? The facts, they're just great: we double-checked most of them in Ian Chilvers's Dictionary of Twentieth-century Art. (OUP publish it, and we think it's wonderful.) But the views: don't take any of them on trust! They might land you in serious trouble in the wrong sort of classroom, or private view— or wherever it is you're hoping to knock 'em dead with your artistic savvy.

Chris Ofili rocketed to worldwide recognition for his use of elephant dung, thanks mainly to Mayor Giuliani's "sick art" outburst.

B ut then, who are you to trust? Saber-toothed sophisticate Rosalind Krauss? Grouchy but trenchant Robert Hughes? The assiduously contemporary Lucy R. Lippard; the nimbly witty Peter Schjeldahl; 1950s-man David Sylvester, 1960s-man Tim Hilton; the exuberantly bilious Brian Sewell; or the incisively indecisive Matthew Collings? (To name only some of the critics enjoyed around these offices.) None of them, no way. Art writing is best read when it's in interesting *dis*agreement with your own instincts, and those, finally, are what you're left with. No-

one knows the truth about modern art, that's the truth; you pick up the trail from wherever you happen to be, and there will always be more to discover.

Still, you might ask what's the broad shape of this story. Here are two suggestions. One: it's a tale summed up by David Bowie's great line (before he

2000 In Rio de Janeiro, a man who holds up a bus and shoots a pregnant woman hostage is suffocated by the police on the way to the station.

2000 Charles Saatchi buys Tracey Emin's bed for £150,000.

2000 A Canadian seed producer accidentally supplies British farmers with genetically modified seeds.

descended from rock to the mere art world), "I had so many dreams, I had *so many* breakthroughs." A history of progress and setbacks, and perhaps too many of them: that's the modernist version. Two: it's not really a linear narrative at all; it's a tangle of grass-roots on the slope of time, and its trails won't be teased into any order of precedence. In effect, this book subscribes to that second, postmodernist account.

And, you might ask, what now? OK, *now* (not tomorrow), we've again got two versions on this business of art. One says this: Art is creativity, curiosity, new things happening in your mind and life. It's an emerging surprise, it's even a sudden shock; it's liberation. The danger it confronts is Death by Museum, the imprisonment of the curator's frame. To avoid it, it needs to keep on the move, nomadically in step with new resources and technologies.

The other voice says: Creativity and Curiosity belong everywhere. But there is one strange thing with this species, and that is the way it can wrap its hands and heart and eyes around a piece of inert matter and coax it into life. Making

> **INNER CIRCLE**
> Among the many books this little book has leant on, one at least (beside the indispensable Chilvers) deserves mention: Bruce Altshuler's fantastically well researched, deeply intelligent but often hilarious *The Avant Garde in Exhibition: New Art in the 20th Century* (Abrams, NY, 1994).

> **OUTER FRINGE**
> "But why haven't you mentioned...?" Oh, apologies are boring. Look, the reason your personal favorite 20th-century artist goes unsung in these pages is simple: whatever you suppose, he or she is NO DAMN GOOD. OK? (The only exceptions to this rule are personal friends of the author's.)

material objects that will serve as visual symbols—call them paintings, sculptures, whatever—is about where humanity starts, and however hard it may be to make the symbols vital, it isn't stopping now. For "there is no past or future in art": it was Picasso who said that.

Anyway, this author has had enough of talking about what other people make, he's off to do it himself. It's over to you.

Hackneyed British realism or a bridge to the future? Julian Bell (who?), *The Arrest at Nevada Bob's* (1999). Museum of London.

Index